Dance Works

Dance

STORIES OF CREATIVE COLLABORATION

WESLEYAN UNIVERSITY PRESS MIDDLETOWN, CONNECTICUT

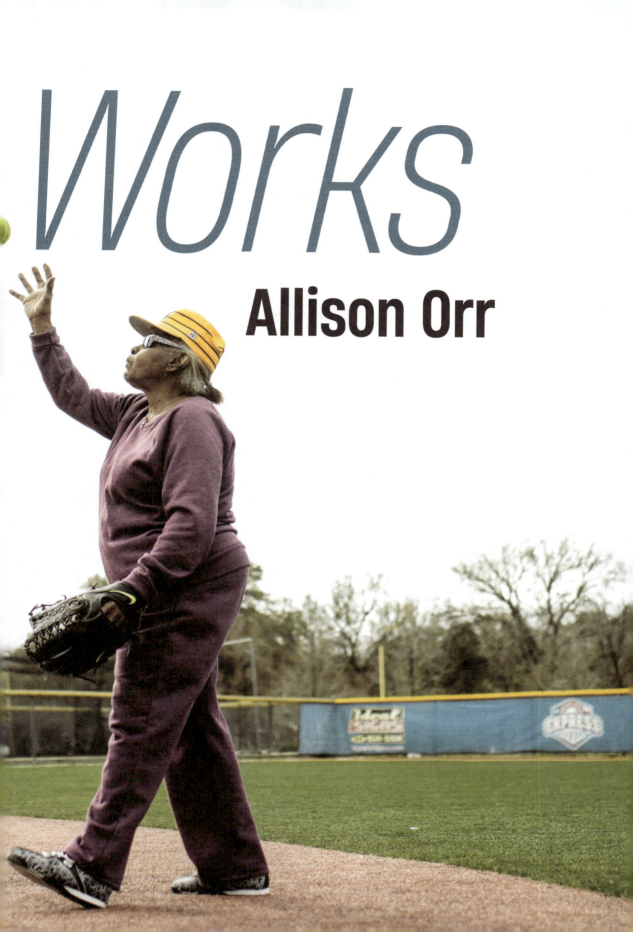
Works
Allison Orr

Wesleyan University Press
Middletown CT 06459
www.wesleyan.edu/wespress
Text and photographs unless otherwise noted © 2023 Allison Orr Dance, Inc.
All rights reserved
Manufactured in the United States of America
Designed by Richard Hendel
Typeset in Utopia, The Sans, and Heading Now by Passumpsic Publishing

Library of Congress Cataloging-in-Publication Data
NAMES: Orr, Allison, author.
TITLE: Dance works : stories of creative collaboration / Allison Orr.
DESCRIPTION: Middletown, Connecticut : Wesleyan University Press, 2023. | Includes index. | Summary: "Personal and critical reflections by an acclaimed choreographer on dance making as community making"—Provided by publisher.
IDENTIFIERS: LCCN 2022040241 (print) | LCCN 2022040242 (ebook) | ISBN 9780819500243 (trade paperback) | ISBN 9780819500342 (ebook)
SUBJECTS: LCSH: Orr, Allison. | Dance—Social aspects—United States. | Community arts projects—United States. | Choreographers—United States—Biography. | Women choreographers—United States—Biography. | BISAC: PERFORMING ARTS / Dance / Choreography & Dance Notation | ART / Public Art
CLASSIFICATION: LCC GV1785.O59 A3 2023 (print) | LCC GV1785.O59 (ebook) | DDC 792.8/2092 [B]—dc23/eng/20221018
LC record available at https://lccn.loc.gov/2022040241
LC ebook record available at https://lccn.loc.gov/2022040242

5 4 3 2 1

Contents

Foreword *by Liz Lerman* vii

Acknowledgments xi

Beginnings 1

1 ***In Case of Fire***
A Dance for Firefighters 19

2 ***The Trash Project***
A Dance for Sanitation Workers 35

3 ***PowerUP***
A Dance for Electric Utility Workers 65

4 **Dances for Places and Their People**
Baseball Fields, City Pools, and More 101

Appendix 1: The Steps: Forklift's Practices for Collaborative Performance 147

Appendix 2: Major Works 161

Notes 163

Index 165

Foreword

by Liz Lerman

The video clip shows a man standing next to his van, pointing both arms in the direction of a similar vehicle a few feet in front of him. He says, "We'll come around; we'll all get here, we'll see him. Once he starts moving, we'll all move together," and then the camera moves back and you see a whole line of vans, each with a man standing by, and the men all open the side doors at the same time and at the same speed. There is much laughter. And then the man says, "It's all a dance. We are moving together."

These are the words of the Wesleyan University plumbing foreman Dean Canalia, in a rehearsal for a piece that Allison Orr and Forklift are making for the workers who labor all over campus. And this man, Dean, through his contact with the work that is centered in this book, has just enunciated a massive truth: the world is in motion, and we are all a part of it. What Allison Orr writes in this narrative is the acknowledgment of that, and then all the ways it is possible to make this truth evident by the way people work, play, and move about their day. And while she is convincing the participants, she is also convincing the rest of us to pay attention, to see the beauty and the aesthetics in removing trash, in rowing a gondola, in impersonating Elvis, in caring for the trees in a city, and in the ways in which people physically partner their trucks, vans, and automobiles. These lives and this work are, in Allison's view, the stuff of dance, of choreography, of theater, and are the essential elements of an artistic life.

I believe that choreographic thinking is a compendium of practices that teach us how to live within a constantly changing world. It's not just the way things move in the wind, or the way the stars and moon change in the evening sky, or even the way a dancer might cross the stage. It is also our institutions, our closely held notions of history, and the way our bodies react to our own inner life and the emotional experiences of those around us. What Allison Orr describes in this energetic and surprising book is how she translates all that she knows as a choreographer into language and action that make these physical truths abundantly clear. I am so happy to add a few words of introduction and to support my friend, colleague, and joyous rebel with the conviction that her work matters.

The organization of this book is linear, but the feeling of the structure is of concentric circles of knowledge building. You read how her own deepening understanding of class and race as well as power dynamics in neighborhoods, jobs, governments, and, yes, even her own small nonprofit organization need to adjust and change in order to bring out the humanity and community forged in these projects. You feel the evolution of her practices and chart her willingness to notice shortcomings, understand their sources, and thus be able to change herself, her work, her methods, and all the people she touches. The fact that she is a movement artist, and bringing people back to their bodies and their physicality, is an essential aspect of her vision even as she is serving, making, sharing, joking, collaborating, and testifying.

How does this all work? What does it take to build relationships among artists and civic workers? How is it possible that an electrician can begin to see his work as an extraordinary pattern of motion and that others will see him, the work he does, and the idea of dance entirely differently after experiencing a Forklift production? What does it take? So much of the work that Allison and her colleagues do is invisible. It's not invisible to the participants, but it is to most of us unless we consider what precedes the event itself. How many early morning hours did Allison ride with the people who remove our trash? How many meetings did she attend before the ride was possible? How many people did she have to persuade that this was not only possible but useful?

In answering these questions, Allison and her colleagues give us new language and new images. She does something called a *job shadow*. She takes Venetian rowing lessons when working with gondoliers; she figures out when and how to ask a firefighter to join so that she won't get a "no." We are supported in our own discoveries by the theory from other disciplines that Allison brings to bear in her work. For example, we are treated to an ongoing discussion about what it means to be in a relationship as an outsider. We learn about the rigorous methods that iterate with each project and see the details that show us how to do it. At the same time, she writes with a thoughtful awareness of the risks, not just for herself and Forklift but also for the communities of people she engages. This is a remarkable contribution for us all as we navigate our differences and attempt to bring our atomized worlds a little more in contact with each other.

And because this book is a personal and professional accounting of a life in the field, we learn, too, about Allison's husband and children and about being a mother. How priorities adjust and change and how having a family informs the work at every level. Here is where I must add something personal, too. Allison babysat my own daughter when she spent time at Dance Exchange, the company I had founded years earlier. I had the great privilege of knowing Allison as a young thinker and doer. I watched as she

furthered what she had begun in college and pushed for its rightful place in the dance worlds we were all building. I always said that Allison just needed to land in a place that would tell her "Yes! Keep going!" That she wasn't crazy at all for the ideas and visions she had. Quite the contrary. My memories of that time together at Dance Exchange are explicit and clear; she was a woman on a mission. She knew she was onto something that was important and beginning to come into view and take shape. But, as she clearly states throughout this book, she needs her collaborators— the workers themselves—to make the vision clear and real.

We are the lucky companions to a delightful narrator who shares the best stories, but also the grief and hardship that is real in making art and in making community, in restoring beauty to its rightful place, while convincing those living their lives that they have wondrous things to contribute.

Acknowledgments

Before working on this book, I used to think of writing as a relatively solitary endeavor, especially in contrast to dancemaking, which takes many people's collaborative energy. Little did I know, when I began writing this book, how many people would help make it possible, and how much I would benefit from their support, thinking, and creative contributions.

First, thank you to Barry Chernoff of the College of Environment at Wesleyan University who asked me to come to Wesleyan and begin writing a book. Barry's invitation stunned me. Me, write a book? Impossible! But he was serious, and with his support and that of my fellow 2015–16 Think Tank faculty and students, I got started.

Thank you to Essel and Menakka Bailey for underwriting my fellowship year as a visiting scholar, professor, and Think Tank member at Wesleyan University, and to all on campus who continue to support me and Forklift Danceworks. Suzanna Tamminen, editor-in-chief of Wesleyan University Press, has been an extraordinary coach and cheerleader, and I am eternally grateful to Megan Pugh, developmental editor, who took my early draft and coaxed this fuller, more complete story into being.

Marty Pottenger and Lisa Byrd read drafts as well, giving me invaluable feedback and asking important questions. Clara Pinsky's steadfast coaching kept me moving forward, and Gretchen LaMotte's careful and thoughtful editing was essential. I had numerous panicked calls with longtime friends Alison Kafer and Ben Parzybok, who shared their own experiences with writing and gave me tools to keep going. Beverly Bajema's consistent love and relaxed attention guided me from my first drafts all the way to the finish line. Much appreciation to interns Sarafina Fabris-Green, Annie Kidwell, and Madison Sheridan for their help with research, tracking down photos, and securing permissions. Thank you to all of those who listened to me, encouraged me, and held me to high expectations, reminding me why I should keep at it.

A number of my mentors appear in the following chapters, but I want to especially thank June Watanabe for her fierce and honest coaching, Liz Lerman for continuing to teach and lead me and countless other artists, and Deborah Hay for seeing and articulating to me why this work

mattered. I am indebted to numerous fellow artists and practitioners whose work instructs me, and I am especially grateful for the support and friendship of Stephanie McKee and Jawole Willa Jo Zollar.

Thank you to Krissie Marty, who walked up while I was coaching two hundred two-steppers on the steps of the Texas Capitol and said, "You know, I think I can help you here!" And help she did! Her brilliance, tenacity, and courage have been central to Forklift's success for over ten years, and her knowledge and insights are woven throughout this book.

Andy Garrison and his brilliant film *Trash Dance* forever changed my life and the trajectory of Forklift Danceworks. Thank you to Andy for taking a leap of faith and beautifully chronicling the creation and performance of *The Trash Project*. Andy's remarkable film tells the story of this project in a visually stunning and deeply moving way. Learn more about Andy and his work at trashdancemovie.com.

Gratitude to MacDowell for giving me space (and delicious meals) to move my early draft forward. Also, thank you to my family, both immediate and extended, who have cheered me on through the past seven years of writing. I am especially thankful to Judy for the use of her beach condo; to my children, Genevieve and JoJo; and to my husband, Blake, who said yes every time I said, "I think I need to go away and write some more . . ." Blake has been my most consistent sounding board—both for this book and throughout my career—and continues to be my best listener.

And of course, thank you to everyone who has collaborated with me and with Forklift, from the employees at Mills College in 1998 who allowed me to shadow them on campus to the Watershed Protection employees in Austin with whom we are working now, in 2022. We at Forklift have collaborated with over fifteen hundred people in the past twenty years, and this book, much less our work, would never exist without their expertise, kindness, generosity, and sense of adventure. As I wrote this book, I interviewed many of our past collaborators from different City of Austin departments. They have reviewed and approved their contributions, correcting and refining my memories of what went into our dancemaking, but any omissions or mistakes are all mine.

There are also many essential people working behind the scenes at Forklift, including our administrative staff, tech crews, composer and designer, production and stage managers, and performance volunteers. Some of those people appear in the following chapters, but many others do not. Their omission does not reflect their importance, which is immeasurable for the creation of every Forklift show. The same goes for our board members and countless other supporters: without their generous donations of time and money, we at Forklift would not be able to do our work. Their belief in our mission sustains us.

This book captures my understanding of my own development as an artist and administrator, the growth of my company, and how we have conceived of our work together to date. I expect our work will continue to change and evolve. Now that Forklift is twenty years old, it seems important to reflect, and to share our process with others. I don't expect that you will read this and then decide to go out and make dances just as we have, but I hope you come away with a sense of the power of illuminating underacknowledged relationships, the extraordinary value of the creative process, and the ways that collaboration can lead to both personal and social change.

Finally, thank you for your willingness to read this book. As all performing artists know, having an audience is what allows us to bring our work to fruition. I appreciate your curiosity to learn more about me and my fellow collaborators. I am so grateful to get to tell you this story.

Dance Works

Beginnings

Jenna ran the enormous industrial dishwasher. Stationed right where dirty trays entered on a conveyor belt, she grabbed each dish with impossible speed. Filling the dish racks, she lined up dirty plates on their sides with a flick of her wrist while her other hand tossed silverware into the soaking tub. She set aside the heavy plastic cups until she had enough to fill an entire rack at once, placing the cups upside down and laying the full rack onto the belt. Jogging to the opposite side of the dishwasher, she grabbed a hose and sprayed maple syrup off a greasy baking sheet. Moving back around the machine, she opened the heavy metal door and pushed the full racks through as steam bellowed around her face. Whenever the dishwasher came to an unexpected halt, she opened the machine's side door and reached in to remove the offending dish, pot, or pair of tongs so the washing could continue. When the machine stopped, Jenna sometimes yelled out instructions to her fellow dishwashers, but mostly she communicated with gestures, her hand motioning "stop," or a raised finger swirling in a circle signaling "go" once the machine was running again. A second dishwasher worked the end of the belt, carrying the clean dishes and cooking pots—which Jenna had organized to come out of the machine in the exact order in which they needed to be put away—to their storage places. A third quickly sorted the hot silverware into piles. Like a principal ballerina, Jenna's confident movements guided her team and, it seemed, the dish machine itself.

For over twenty years, I have been making dances with people who, like Jenna, don't think of themselves as dancers but are movement experts nonetheless. I founded Forklift Danceworks, a community-based dance company in Austin, Texas, in 2001. We have partnered with multiple City of Austin departments—Fire, Sanitation, Power, Police, Urban Forestry, Aquatics, Animal Services, and Watershed Protection—to create one-of-a-kind performances through which city employees share the movement and stories of their work and lives. These City of Austin partnerships have been our biggest projects, but we have made dances with many other people, as well, including college custodial staff and dining crews (like Jenna's), warehouse employees, maintenance teams, a symphony conductor,

Venetian gondoliers, adult roller skaters, neighborhood elders, and people who are visually impaired. To date, we have produced thirty unique performance projects in five countries, partnering with fifteen hundred collaborators for a total audience of more than forty-five thousand people. We endeavor to give the partnering community a platform to share their stories on their terms, accompanied by theatrical lighting and live, original music. Our shows are typically free to attend and are often outdoors, situated in the spaces where our collaborators' movement skill is most authentically performed and witnessed; a retired airport tarmac, a baseball field, and a city swimming pool have all been stages for our dances. Our projects often take multiple years to conceive and create.

I have written this book for both artists and non-artists alike. I am eager to show how creativity can be a vital and essential tool for change in all kinds of contexts. I am also writing to describe how and why excellent and unforgettable dances can be made with people who may not identify as dancers, in order to encourage a broader and more inclusive attitude about how, where, with, and by whom art can be made. And I am writing about work—the dance in work, the work of dance, and what work dance can do for us in our communities.

At its core, our process at Forklift is about building relationships. We use dancemaking as a means to build trust and create opportunities for change. Audiences leave our performances with a deeper appreciation for and understanding of the performing group—be they city staff, other institutional personnel, or neighborhood residents. Relationships are created and nurtured across lines of power and perceived difference—between employee and boss, resident and city staff member, elected city official and neighborhood leader, elder and young person. I hope that this book will demonstrate how a creative, inclusive process of artmaking can help us listen as well as see one another and ourselves more clearly. Ultimately, I believe that a collaborative and ethical creative practice can help lay the groundwork for long-term, human-centered change.

My understanding of this process of artmaking has changed and deepened over the past twenty years, and this book spans my journey into growing awareness. I have learned mostly by doing, and the people who have agreed to partner with me and my team have been my most influential teachers. When I began this work, I thought mostly about the show I was hoping to make, and did not consider the larger questions my team and I ask now, including what outcomes the collaborating community would most want to see come out of our partnership. In essence, I have come to see dancemaking as the middle, not the end, of the process.

In addition to charting my own personal growth as an artist, this book describes the formation and development of Forklift Danceworks. Both our community collaborators and my fellow artists have shaped who we

are now as a company, and we have grown by responding to the expectations of our partners and our increasing understanding of what artmaking can do. Certain aspects of our operation, like paying performers and community advisers, are a regular part of our practice now, but they weren't always. Offering meals before performances and ensuring that the families of the community performing have first and easy access to tickets are also standard components of our process now. I no longer credit myself as the sole choreographer, but instead state in our performance programs that the choreography was created in collaboration with the cast. We have deeper and longer conversations about the potential impacts of our collaborations with our partners, considering how our partners will benefit (or not) from a project, both immediately and years down the road.

■ The structures of power and inequity that pervade all of our lives are present in community-based work, too. As a White woman, raised in Texas and from a middle-/upper-class background, my identity, family history, and position in society have impacted my assumptions, struggles, and orientation toward community engagement. Throughout the following chapters, I will share my growing recognition of and attention to my personal history in relationship to this work. For example, when partnering with linemen at Austin Energy, where I was usually the only woman in the room, I learned to deal with my own insecurities centered in what I had been taught as a woman. When collaborating with mostly working-class African American and Latino/a employees at Austin's sanitation department, I learned to practice showing up authentically, joining in with awareness of my own biases and assumptions, and trusting the wisdom of the group. Overall, in the past twenty years I have learned not to expect trust but to earn it. I do believe it is possible to do this work ethically, across differences, but this is not easy, not guaranteed, and is unlikely to succeed without care and ongoing critical reflection.

Through this book, I share strategies that community leaders, organizers, and those working to build connection and understanding across disparate groups of people can use. For those in city planning and government, I will describe how we at Forklift have developed large-scale, multi-year partnerships. This book will also be useful to teachers and students, especially those studying civic engagement, devised theater, community-based artmaking, social practice, performance studies, social justice through collaborative artmaking, and art as activism. For artists who work in communities that are not their own and with people who do not identify as artists, this book will offer lessons learned, advice, and guidance. And for the people who perform the labor that supports our cities and communities, I hope this book does justice to the vital work you perform every day—even if only in a small way.

4
Beginnings

■ As a choreographer coming from a modern dance background, I see an inherent and natural relationship between the movement of labor and dance. Dance, from this perspective, can be thought of as movement performed in space and time. The movements I observe at places of work are purposeful, spatially precise, and follow clear rhythmic patterns. Picture a master arborist pruning a tree, repelling from limb to limb as she balances her weight and coordinates the timing of each step. While working, as when dancing, people pay close attention to aesthetics and intentionally create beauty. Imagine a grounds crew as they meticulously drag a baseball infield, creating a flawlessly smooth playing surface, or a master cake baker, twirling lifelike roses out of icing.

The dance of labor can be expressed through individual and collective virtuosity. If you know a carpenter's work well enough, you can see his unique hand in the shelf he has carefully molded out of a piece of pine. At the same time, ensembles of workers maintain our neighborhoods, towns, and cities through their coordinated movement and expertise. Both also demand a commitment to learning, years of study, an acute understanding of technique, and often an apprenticeship with an expert. The hours of devotion it takes to create well-crafted works of dance and labor are often difficult to see or appreciate. Deeply embodied knowledge makes movement look effortless.

Despite these similarities, labor and dance are assigned different cultural values. Artists, though often faced with low economic compensation, can accrue a measure of cultural respect, validation, and capital that those who perform physical labor are often denied. What's more, many artists have something laborers do not: an audience that can provide applause, encouragement, financial support, recognition, and feedback. In contrast to both art and white-collar work, jobs that require physical labor are commonly lower-paid and categorized as "unskilled," and the essential, physical work laborers do often goes unseen. Customers don't usually know who does the work and what it takes to keep their water clean, their power turned on, and their trash picked up. Customers and service workers have an inherent relationship, but it remains underacknowledged and depersonalized. When the labor can be witnessed, with stories and movements that showcase workers' expertise, customers move to a new role—that of an audience, attentive to the people and knowledge they may have taken for granted. Through performance, a new relationship emerges, and with it the groundwork for other shifts in perspective, including the desire to effect systemic change.

Movement and dance offer an opportunity to create relationships and build agency across lines of difference. Movement is inherent to our humanness, and dance can be made with any*one* and *any*body. The making of a dance is a creative act that can, when following values of inclu-

siveness and respect, bring a team of people together in an entirely new way, for we have to bring our minds and bodies into collaboration. The dance becomes a sort of third space—not me, not you, but something we share. A new form of communication emerges when electric linemen are asked to string a power line—something they have done on their own hundreds of times—in unison with each other and in relation to the beat of the music. People also take risks as they make something new. People move beyond ordinary ways of being and connecting with each other, building trust and seeing themselves and their fellow coworkers or neighbors in new and more expansive ways. Groups strengthen their capacity to work together, solve problems, and listen to each other. Distance between managers and entry-level staff can disappear when people collaborate and perform together. In this process of dancemaking, participants get to show the movement they are experts at, and in this way they shine.

For people who have practiced and mastered physical labor as part of their jobs, a significant component of their story can only be told through movement. Watching Melissa McGrath, then Austin Police Sergeant, direct traffic at a busy intersection, I quickly learned something of the physical demands of her job. With her right arm extended straight out from her shoulder and her palm up, she directed the cars to move forward with a rapidly repeating wave of her fingers. All of a sudden, her left arm shot to her back left diagonal as she flexed her left fingers up, anticipating the car approaching behind her and sending the message: "Stop."

I was reminded of the dance ethnographer Deidre Sklar, who has advocated for a deeper valuing of movement in studies of culture and a greater recognition of how culture impacts movement in the study of dance. For her, the way people move "is as much a clue to who they are as the way they speak."[1] Melissa was aware of the entire space and all the action happening around her; nothing and no one got past her. Her training was expressed through her body—the demand for constant vigilance, a heightened capacity to read a space, and a confidence that her body would do as she commanded.

In the dance that Melissa and I went on to make together, her movement communicated the complexity that her job required. After flawlessly directing imaginary traffic around her, she concluded her dance by doing what she was never allowed to do while on the job: she closed her eyes. Coming to stillness and standing facing the audience, she lifted her right hand, palm up with her right elbow bent, and gently rolled her fingers in, gesturing for people to come toward her.

■ My path to becoming a community-based dancemaker was somewhat circuitous, for it wasn't until my late twenties that I began to realize I could put my two loves—the studies of culture and dance—together.

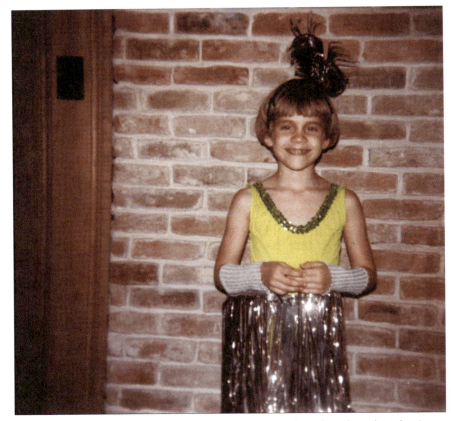

Figure I.1. Allison at age six in one of her favorite recital outfits. Photo by John Orr.

I have always loved to move. My younger sister was my first choreographic collaborator, and together we created dances to my dad's records, using the Beatles, Peter, Paul, and Mary, and my personal favorite, Kenny Rogers, as our chief accompaniment. When I was four years old, my mom enrolled me in our neighborhood dance studio, where I delighted in taking classes in ballet, tap, and baton, eagerly awaiting every recital. But as a preteen, I was told that with my extraordinarily flat feet I would never make it as a ballet dancer. What do you do as a girl who loves to dance but can't make it as a ballerina? In Texas, you join the drill team! During high school, I was a proud member of the Austin High Red Jackets, a dance squad of fifty girls who rehearsed year round. We performed perfect high kicks, precise military-inspired marches and drills, and regimented jazz-influenced routines at school events, sports halftimes, and state competitions. We were a "Top 5 Team in Texas," and we liked to say that "while Austin High might lose the game, the Red Jackets *always* win the halftime." We pushed our bodies to the limit, and I learned firsthand about grit and determination, pushing through pain, and what it took to perform elaborate, precise choreography in unison. I credit drill team for

my love of spectacle and large-group movement in space, which the Red Jackets displayed every time we took to the hallowed ground of the Texas football field.

In college, I took my first-ever modern dance class. My mind was blown when I learned you could actually make a dance *about* something—not just choreograph to music or string together movement as I had been taught. I joined the college dance company and began to learn about the wider world of concert dance. I took classes in jazz, ballet, modern, and improvisation and even got to choreograph my own dance for the stage my senior year. Still, I wasn't a technical powerhouse and I certainly didn't see myself making dance a career. In the dance world that I knew about at that time, I didn't have the skills to succeed as a professional dancer or choreographer.

At the same time, I stayed busy with classes in anthropology, which I chose as my college major. I had always been inspired by the study of human cultures, and I remember shooting up my hand in ninth grade geography class, proud to be the first one to answer when my teacher asked for the definition of ethnocentrism (the belief that one's culture is superior to others'). My parents modeled being global citizens—both spent time in Latin America as college students in the 1960s, and my mother, who taught high school Spanish, spoke Spanish frequently and expected that my siblings and I would learn Spanish, too.

Beginning at the age of eighteen, I spent four summers working in rural Latin American communities on latrine construction projects. During those summers, I learned countless life lessons, especially about my cultural biases and assumptions. Like when I arrived at my assigned village in the mountains of Ecuador and learned that the empty house that my fellow volunteers and I were to live in had no electricity, running water, nor a latrine. The field behind the house served as a bathroom —something that initially made me uncomfortable and scared. But of course, I was there to live with, and help, this community—not lament the absence of luxuries to which I was accustomed. The trips also taught me about grassroots organizing. I watched as the mayor of one village worked strategically to engage her fellow villagers in building latrines. She always sent a member of her family or a village young person with us on our home visits, and she had me and my fellow volunteers attend all the important village functions, like Catholic Mass, town meetings, and community celebrations. Along with these visible gestures of respect, I learned how little things could build trust, such as playing with the children and remembering their names, not stopping work until everyone else had, and graciously eating all that I was offered, even if—as with the guinea pig that was a delicacy in the mountains of Ecuador—I was not used to it.

As an anthropology student, I studied the basic tenets of ethical and sound fieldwork. I got a chance to do my own ethnography, during my third summer in Latin America, conducting and recording interviews with a group of Paraguayan women who had formed a work collective. I studied how these women understood their daily lives as empowered *campesinas*, female farmworkers, and with the help of my women's studies professors, I wrote my senior thesis from a feminist perspective. I didn't at that time know there was a field of dance anthropology, so I still saw my interest in dance and fieldwork as disconnected.

My experience in Latin America gave me my first full-time job after college. I was hired as a parent-child educator for an Austin social service agency, and because I was fluent in Spanish, I was assigned to work with Spanish-speaking families—primarily couples and teen mothers. I went on home visits, meeting with families on a weekly basis to help them connect to parenting classes, school support for their children, job training, and basic needs like groceries and rental assistance. I watched my coworkers, who had much more experience than I, use the networks of the neighborhoods to spread the word about our services and connect families to resources. I worked in neighborhoods I had never gotten to know growing up in West Austin—including St. John's, Dove Springs, and the Holly Street neighborhood in East Austin. What I loved most was getting to be with people in their homes and in their communities.

I managed to keep dancing, too. I took night classes in choreography at Austin Community College and did part-time work teaching dance to preschoolers and aerobics to adults. After three years at my social work job, I took a leap of faith and applied to graduate school at Mills College in Oakland, California, to formally study dance. My boyfriend (now husband) and I both liked the idea of moving to the Bay Area, and I had a hunch that there might be something for me to discover by entering the dance world as an official student.

At Mills, my love for culture, fieldwork, being with people, and dance finally came together when I learned about community-based artmaking — art, which I learned at the time, to be created and often performed by the people whose lives most directly connect to the story being told. I had an extraordinary choreography teacher, June Watanabe, whose teaching combined an emphasis on form and structure with authentic, inner expression. She drew from the work of Louis Horst, a noted musician, composer, and collaborator to many early modern dance pioneers who established an approach to teaching choreography in relation to other modern art forms. We studied Horst's text *Modern Dance Forms*, and June took us through experiential, nature-based, and meditative assignments. "Since most choreography comes from a personal space, whether it be expressive, informative, or intellectual in approach, being very specific

in form helps us look at the personal in relationship to something outside oneself," explained June many years later when we talked about her teaching. "A work gets lost without a form."

June also made clear that, as she put it, "life informs dance and dance informs life." She validated my desire to look outside the studio for movement inspiration while holding me and my fellow students to high choreographic standards. She kept asking, "How do you move your work forward theatrically without sacrificing its authenticity? How does the work, through its structure, speak for itself?" I would leave every one of June's classes energized and thoughtful, wondering how to answer these and other questions.

The MFA program at Mills was heavily focused on performance and choreography, versus dance history, critique, or academic analysis. I spent most of my time in the studio, either in class or choreographing with my fellow students. We studied the titans of modern dance—including Graham, Humphrey, Dunham, and Cunningham—with some exploration of the postmodern rebellion of the 1960s. I was energized by the work of choreographers of the early 1960s including Yvonne Rainer, Steve Paxton, and other members of the Judson Church choreographers group, who brazenly used pedestrian movement as material for dances. Yvonne Rainer's *Trio A*, which I was delighted to learn she taught to "nondancers," including a truck driver, made a big impression. In June's Contemporary Forms class, I first learned about artists working outside the traditional, mostly White, able body–led, and trained performer frame of modern dance, including postmodern dance pioneer Anna Halprin, multimedia theater innovator Ping Chong, experimental choreographer Blondell Cummings, choreographer Victoria Marks, the artists at AXIS dance—a mixed-ability dance company—choreographer and dancer Jawole Willa Jo Zollar and her company Urban Bush Women, dancer Ann Carlson, and theater-artist Marty Pottenger.

I was lucky to find snippets of Carlson's "Real People series" (1986 and on) in Mills College's video collection, made with and performed by people who shared common professions or activities, including nuns, basketball players, security officers, anglers, and NYC lawyers. I watched the tape multiple times to study the way Carlson directed and integrated basketball players' typical gestures in their performance. Carlson agreed to a phone interview with me for a paper I was writing about community-based artmaking, and she told me that her definition of dance is "any conscious movement in time and space," a view I came to share.

Marty Pottenger, who was employed as a construction worker for twenty years, began creating performances in the mid-1970s based on stories from people's daily lived experiences. From 1996 to 1999 she collaborated with the people and organizations who were building New

York City's Water Tunnel #3, the largest non-defense public works project in the Western Hemisphere. Pottenger embedded with the workers, or "sandhogs" who were laboring hundreds of feet underground, and created multiple arts-based projects that arose from the stories of the people she came to know. While at Mills, I read a long article about this project in *High Performance* magazine, and immediately began to learn all I could about Pottenger and her work. I was moved not only by how she engaged people not trained as artists in artmaking, but also by how she tackled understanding and sharing information about an enormous civic project through art. Pottenger has gone on to direct numerous performance projects with municipal and institutional entities and their employees, and her vision for the critical importance of artmaking in the context of civic and community development continues to guide and motivate me.

Fortunately, June noted my interest in community-based artmaking, and encouraged me with special assignments, including directing me to research the choreographer Liz Lerman and her company. Lerman founded the Dance Exchange in 1976, forming a touring dance company for dancers aged twenty-five to eighty-five. I was impressed to learn that, though she had professionally trained dancers in her company, she also collaborated with shipyard workers, construction workers, scientists, and numerous artists and community members with no dance training. Their performances, which took place not just onstage but in public parks and on city streets, forged greater understanding and respect for both the communities they featured and for community-based dance itself. So many of the tenets of the Dance Exchange's practice aligned with what I had learned studying ethnography and working in public health and social work. I signed up for the Dance Exchange's Summer Institute and spent two weeks working with the company between my first and second year at Mills. I met Liz and her fellow dance company members and was introduced to their tools for making inclusive dances and working with personal stories. Getting to study and now work alongside contemporary artists engaged in rich, collaborative, community-based projects encouraged me to put similar ideas to work in my choreographic explorations.

When I returned to Mills for my second year, I was interested to learn more about the Mills College employee community. Mills was an elite, progressive women's college, where the undergraduate program was exclusively for women and the graduate program included men. I was curious about what the campus staff, especially the men, thought about working at Mills. I chatted with the maintenance guys who did repairs in the dance studio, and they agreed to give a fellow grad student, Ann Robideaux, and me a tour of the physical plant buildings.

I was bowled over by that tour, where our two host employees, Billy Rose and Joey Wilson, proudly showed Ann and me the different work

areas of the Physical Plant building. We saw the carpentry shop with the wood saws and planing machines, the painting shop with numerous cans of paint lining the walls, and their maintenance area, filled with all kinds of tools, ladders, compressors, and the like. I was struck by the career and trade expertise these men had. And there was so much entertaining equipment and movement to watch! It was like a little city that I never knew existed and certainly wouldn't have found on my own.

Then one day, exhausted after a long day of dance rehearsals, I was sitting alone in the school cafeteria when I looked up to see a man washing the windows outside. He was facing me, following a clear and precise process: wetting his sponge in his bucket, climbing a ladder, and soaking the window with broad strokes from side to side, up and down. Then, taking out a squeegee from his back pocket, he quickly skimmed the glass in a snaking pattern, ending up at the edge of the window and slinging the water off with a flick of his wrist. June had recently assigned our final semester choreography project: We were each to make a dance exploring our unique voice as an artist. I knew I wanted to connect performance-making with ethnographic and community-based processes, but I was still figuring out how. I was enthralled with this man's attention to movement and design, and wondered whether there was any way he would work with me on a dance.

I followed up with campus administration, learned that he was our campus foreman, Manuel Godinez, and got permission to talk with him. Jogging alongside or riding shotgun in his van as he hustled from job to job, I observed that Manuel seemed to be working constantly. Speaking Spanish, he told me he was one of the longest-standing employees at Mills and that he mostly worked alone, doing the special maintenance, setup, and cleaning work that only he knew how to do. After a couple of visits, he asked me to explain exactly what I wanted him to do. I shared that I wanted him to wash the cafeteria windows, just like I had seen him do a few weeks before. He agreed, but with the stipulation that he would not rehearse—he could show up for the performance and do his part, but that was it. This was an early lesson for me in responding to my collaborators' needs. At first, I was afraid I was not going to be able to pull it off without any practice. I wanted to add in a sound score and didn't know how long it would take Manuel to wash the windows. But I knew I couldn't push Manuel for more time, and because I had seen him do this movement before, I knew he could make it work. It was I who needed the practice.

I recorded an interview with Manuel while riding in his van, and with that material my friend Bob Boster, an experimental music student, built a flexible sound score. Bob selected bits of the recording where Manuel spoke, in Spanish, about his work and what he liked about his job. Bob

mixed that with sounds of Manuel's van and other ambient sounds of the job, and during Manuel's performance Bob ran the music, fading it in as Manuel approached the windows.

Manuel's solo was the third in the series of employee dances I ended up putting together, each performed at lunchtime. At the same time that I was getting to know Manuel, I was also shadowing the grounds crew. A sextet, by crew members Gustavo Buena, Miguel Cendejos, Joseph Dusich, Ron Galvan, Oscar Gomez, and Freddie Lopez, began our series on Tuesday with a lunchtime performance featuring weed eaters, rakes, and their biggest riding mower, performed to Vivaldi's Allegro from *Spring*. Billy and Joey, who had shown me the Physical Plant building, performed their routine on Wednesday, hanging a banner in front of the library, accompanied by "Largo al factotum," a famously funny aria from Gioachino Rossini's opera *The Barber of Seville*. After quickly driving up in their maintenance van, they jumped out and opened the back doors, first pulling out the wrong tools and then struggling to get the ladder off the van. The audience cracked up as Billy and Joey went one way and then the other with the ladder, eventually setting it up and installing the banner after a number of well-timed false starts.

By the time Manuel did his performance, word had spread, and it was standing room only in the cafeteria. Most of the maintenance team had come out to support him, standing together to watch him. I realized at that moment that this was the first time in my nearly two years on campus that I was in a space filled with both students and campus staff. And it was packed. As Manuel finished cleaning the last corner of the bank of windows, Bob faded the music and Manuel exited back to his van, carrying his ladder and bucket. The crowd burst into applause and I had tears in my eyes. Manuel came back and took a bow, lingering a little to talk with his fellow workers and some students. Then he got back to work.

I was elated by the choreographic opportunity that collaborating with Manuel and his fellow employees offered me. I had been struggling with my graduate school assignments to come up with movement material. Alone, working in the dance studio, I just couldn't find inspiration. But working with the employees, who had more movement ideas that we could use, was easy. The dances were good. It felt like freedom.

By the time I finished my graduate work at Mills College, I knew I wanted to work in a community-based way. In my written graduate thesis, I stated, "As a choreographer, I am interested in drawing inspiration and source material from the community around me." I had also determined that I wanted to collaborate with the people who do the often invisible work that sustains our communities. What I didn't know yet was how to create wider institutional partnerships, and how I would grow in my understanding of my role and responsibilities to my collaborators. Re-

flecting now, I can see that my focus was pretty narrow. I was working hard to just get the dances made. I didn't consider other potential outcomes the dances might have had for my collaborators or the wider campus community. Today I would ask more questions. Apart from making a great dance for me, what would the employees have liked to have used this forum for? Would they have wanted to communicate anything to the students or administration? They were on the clock while working with me, and I did think to bring tacos to the few rehearsals we had and ensure they got copies of the program and a video of the dances. But since then I have learned to be ready to address and incorporate other needs and desires from my partners. Today my team and I lead with the question of what needs our collaboration can meet for the partnering group or community. Their answers ground our dancemaking through the entire collaboration.

■ By the time I graduated from Mills, I knew I wanted to return to Washington, DC, and work with Liz Lerman and her company. The structure of the company was such that everyone, not just senior leadership, got to teach and choreograph, and I wanted more time to learn and practice the company's techniques for dancemaking. My sister was also in DC, so I had someone to live with while Blake, my then fiancé, remained in the Bay Area to finish his studies. I flew out in June for the company audition, but didn't get in. Thankfully, Liz and the company were starting an intern program, and I applied and got accepted. I was assigned to be Liz's teaching assistant, and I shadowed her while she taught a weekly class for older adults. I also did some basic administration, toured with the company to support with teaching, and even did some housesitting and child care for Liz while she traveled. I got a very close look at the workings of an arts organization while learning many tools to use with "non-dancers," or as Liz quickly corrected me, "people who are new to dance." One day in the classroom while planning with Liz, I asked her, "How do you know what to teach?" Smiling at me, and with a clarity I will never forget, she answered immediately, "Just look at your students, the people who are in the room with you. They will tell you what they need."

While at the Dance Exchange, my fellow intern Sarah Lowing-Scott and I produced what was my first public performance, *Dances for Dogs and the People Who Walk Them*. The relationship between dog owners and their dogs in DC was unlike any I'd seen before—dogs went with their owners *everywhere*. At night, I felt that I was watching a show as dogs paraded with their owners down our street, out for their evening walks. One day I borrowed my landlord's dog and took him to the dog park. I was immediately struck by the possibilities for choreography: the specific rituals that owners had with their dogs as they played fetch, handed

out treats, or commanded their dogs to sit or stay; the funny way owners would get caught up in each other's leashes as dogs ran from one side to another. Sarah had a beautiful chocolate lab named Longfellow, who was blind. One day she and Longfellow showed me what she told me was a duet. To play fetch, Sarah called out to Longfellow, who would come to Sarah and sniff the toy she was preparing to throw. Once she tossed the toy, Longfellow used, as Sarah recalled many years later, his incredible sense of smell to launch his barrel body through the space to find it. Their simple routine communicated their care for each other and their collaborative partnership. It was a dance waiting to be performed.

Sarah and I recruited dog owners, including friends from the Dance Exchange and strangers who'd responded to signs I put up in my neighborhood saying "Dogs (with owners) Wanted." We worked with about thirty people and their dogs to choreograph five short dances to 1920s and '30s big band music. The music gave the movements a carefree spirit while putting some pep in the dogs', and dog owners', steps. Everyone involved was a volunteer. We borrowed a sound system from the Dance Exchange, and my fiancé Blake Trabulsi designed the poster and put together a short program that we photocopied and handed out. The day of the performance came and DC shut down due to a blizzard. I called Liz, panicked about what to do. "Excellent!" she said, "Now you can call all of your press contacts and tell them you will do the show next weekend. That gives you one more excuse to make contact." We did get great press, with a color photo on the front page of the *Washington Post* and a short spot on the BBC (the English are crazy for dogs, too, apparently). The following year, I moved back to Austin and remounted the show with a new cast of dogs and owners. *Dances for Dogs* also became part of the Dance Exchange repertoire, and has been taught multiple times to many, many dogs.

■ My interest not just in movement but specifically in the movement of work has deep roots in my upbringing. Family time was work time in my home. Togetherness looked like working side by side with my parents, sister, and brother — weeding the flower beds, harvesting vegetables from the garden, or cleaning the kitchen. My father's parents grew up in rural Texas and came from what my grandfather called a long line of "dirt farmers." I inherited their frugal mindset, hands-on attitude, eagerness to solve problems myself if I could, and love for a job well done. My mom has an uncanny ability to talk just about anyone into helping her, and no one stood around very long in my house without being given a job to do. Even when my friends came over, they were put to work — reading to my brother, walking the dog, or changing a lightbulb.

As a family, working together was not only the main way we spent

time together; it was also how we expressed creativity. Our summer grape-picking ritual is a standout memory. My dad, growing up in Texas, had learned how to harvest mustang grapes as a child to make homemade grape jelly. Every summer, he and my mom took me, my sister, and my brother to a spot off the highway where they caught sight of grapes growing abundantly. While my brother, still a toddler, slept in his car seat, my parents hoisted my sister and me into the trees and we gathered as many grapes as we could, trying to avoid the itchy vines while staining our hands and clothes deep purple. The next weekend, with my aunt's or grandmother's help, we took the grapes off their stems and boiled them in oversized pots. Straining the sticky juice and adding lots of sugar, my mom poured the mixture into glass jars, sealing the jars with wax and setting them in boxes to give away or store. This was more than work; this was a communally made creation that we enjoyed sharing with others. Reflecting now, I can also see how my early love of embarking upon a family work project is also ignited when tackling all that the production of a performance requires. Production takes a team — it demands that a group come together with a common purpose. This is probably one more reason why I am so happy while deep in making a show!

My parents were White political progressives, and modeled being engaged in public life. In our affluent neighborhood, we were often the only family with a Democratic candidate's campaign sign in our front yard every election season. When we moved from Houston to West Austin, my parents sent me to a predominantly Latino/a and African American elementary school across town in East Austin to finish sixth grade, making me one of the few children from my neighborhood to attend this public school. When I wanted to learn more about White flight in ninth grade, my dad helped me create a survey for my fellow neighbors, which I distributed door-to-door, asking pointed questions about their decisions to send their children to public or private schools. My parents displayed their values through actions, but they didn't talk much about their political beliefs or the complexities surrounding them. Only when I became an adult did my dad share with me how he had fought with his parents and extended family over the centuries-old racism that had been passed down through the generations. In the 1960s, my grandparents did not allow my dad to bring his Black college friends to their home in Dallas. Undeterred, my father supported the civil rights movement, and after he became student body president at the University of Texas in 1965, he lobbied the administration and worked with Black and White student activists to more fully integrate the campus community.

My parents' values meant that my siblings and I grew up knowing the world was much bigger than our small, wealthy Austin neighborhood. Most of my friends lived in other parts of the city and came from

middle- or working-class families. Looking back, I can see how my parents supported my choices to build relationships beyond my neighborhood, class, and race. At the same time, we lived an economically privileged life. My father was a successful corporate lawyer and made more money than anyone in his family had before. We went on nice vacations and were members of the country club, and I attended a private university, which my father paid for entirely. My parents were somewhat conflicted about their class position—we critiqued the extensive social calendar of the Austin elites, but at the same time got our feelings hurt when we were left off an invite list. Several members of my family also struggled with mental health issues, including depression, and when I look back I can see how we were pretty isolated in our wealthy, West Austin neighborhood. It was difficult to speak honestly about what was going on, and we felt pressure to keep up appearances—at school, at the country club, and at social events. In contrast, the structure of work provided a way to connect with others, and it was moments such as working alongside our yard crew, volunteering to clean up the school gardens, or diving into a project with others at church, where we felt most at ease.

Still, my family was well connected, and as a young and emerging artist, those connections certainly worked to my advantage. City leaders were willing to consider my ideas, and friends and family have supported both me and Forklift as an organization by opening doors, securing press attention, and providing financial support. Over time I learned more about how these advantages were predicated upon systems of inequity deeply engrained in our country. Self-examination has helped me honestly and authentically collaborate and partner with people of all backgrounds, and increasingly I am learning to use the advantages I have to build more equitable systems for others.

■ A central belief that underlies my work is that it is fundamentally a good thing to be in relationship with people who are different from me, and worth the struggles and complexities that may emerge. This does not mean that I have unilaterally decided that my and my team's presence will bring about positive outcomes for any community, anywhere and at any time. I have learned over time to consider carefully, with each new project, the impact of our presence, both together as a team of artists and in conversation with our potential collaborators. I acknowledge that my presence as an outsider will change the chemistry of the group, and that change may be useful but is certainly not guaranteed to be unproblematic. But not doing the project, because it is safer to stay in my silo, doesn't give me the opportunities to forge the kinds of change I would like to make in the world. At some point, I will enter a community as an outsider.

This work demands close and vulnerable relationships with fellow

human beings and requires real self-examination and honesty. Community-based artmaking demands a lot of rigor. It is hard work, and it isn't a process that all artists want to do, should do, or are prepared to do. Nor is it something that others necessarily want—or should be expected to want—to be involved in. At Forklift, we encounter understandable hesitation and resistance, which we try to listen to, respect, and learn from. I have to be willing to work on the feelings that I might bring to an interaction with someone else—noticing and reflecting when I'm feeling insecure, embarrassed, confused, and self-critical, or superior and judgmental. I have had to unlearn a lot of what I was taught (directly and indirectly) as a White, middle- and upper-class person—especially around thinking that I am right and always know best. Instead, I continue to learn from the wisdom of others. I try to lean into curiosity, humility, and vulnerability. On every project, my assumptions are challenged and I learn something new. Each time I make a dance, I am reminded that my vision, even though I work to keep it wide and expansive, may inevitably miss something.

I have been lucky to have strong examples and mentors who came before me, challenging traditional notions of who can be a dancer or performer and thinking through some of the same issues I continue to grapple with. After working with Liz, I studied with Deborah Hay, and over the years, my thinking has been enriched by witnessing and learning about the work of my contemporaries, including artists Suzanne Lacy, Celeste Miller, and Stephanie McKee and Junebug Productions along with scholars who have documented the history and contemporary expression of community-based practice, including Jan Cohen-Cruz and Petra Kuppers, to name a few. From learning about their work, I have gained a sense of solidarity, knowing I am part of a larger field in which many use artmaking to creative problem-solve and drive social change.

I tend to think practically, rather than theoretically, and I learn quite a bit as I go. But over the past few years—in part because my work has brought me to more college campuses—I have turned to the fields of critical and performance ethnography to help me think about the ethics around working in community. A dance colleague recommended I read the work of D. Soyini Madison, and I found her questions for those considering entering a community to certainly apply to my fellow artists and me. She asks one to consider: "What is changed by my presence? What are my knowledge gaps, or what is it that I don't know that I don't know? What purpose does this work serve?"[2] I have since learned to ask these kinds of questions sooner in the process. Reading Madison, I reconnected to my early and ongoing love for both dance and ethnography, and her work, along with that of other artists and scholars, has helped me to more fully integrate issues around accountability and responsibility to our fellow collaborators into our work at Forklift.

In writing this book, I also studied the work of performance ethnographer Dwight Conquergood, who spent his career researching and living with members of marginalized communities. Conquergood cautions against entering the field merely for the purpose of "finding some good performance material." To avoid "performative plunder, superficial silliness, curiosity-seeking, and nihilism," he counsels artists and their interlocutors to have real conversations in the service of creating "dialogical performance." To me, this means that as artists, organizers, and outsiders to a community, we acknowledge that we will be changed by the community—that we will be challenged and our work will be reflective of that. The process is ultimately about being in conversation, aware that together we will create something that alone, neither group could make. This advice from Conquergood especially resonates with me: "One does not have to delay entering the conversation until self and other have become old friends," for "one cannot build a friendship without beginning a conversation." Instead, one must enter the conversation with—and here he quotes folklorist Henry Glassie—"energy, imagination, and courage."[3]

There isn't a perfect way to do this work. It is inherently messy, and one will inevitably make mistakes. But it is in that struggle that true dialogue emerges, relationships are built, and good work can be made together.

In Case of Fire
A Dance for Firefighters

By 2000, I had been back in my hometown of Austin, Texas, for about a year, and for the first time I was making a little money teaching dance. I got my first City of Austin arts grant to teach creative dance classes at a nonprofit preschool, assisted a fellow dancer with her movement classes for high school students with developmental disabilities, and taught dance classes at a private high school. I also started a series of modern dance classes for adults over age fifty. My mom and a few of her friends were the only students, but I was putting the skills I had learned at the Dance Exchange to work. And I continued dancing and choreographing myself, taking technique classes at contemporary dance studios, and making short dances for the stage with my fellow trained dancers as opportunities arose.

Sometime that summer, my husband, Blake, and I were having dinner with old friends at a Tex-Mex restaurant. I was sitting next to Stephen Truesdell, a firefighter. He asked about what I was doing artistically, and I began to talk enthusiastically about recent projects, including the series of dances I had made in my master's program at Mills with campus employees. I hoped that because Stephen's work as a firefighter involved physical labor, he might be interested. I described the three dances I had crafted with campus employees, explaining how we used the movement of work—mowing the grass, hanging a banner, and washing windows—to create short performances that highlighted their contributions to campus life. Stephen listened closely, and he seemed to get it. He then said, "You know, you could do a dance like that with firefighters."

Perhaps that's why when I drove past a group of firefighters sometime around then, I paid close attention. Sitting at a stoplight, I noticed a group of firefighters cleaning up after a fire. I watched as clusters of firefighters worked together to lift each long hose, everyone taking a section, and walk the heavy, weathered material out to its full length. Laying the hose flat on the ground, one firefighter stood at the end and gently walked atop it, pushing the water out of the opposite end while the rest of the group kept the hose laying straight on the ground. They did this with several

hoses, and in duos and trios, rolled them all up, ensuring they were folded in on themselves just right as they hauled the hoses back to the truck to store them properly. I had no idea that just putting a hose away would require this kind of coordinated movement and effort—and this was at the end of the job; the fire was out. I drove off thinking that there was so much more to learn, and so many more movements to understand, than I had realized.

Stephen's interest in these dances, followed by his nonchalant statement that I could do something similar with firefighters, had set my mind in motion. The funny thing is, Stephen told me many years later, he wasn't really serious. "I did see the correlation," he revealed, "but I was kind of kidding around. And then all of a sudden you thought it was a great idea and you were ready to pursue it, and I thought, 'Oh my goodness, what have I gotten myself into? How am I going to explain *this* to my crew?'" Because of his kind nature, though, he followed up with his supervisor, and together they set a date for me to come by Station 11 on Kinney Avenue. The last thing Stephen told me before I went to the station was: "Don't talk right away about making a dance, and be sure you *never* tell them it was my idea in the first place."

Right away I met Lieutenant Mike "Sully" Sullivan. Tall and lean with twinkly blue eyes and a full mustache, Sully had a command for words and a knack for cracking well-timed jokes. I immediately liked him. He came from a firefighting family—he and his three brothers all worked as Austin firefighters, and at the time he had already served for more than twenty-five years. He was a leader in the department, and as the lieutenant on duty, he ran the station, so his early support was key. Lucky for me, he did see something in this idea. As he later recounted, "One of the rookies pulled me aside and said, 'Man, why are you interested in this? Why do you want to do this?' And I said, 'It's the oddest thing I've done in twenty-five years here. And it sounds like fun, sounds like good PR, and you gotta call it something different!'"

Apart from Stephen and Sully, the crew at Station 11 included Randy Pierce, Meg Pace, and engine driver Don "Doc" Murdock. I typically found Doc sitting alone reading when he wasn't busy checking the engine or cleaning his gear. Doc recalled, "As firefighters, we get a lot of stuff thrown at us. But this particular one was like, 'Ehhhh, not really interested.'" Don went a step further and admitted, "Your idea was real distressing to even think about. I heard one or two guys saying, 'She's crazy. She's nuts. I ain't dancing. It's not gonna happen.'"

I could sense that the firefighters were trying to be nice to me but that they were not in any way ready to commit to working on my project. At that time, though, I was not fully aware of how resistant Doc and his fellow fighters were toward my idea. Now I see this skepticism as a typical

part of the process of building trust when collaborating with people new to dance. I was just a few weeks into getting to know them, after all, and it was way too early in the process to be talking about a performance. So I looked for easy ways to be around, showing up eager to learn about the job, without asking too much of anyone or being too annoying.

I did need an official way to be around, which is something very important to understand when working with city departments and other institutions—there are rules that non-employees must follow, too. In this case, to continue to spend time at the station and get on the fire truck, Sully told me to complete a formal request—for at that time, any citizen could ride out on a fire truck by signing a waiver. Sully put in a good word for me with the fire chief in charge—which must have helped—and I went to HQ, filled out the paperwork, and was officially approved to ride on the truck with no pushback from the higher-ups. Doc, Stephen, Sully, and their fellow firefighters at Station 11 also agreed I could continue to drop by the station. Ride-outs had begun.

■ Spending time with people as they're active on the job is one of my favorite parts of the creative process, for this is how I come to understand the culture of my collaborators. And I get to work! Today, Forklift has honed this process such that my team and I spend months embedding ourselves within the partnering community to build relationships and gain trust. We job shadow, work alongside employees as we are allowed to, attend safety trainings and other employee or community events, spend unstructured time just hanging out, and read and study about the work and community. All of this is critical to the dancemaking process, for it is here that we see the movement vocabulary of the job and community and learn about participants' lives.

We try to job shadow participants two or three times a week for a few hours each time. Once we are in full production-mode, one to two months out from the show, we are at the work site every day. Like ethnographers, we use methods of participant observation, where researchers immerse themselves in the studied group by spending extensive time with the community and participating in the everyday activities of work and life. But unlike ethnographers, we are not aiming to publish written research. We are making a dance. In our fieldwork, we are focused on finding performance participants, understanding key movement elements, and hearing stories the group wants to share. We use research strategies inspired by anthropology and ethnography, but ultimately we are headed in a different and distinct direction—that of artmaking.

By October 2000, I was making regular visits to Station 11, stopping by for a couple of hours at least twice a week. The station, in an older neighborhood in South Austin, was a little house with a kitchen, living/

TV room, bunk room, and bathroom. The firefighters' shifts kept them on duty for twenty-four hours, then off for forty-eight, so every third day the station was Stephen's and his fellow crew members' home. In the beginning, hanging out was awkward, especially because in between calls there wasn't much I could do besides just stand around and talk. I asked about their general routines, what they liked about the job, and why they chose to be firefighters. I made a decision to show up energetic and curious, even when I was feeling anxious about my project's uncertain future.

When I asked Sully about his memories of this early, awkward stage, he reminded me what I did to work through it. Taking off his wire-framed glasses and leaning in, he explained, "You were approachable. You were nice. You were fun and you spent real time with us." After a couple months, I got more comfortable being at the station and it felt easier—plus, when one day we rode up to the nearby grocery store (in the engine!) to pick up groceries, I learned that the team loved ice cream. From that point on I always tried to show up with ice cream, which Sully reminded me "was the other silver bullet."

For each group, this process of working one's way into the community is a little different. Sometimes, personal connections help: I got to Venice, Italy, because a former professor from Wake Forest hired me as the program assistant for the university's Venice study abroad program in 1995. He also hired me to return in 2002 to be the summer program assistant, and this is when I began taking rowing lessons, gradually making my way into the tight-knit gondolier community. Beginning with one introduction from a friend, I slowly met other gondoliers who ended up being interested in working with me to tell the story of their historic trade. Together, we created *The Gondola Project*—a dance for eight gondoliers and their gondolas on a canal in Venice, performed in 2003 and 2004. When making a dance with local two-steppers in 2010, I visited Austin's country dance clubs and began to casually meet the regulars in the two-stepping scene. These dancers then guided me to connect with the two-stepping community's leaders, who ultimately conceived the piece with me. Once I begin meeting people I want to work with, it is important that I not move too quickly, and instead allow for the time it takes to build relationships organically. I also have to remind myself not to take things personally. I am there to learn and listen. It will feel awkward and I will feel out of place, but if I keep showing up eager to learn and happy to be with the people in front of me, we will eventually become more comfortable.

After I had spent about two months with Station 11, Sully and Stephen decided I should get to know the firefighters at Station 17, about a ten-minute drive south. Station 17 was a whole other world—busy with lots of calls, about three times as many firefighters, plus an engine, ladder truck, and rescue vehicle to operate. It was also where the call came to report the

first and only "live burn," as the crew called it, that I traveled to with them. As soon as the radio barked out news of a nearby house fire, the firefighters sprang into action, throwing on their gear and taking their assigned positions in the engine or ladder truck. Within moments I was seated in the back row of the engine and we were racing down the highway, sirens blaring.

When we were just a few minutes from our destination, a call came in over the radio saying that a firefighter was down, knocked over by an explosion caused by a gas leak. It was a sobering moment. The firefighters became quiet, steadying their focus while the driver pushed the engine even faster. The head officer gave orders, preparing the team to deploy as soon as we arrived. When the engine parked, each firefighter moved efficiently to grab equipment, pull hoses, or connect to hydrants for water. In their helmets and full gear, voices could get lost, so they communicated with hand signals or over radio. Told to stay by the truck and not move one inch, I watched as the firefighters approached the house, assessing the situation. They searched the house, determining there were no residents inside, and learned that the firefighter who had been blown off his feet when the gas ignited wasn't injured because he was wearing his protective gear and air mask. They then kept the fire from spreading further into the house until the gas company team arrived to shut off the gas at the street. Once the gas was completely turned off, the firefighters extinguished the rest of the fire.

The way this group of individuals coalesced into a single unit within a matter of seconds was astounding to me. Their deliberate action and quick deployment into clear job roles showed me that they knew how to move expertly as a group. I wouldn't need to devise much choreography for them at all—I just needed to set up the right scenarios for them to show what they already did so very well.

Captain Mike Stephenson, a tall and serious guy who was the commander over both Stations 11 and 17, helped me see what some of those scenarios could be. Mike later told me what he remembered of our first meeting. "I thought you were crazy, absolutely crazy. And I thought there was no way I was going to get a bunch of firefighters to help you out." We were sitting down together with his wife, Laura Stephenson, who was also an Austin firefighter. "I know my husband," Laura laughed, "and he ain't going to be doing any dancing unless it is Country Western."

What I remember about meeting Mike was liking him right away. He was a natural teacher, and I sat in the kitchen at Station 17 while he stood at the chalkboard, drawing diagrams and talking me through basic firefighting information. I had a hunch Mike might like the idea of the dance because it would tap into his love of teaching and sharing the story of firefighting. "When you started explaining the concept to me," he recalled,

"I thought, 'Oh, we can do that. That's no more than a slow speed drill.'" Exactly! The firefighters would "dance" by executing their typical work drills at a slightly slower pace. Once I started talking about my ideas in a context and language that the firefighters could understand, I started to get their buy-in. At the time, Laura worked in the public education division with the fire department. Mike suggested I take my idea to her, thinking that if she liked it, then maybe my dance could be part of a public education event. Laura and I had a brief conversation on the phone, where she expressed interest and welcomed me to come by her office and tell her more.

With butterflies in my stomach, I walked into my first official meeting with department leadership to discuss my idea, carrying a folder of a few press articles, a résumé of past projects, and a brief one-page proposal. Laura Stephenson greeted me with a warm smile and a firm handshake as she introduced me to her colleague with public education, Palmer Buck. We sat down around a small table in their office and I laid out my proposal. I wanted to direct a free, thirty-minute, family-friendly event that would educate people about firefighting and fire safety, featuring the firefighters I had gotten to know from Stations 11 and 17. I would fundraise to cover the artistic costs, including my fee. The department would need to allow the firefighters to rehearse and perform on work time and let us use vehicles and fuel for the show.[1] Palmer and Laura listened closely, nodding their heads. They thumbed through my press articles and materials, and began to talk about how this could be a new way to reach the public. I made sure to talk about what I thought this could do for the department — raise visibility and show the human side of firefighting. When I checked in with Palmer later, he explained why he was interested: "We were always looking for innovative ways to spread our message about fire prevention. Laura and I had agreed that no idea was too silly. So when you came in, we thought . . . 'Dance? OK, tell us what you need. What's your vision?'"

Also, Palmer and Laura liked the potential cast. "When you told me who you had lined up to participate, I was amazed," reflected Palmer. "The group you had somehow managed to bring together had a lot of powerful personalities. Truesdell was a consensus builder. Sully was a character but also a consensus builder. We have fire stations that are just fire stations, but we also have a lot of our fire stations that are families — groups that work together and see each other like a family. And Stephenson, he had that as captain over Stations 11 and 17." Palmer concluded, "That family organization convinced each other to move forward."

Laura and Palmer took the idea up higher to leadership. There was, Palmer told me later, considerable pushback, but by selling it as a positive and low-cost event that would reach the public in a new way, they were eventually able to get approval. Palmer remembers explaining that this

would be a chance to tell their story through movement, and that the firefighters I had recruited were willing to give it a try.

Laura and Palmer recommended the performance coincide with Fire Prevention Week in October. We settled on October 13 at 2 p.m., about eight months away. We decided to hold the show in a small training facility belonging to the fire department, right across the street from the public education office. It was an easy-to-access location, not far from downtown, and had a tower, hydrants, and a big empty lot—everything we needed for the firefighters to perform their drills, work with water, and rappel, with enough space for two engines, a ladder truck, plus bleachers to seat the public. We now had a date, a time, and a place. We also settled on a title: *In Case of Fire*. We could start making the show with real confidence.

Doing that meant much more than devising choreography. I had to create a budget, build a marketing plan, solicit sponsors, and determine production and logistic details. I had to bring in some help! My husband, a graphic designer, designed the poster, while I crafted marketing language and a press release with Laura and Palmer. Stephen and Sully recommended I reach out to the Austin Firefighters Association (the firefighters' union), which agreed to serve as a sponsor. In addition, I approached local businesses I had family connections with, and was able to raise $5,000 to cover production costs for equipment rental, publicity and printing, a videographer, and small stipends for the sound designer and me. Palmer and Laura already had expertise coordinating public events for the department, so they worked with me on a logistics and production plan. They secured bleachers for the audience from the Parks and Recreation Department, ensured we had a parking plan for the public, and coordinated our weekend rehearsal and performance schedule.

Not having the funds to pay for live musicians or a composer, I knew I needed prerecorded music that could set the tone and help tell a story, without demanding—as in typical concert dance—that the performers move to it exactly in rhythm. I needed something that would provide a setting and mood without dominating the inherent movement of the work itself, which I wanted to highlight. I had watched Twyla Tharp's *In the Upper Room*, with a score of the same name by composer Philip Glass, while in graduate school. I thought Glass's repetitive style of composition might reflect the way these movements, too, were learned through many years of repetition, and that the music's majestic feel—with its strings, brass, and woodwinds—could evoke the heroic nature of firefighting. Plus, the music occasionally featured bells, which conjured up earlier days when bells were used to call firefighters and alert the public.

Choreographically, I knew I had to feature movement the firefighters could perform well and without a lot of rehearsal. The public education

office wanted the event to share basic information about fire safety, including the importance of residential smoke detectors (check and change the batteries, folks!). At the same time, I was thinking about what was most important to tell the public about the work. What had I been most interested in and surprised to learn? These questions helped me think of possible content for the dance.

■ Each firefighter was responsible for a particular region or group of streets. As a test, they had to be able to draw freehand maps of their territory, and to call out their streets, listing them off from north to south or east to west. Stephen explained: "We study streets every day. We would sit there at about one o'clock and someone would put on a pot of coffee and we would go through our streets. We usually just had them on flip cards, and someone would call out an address and someone else would describe the fastest route there." Driver Don "Doc" Murdock's knowledge of his territory was the stuff of legend. During this drill, he would provide a set of answers, depending on the nature of the emergency, saying, in Stephen's recollection, "If it was a medical I would go straight there, but if it was a fire, I would consider taking this street and then this street so I could get a look at it from all sides." Even on his days off, Stephen told me, Doc would drive his streets to be sure there wasn't any construction or changes to the roads that might get in the way of him getting his engine to its destination quickly.

Early on, Doc pulled me aside and kindly told me that, though he liked me, he didn't want to have anything to do with my project. He would not be performing. "Completely fine," I told him, and assured him that I didn't want him to do anything he didn't want to do. Besides, I said, he was still helping me by just talking to me and telling me about the job. In my mind, though, I wasn't giving up on Doc. I imagined a solo for the show, in which a firefighter drew a huge map of South Austin on the ground, as a voice called out the names of street after street. I wanted that solo, both to showcase this detailed knowledge and to provide a period of quiet intimacy, changing the pace before a full-group finale. And I wanted Doc to do it.

One day, I sat down with Doc and asked him to draw me a map and call out some streets for me. After he'd done it with typical ease, I asked him if he would do it in the show. Years later, as we sat in his living room, he said, "I was probably more reluctant to do it more than anyone else because I'm an introvert." Grinning just a little, he continued, "But I took pride in knowing my territory. Once you got those hooks into me, I was like, 'OK, this is something I can do.'" Besides, he said, "It seemed natural to me because I've been drawing that map forever." I've seen this pattern again and again in my projects: for non-performers, the prospect of

performing for an audience is often foreign and intimidating until I make it clear that what they'll do in the performance is what they already do every day.

The solo lasted four minutes. Two engines slowly exited the space, and Doc walked out onto the asphalt. A haunting piano melody began as he uncapped a spray can of washable chalk and methodically painted an oversized map on the ground. He kept his gaze down and focused while the audience heard his voice, very much in the same style as the repetitive piano, calling street names in north to south order. He finished by accenting it with a small and quickly painted American flag. He stood up and smiled, waving to the audience as he walked off. "I remember being anxious, hoping it would get over with," Doc said. "During the show, I was surprised I felt so good. It felt as natural as could be. I wasn't nervous, I enjoyed the heck out of it." Doc's solo was very simple, but displayed the elements that I most love seeing in a dance—clarity of movement, uniquely personal skill and expertise, and an opportunity for the audience to learn and be surprised by all that must be practiced to do this job well.

Getting to work with Doc was a significant lesson for me—a reminder to be in the moment and sit with uncertainty, persevere, and trust that something would emerge. When I visited with Doc later, he told me that he had learned something similar. "I'm not a creative person," explained Doc, "but you did make a comment to me during the show. You said, 'You look like a rockstar.' You said that. You said those words, and those words did stick with me all my life . . . I found it intriguing, you know, every kid wants to be a rockstar, so eventually I took up guitar." Later, he started a rock band. I was amazed. "The show stretched all of us," he said. "I'm not automatically negative about these kinds of things anymore."

Doc signed on about two months before the performance. By then, I had developed a rough sketch of the entire dance to share with my closest collaborators, including Mike, Sully, Stephen, and Dawn Clopton. Dawn, then a lieutenant at Station 17, was a smart and seasoned firefighter who rose through the ranks, eventually becoming the first female division chief for the Austin Fire Department. She was approachable and liked to solve problems, and she made herself very available to me. With her and her fellow officers, I reviewed the high-level details of each section so I could ensure I was on the right track, that my ideas were doable, and that leadership was behind them.

Working with Dawn and the rest of the firefighters, I was coming to understand my role as a kind of chief curator, something that continues to guide my work today. I am still listening and taking in input, but my job is also to hold a broad vision of the entire dance to make sure it all hangs together. This is where my skills as a trained choreographer come into play. As Dawn told me when I interviewed her for this book, "It was a

collaboration. You didn't come in with a preconceived idea. We both had to give and take. Also, everything—even though we might have stylized a few things—came from movement we already did in our work." At the same time, as Sully told me, "Your perspective was always from the grandstands. That's something that none of us experienced or shared."

In Case of Fire had five sections: an opening group piece for the entire cast of thirteen, a trio for the three officers, a quartet for the women on the shift, Doc's solo, and a grand finale with the full cast plus the two engines and the ladder truck. In the first section, each firefighter slowly set out his or her "turnouts"—safety gear including pants carefully tucked into boots so that they could be stepped into with efficiency when the time came. Once their gear was in place, they returned to stand by their vehicles, hidden from sight. Captain Mike Stephenson then walked out, set his gear down carefully, and dramatically lit a safety pan of oil on fire. Measuring about three-and-a-half square feet, the pan quickly filled with flames that leaped up about a foot off the ground. Yelling "Fire!" Mike cued the crew to run in and take their places beside their gear. Moving rapidly, each firefighter quickly put on his or her boots, pants, jacket, helmet, and gloves in a matter of seconds and then ran to a fire truck. It was, as Mike and I had discussed, a familiar drill for the firefighters, and, as I had realized when watching them rush to an active burn, incredibly compelling to watch.

Mike, Sully, Dawn, and I had worked out the second section in the garage of Station 17 over two meetings. The three of them—all officers—entered in a line, each carrying a red CO_2 extinguisher, and positioned themselves around the fire burning in the safety pan. One by one, they aimed their extinguishers away from the fire behind them, squeezed the nozzles, and arced the hoses of their extinguishers over their heads, ending by pointing at the fire. In a satisfying theatrical effect, the extinguishers shot out a white cloud of CO_2, cooling the air and resembling snow. The three officers then circled the pan, gathered together, and swept their extinguishers across the fire in unison, putting out the fire and releasing one last grand plume of snow.

Dawn was in the third section, too, along with Julie Huser and Louise Joubert—all three from Station 17—and Meg Pace, from Station 11. The demographics of Austin firefighters typically skewed both White and male—of the thirteen total firefighters at these stations on this shift, twelve were White—and having four women firefighters on a single shift was unusual. The women were a tight group, easy for me to befriend, and quick to acknowledge the challenges of working in a male-dominated field. They were immediately on board with a section that would feature them exclusively. Looking back on the show many years later, Julie smiled as she described the process. "When you first showed up, we had no idea what you were talking about. What could we do that is artistic? But once

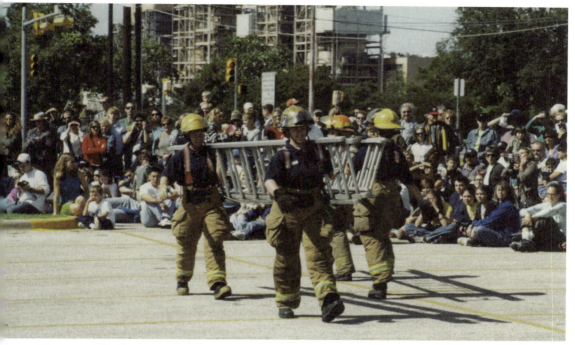

Figure 1.1. Julie Huser, Meg Pace, Dawn Clopton, and Louise Joubert performing their quartet for *In Case of Fire*. Photo by Blake Trabulsi.

we started coming up with ideas, then we could start to see it, and then it got more and more exciting. It opened up our imagination to think about what we do in a different way."

It was Dawn who suggested the central drama of this section: working with ladders. Ladders, she said, "are a check mark in training. They are heavy and big, and if you can handle them, then you're good." I liked how physically this idea would speak to the women's strength and skill, and Dawn sat on the couch at the station with me, talking the section through. A couple times she kindly interrupted, saying, "You know, Allison, we can't really do it like that because that isn't proper procedure," or "it really would work better if we faced the ladders this way." She asked me questions, too, helping me figure out what was most important to communicate.

I interviewed all the women. Interviewing has become a regular part of my research process, and I use it to understand more about my collaborators' values, culture, and beliefs. Once I have gotten to know participants, I ask permission to record an interview where I ask basic questions about the job, including what people love about their work, what is hard about it, and what they most want others outside of their community to understand. Talking with the women firefighters, I also wanted to understand what it was like to risk their lives as part of their job.

Julie spoke very eloquently about this, and a recording of some of her response played over the music in this section of the piece. "You are always afraid to risk your life . . . that is a human emotion you have to have," she shared. She also spoke about gender: "Usually they don't realize it . . . When we are all in our gear, we all look the same. They don't realize it until we take our gear off, and then they are like . . . 'Wow.'"

■ Rehearsals began in early September, about six weeks before the show, which is still the typical timeframe for Forklift projects today. Scheduling rehearsals is an art in itself, and the process demands a lot of communication with the departmental leadership and employees. Often we ramp up to rehearsals, trying for a couple weeks to make them happen before they really start in earnest. Rehearsals get scheduled based on participant availability, which means my team and I hold rehearsals at all times of day —first thing in the morning, on lunch breaks, at the end of a workday, or when the night shift is just starting. Often we show up and are told a truck is down or an employee is out, and we can't rehearse. Or, we are given fifteen minutes when suddenly a group of employees are free and we have that time to try something. We have to remain extraordinarily flexible and bend our schedule to follow what works for our collaborators.

For *In Case of Fire*, that meant meeting with small groups at the stations, and running through ideas out on the parking lot or in the garage. I joked with Dawn that she was my rehearsal assistant, but functionally that was about right. I would tell her what I wanted to happen in the piece, and, standing next to me, she would yell out to the group, using terms the firefighters could understand along with an explanation of just how to do it. For example, when I wanted two firefighters, Louise and Travis, to turn upside down while they were rappelling down the training tower, she told them how to do this in sync and by turning in the same direction.

Occasionally we worked in small groups at the performance site, too, and that's where we were when on the morning of Tuesday, September 11, a call came through the radio saying that a plane had hit one of the World Trade Center towers, and that all engines and personnel were to return to their stations immediately. Within moments, the firefighters were in the engine headed back to Station 11. By the time I drove home to watch the events unfold on TV, the second tower had been hit, and I joined the rest of the country in shock and grief.

The fire department remained under lockdown for the next week. Firefighters were not allowed to leave their station except for emergencies and I was not allowed to visit. Dawn Clopton and Travis Maher, another firefighter from Station 17, traveled to New York City to assist in the recovery efforts. For about two weeks, planning for our performance was halted, and I wasn't sure we were going to proceed at all. But Palmer and

Laura were able to get permission to move forward with our October performance, and I was able to return to the stations just two weeks out from our show date. Now that the nation was aware of the heroism and sacrifices of first responders, the show felt even more relevant and important than before. Stephen Truesdell remembers it like this: "September 11 changed everything. We were just going to do this cool show, and then all of a sudden the show had a whole different meaning."

The two weeks leading up to the dance were busy. I test-drove my ideas in small groups, and continued to lean on people like Dawn, Captain Mike, Sully, and Stephen to give me feedback. I took what little time I could get with the firefighters at the stations while they were in between calls, using fifteen- to thirty-minute rehearsals to walk through the scenarios of the dances in the garage or out on the parking lot, while the Glass score played from a small boom box. Since the firefighters weren't led by the music and likely wouldn't be able to hear it during the show anyway, with their gear on and the trucks running, I needed to make sure the timing of movement and music worked. The choreography looked good to me, but as we were working in small groups I couldn't get a complete look at the dance yet. I needed the entire thirteen-member cast together to really know whether the show worked.

I had arranged with Laura and Palmer to have just one full run-through, the day before the show. They had gotten permission for Stations 11 and 17 to go off radio, so that the full cast, all the firefighters from both stations, could rehearse for about four hours without being pulled away for any calls. We gathered together in our performance space at the fire training tower with all the equipment, including the three fire trucks. A good friend and fellow dancer, Christina Jesurun, came to help me. She set up a temporary sound system and ran sound.

It was an intense four hours. Since it was the first time that I had everyone together in the performance space, I started by talking through the whole show. We then walked through each section slowly, setting people's positions and where they would enter and exit. With just an hour left, we got to the finale. Involving the entire cast and requiring coordination of the two engines, ladder truck, and hoses, this was the most complex part of the show. It was also the only section that we had never fully blocked out at the stations. We needed everyone together for that, and this was our first and only opportunity. It was dark by this time, and the cast and I huddled around the hood of a truck, using flashlights to look at the diagram I had laid out. I was struggling to give clear directions, and at one point, one of the firefighters yelled in exasperation, "This is a bastardization of what we do!" I was shaken, and felt uncertain of how to move forward. Fortunately, other firefighters, including Captain Mike, Dawn, and some of the other women on the crew, began to offer ways to make the section work.

They sorted out who would do what—including driving in the engine and ladder, deploying the hoses, and hooking up to the fire hydrants.

Reflecting now, I can see that I was simply not prepared, and I was lucky this moment of tension did not derail the project. I should have taken the time to more specifically design this section in advance with the three officers, Captain Mike, Dawn, and Sully. I would then have had them teach the finale, using the language and directions that the group would have been most familiar with. Also, I would have brought in more support—at least one more assistant to help me troubleshoot problems.

I have learned that the first all-group rehearsal is often the hardest moment for a cast. No one has seen the entire dance come together yet, and people feel unsure and unsettled. When working with eight Venetian gondoliers for *The Gondola Project* in 2003, our first, and only, full-cast rehearsal was especially memorable. Pulling that show together had already involved a series of logistic feats: raising enough money to cover my plane tickets, food expenses, production costs, and small stipends for some of the production team; getting the permits to close the canal we needed for a stage and to perform the show; securing access to power for basic theatrical lighting and a sound system; and being granted permission to hang posters and publicize the event. Recruiting the gondoliers had been challenging: they were not accustomed to working as a group, they competed with each other for work, and they were not used to taking orders from a woman. Other gondoliers even took offense to my presence at the gondola stops when I would go and visit with my collaborators there. And I wasn't paying the gondoliers—for with my limited budget I asked them to contribute their time for free and volunteer. The lead, older gondoliers who joined the project advised that I not offer fees, so that the gondoliers participating would do so as a service to the city, not as a means of making income. But looking back, offering some kind of payment would have likely helped the cast, especially those gondoliers who couldn't afford to miss a fare, to be able to more easily prioritize our limited rehearsals together.

Our first and only all-group rehearsal took place the night before the show, and was scheduled to start at 11 p.m., since it was the summer and the gondoliers worked giving tours until late. There I was, futilely yelling out instructions from the bank of the canal as the eight gondoliers, doing their best to listen and follow, grew more and more frustrated. They couldn't picture what I was asking them to do. It was then that I realized they should start by doing the choreography on land, out of their boats, and I called them to come join me. Standing in position on the cobblestone walkway, they paced through the choreography. This made a remarkable difference to their mood and their understanding of where they needed to be and when. Once they got back in the water, they rowed through the

sections with a new ease. That was when I realized I had come up with a strategy for simplifying the teaching of choreography, which we at Forklift now like to call "Do it out of the boat first!" In the end, the gondoliers did an exquisite job, performing elegant designs in duets, trios, quintets, and with all eight gondolas together to a standing room only audience of more than five hundred Venetians and other admirers.

Since these early projects, our rehearsal strategies have evolved. Now we often make guidebooks for participants, listing the show order and explaining the choreography through words and visual design. With a larger team in place, we assign rehearsal assistants to talk through the show with cast members one-on-one. Still, there is an inherent chaos to the final days of rehearsal, when the show comes together. Unanticipated problems come up, like the gondolier who missed part of that final rehearsal because he was giving a guided tour until midnight. This is why it is most important that my team and I have spent months building relationships with our collaborators, so we can strategize and move forward together, even when challenges arise—because they always will!

■ On the day we performed *In Case of Fire*, the cast of firefighters huddled inside the fire training tower as we went over final notes. Someone cracked a joke and Mike responded immediately, rebuking the firefighters and telling them that this was serious and they better get it together. I had never heard him reprimand his crew like that before, but by telling the firefighters that this wasn't goof-off time, he was putting himself behind the project once again, and pulling the rest of the firefighters along with him.

It was time for the show to begin. I stood on a table so I could see over the heads of the audience and called cues on a radio. The first four sections came off without a hitch, but after the rough run-through the day before, I worried about the finale. With the last section of music starting at a fast-driving tempo, the two engines and one ladder truck raced in on my cue, sirens blaring. The firefighters then climbed out of the trucks, hooking hoses up to the hydrants and pulling the hoses into position. Enthusiastic cheers greeted Louise and Travis when, rappelling down the training tower as they had rehearsed with Dawn, they turned upside down. Another firefighter, Lonnie Saul—chosen by his peers for the task because he was a rookie—climbed all the way to the end of a hundred-foot aerial ladder. As the music built to its dramatic ending, with a chorus of singers reaching their highest notes, stupendous columns of water sprayed into the air and the dance concluded.

The audience of more than five hundred people burst into wild applause. The firefighters came forward and took their bows, beaming as the audience gave them a standing ovation. I ran up to join them, and

they surprised me with a bouquet of flowers. Then Captain Mike Sullivan and Lieutenant Dawn Clopton hoisted me on their shoulders and carried me forward. I teared up, completely overwhelmed. Soon the crowd approached, and firefighters began giving out autographs, showing children the fire trucks and just listening to the glowing feedback. Remembered Sully, "Afterwards people stayed and talked to us for a long time. I still have a picture from after the performance—a little girl. She was interested in my gloves. She grabbed a finger. It was a connection that never would have happened. I never would have even thought this was possible."

After the show, I brought dinner donated from a local restaurant over to Station 17 and the whole crew got together to eat and talk about how much fun it all was. We watched the video that a local videographer, Julia Halperin, had shot for me, and the crew was impressed by how well it had all come together. They laughed and cheered while we watched the video, because of course this was the first time for them to see the show. They poked fun at and complimented each other all at the same time. It was a great evening. This tight-knit group was even closer now. And I was proud to feel like one of their crew, for just a little while.

The firefighters reflected to me what the experience of dancemaking taught them. "It was like looking at your career choice from a different perspective. Almost like being above yourself looking in," relayed Doc Murdock. For Sully, it made him think of the movement in his job differently: "Before I never thought about how I handled a fire extinguisher or a ladder. I just did it the way I'd been taught and the way I practiced. Allison made me think about what we did in a way I hadn't before." "The show changed the way people saw us, and the way we thought people saw us," explained Louise Joubert. "Seeing firefighters of different sizes, shapes, and genders was a big deal—even back then, twenty years ago—and by putting us in a vulnerable position as performers [it] made us more friendly, more human to the public . . . It took us out of our comfort zone and that was good—because that is how you grow."

I vividly remember what it felt like packing up after the show. The parking lot was empty, all the audience and firefighters gone, and I was loading up the remaining cones and supplies into my car. I was the last person to leave, all alone there at the training tower. I took a moment to take it all in, inhaling a big breath as I looked across the empty lot, remembering what had just happened and all the people who had just been there. It was amazing. I was pleased—really pleased. My last thought, though, as I pulled out of the lot, was a little distressing. All I could think was, "What am I going to do now? Because I will *never* have another idea as good as this one."

The Trash Project
A Dance for Sanitation Workers

2

It was 5:45 a.m. and I was running late. Relieved to spot a parking place, I squeezed my Honda CRV in between two hefty pickup trucks, grabbed my clipboard, and hustled across the parking lot. Employees in neon yellow shirts, lit up by the passing cars' headlights, streamed into the Kenneth Gardner Service Center, the main operations building for Austin Resource Recovery—Austin's trash department. The place was bustling. Employees greeted each other with high-fives as they moved down the hallway or up the stairs to the second floor to pick up instructions for their day's routes. Following the crowd ahead of me, I entered a large meeting room, already full of more than fifty employees sitting in chairs or leaning against the wall. As I moved to take a spot near the front of the room, I noticed the colorful mural on the wall with images of the job—men with smiling faces wheeling trash carts, operating giant clawed machines picking up heavy debris, and waving to children out of their trash truck windows.

I was there to pitch my idea of making a dance. The employees at this meeting were field staff, or operators, and were mostly male (96 percent) and predominantly African American (47 percent) and Hispanic (the department's term; 43 percent). The employees in the room that day were attending a monthly safety meeting; hearing about dance from a White woman who had never worked alongside them was probably not something they expected. "I'd say about 60 percent of us in that room paid attention when you started speaking just because we did not have women come talk to us much," remembered Don Anderson, then a supervisor. "I think most of us were thinking, 'Who is this lady?'" But I felt in my element. Meeting with a group of understandably skeptical people and presenting what I knew seemed like a wacky idea charged me up.

I went through my presentation quickly, showing a short clip of the dance I had made with the Austin fire department. I got a few interested looks, but many employees avoided my gaze, staring at the floor. I strategically avoided using the word "dance" to describe my idea—I didn't want people to begin imagining leotards, tutus, turns, and kicks. Instead,

I said we would create a "show" and a "free public event" to educate Austinites about the work of trash collection. All I needed from them right now, I concluded, was permission to shadow them on the job; nobody — and here I used the word strategically — would be dancing just yet. That got a few chuckles from the group, and as I wrapped up one of the employees, Tafari Johnson, stood up to show off his own moves. He strutted in front of a row of chairs, rolling his spine up and down like a snake and snapping his fingers. Applause erupted, and I felt optimistic as I packed up my things and headed out the door. But as Don Anderson recalled, "All I could think was, 'This White lady is crazy. Trucks don't dance!'"

▪ Since producing *In Case of Fire*, I had been dreaming about making a dance with the people who pick up trash. I knew the movement vocabulary of trash collection would be rich for choreography, and I liked the idea of collaborating with people whose work was fundamental to the safe running of our city. I was eager to hear stories about what it was like to do this "dirty work," and I wanted to understand more about our collective relationship with waste: what trash we made, where it went, and what that meant.

But it took me nearly seven years to summon the courage and build the infrastructure to make my early morning pitch to the employees of Austin Resource Recovery. In part, this was because my dancemaking grew out of relationships, and at this early stage in my work, I tended to turn to people I already knew and was connected with, like Stephen Truesdell, who had walked me into the fire department for *In Case of Fire*. I couldn't see how to get my foot in the door at the sanitation department. But I was also just busy — with other projects, with the task of building a dance company, and with the rest of life.

When *In Case of Fire* premiered, I was working closely with the avant-garde choreographer Deborah Hay. Deborah had been part of the Judson Church experimentalists in the 1960s in New York City, but settled in Austin in 1976. By the time I met her, in 2000, she was a long-standing presence in our local dance community. I was intrigued by her process of "playing awake," a set of tools that helped people be fully present in performance. By collaborating with people at their work, I, too, was interested in finding ways for people to show their full selves, not "perform" being a dancer. In 2001, while I was working with the fire department on *In Case of Fire*, I joined Deborah's solo commissioning project, learning *Music*, a solo that she required me to practice every day for a year. Deborah then invited me, along with fellow dancers Beverly Bajema and Steve Ausbury, to perform our versions of *Music* in a shared concert, one after the other, with Deborah going last to close the show. I was chosen to go first, and on opening night, Deborah walked up to me while I was doing

my final warm-up, just minutes before I was to go onstage. "Allison," she said, "you are too ready to do this. I want you to do the solo backwards." "What?!" I looked at her, panicking. "Not possible!" I responded. "Just don't think about it—do it backwards," she said, and then pushed me out onstage. As Deborah was hoping, I was on the edge of my capacity. I was terrified for the first few minutes, but as I got going with the movement, I began to relax. I felt my body beginning to lead, and my mind stopped trying to plan what was coming next. This moment, and many others with Deborah, taught me a lot about how to be in the present. Through experiences like this one, I grew in confidence that I had the skills to handle what might emerge while more easily turning to the people around me to help solve the problems that will inevitably arise.

I had met my next collaborators, John Slatin and his guide dog, Dylan, while taking a workshop with Deborah in 2002. John loved to dance and improvise, and he and his wife, Ana, were fans of Deborah's. During the workshop, I would look over and admire Dylan, a gorgeous yellow lab, as he slept spread out on the ground during his breaks from guiding John. John was blind, and during meals and other break times, I noticed the gestural relationship between the two of them. John communicated with words but also with movement, instructing Dylan when to come, sit, go forward, turn right, turn left, stop, and rest. Brainstorming together, John and I came up with the idea for *Sextet*—a dance for two men who were visually impaired (John and Sozan Schellin), each of their guide dogs (Dylan and Sozan's dog, Zeke), and two trained dancers (Karly Loveling and myself). Again, I was exploring the movement of work, but in this case the work between a guide dog and his owner. I was curious about their relationship, and about how they navigated the world together using a habitual, physical vocabulary. I was moved by their care and connection, and I gained a new understanding of communication through gesture. I also learned more about the importance of accessibility.

Sextet was made for the theater. I was invited by my colleague at Austin Community College, José Bustamante, to create a dance for a concert he was curating at the University of Texas, which came with free rehearsal space and production support. John, Sozan, Karly, and I wanted to make the dance experience as fully expressed artistically for the blind and visually impaired audience members as it would be for sighted audience members. John taught me about audio description, which is a narration that accompanies live action for people who are blind or visually impaired, usually transmitted via headsets and typically only heard by blind or visually impaired theater attendees, movie goers, and sports fans. Working together with Celia Hughes of Art Spark Texas, we created an audio description script that Celia spoke live, describing our movements aloud so that all audience members experienced the narration—

in real time and as part of the sound score. The dance consisted mostly of walking patterns as John and Sozan were guided across different parts of the stage by Dylan and Zeke. Karly and I mirrored these walking patterns, occasionally adopting other gestures from John, Sozan, or their dogs—like scratching a shoulder or perking up an ear. At the end of the piece, I guided John across the stage without his dog; then he called to Dylan, who scampered across to meet him. Next, Sozan walked backward alone across the stage, motioned and called out to Zeke, and the dog lumbered slowly out to meet him.

I loved the impact of the audio description—it made the dance more accessible while also being more interesting theatrically. And many sighted audience members said they enjoyed finally understanding what was happening on a modern dance stage! The dance earned me my first citywide award—I was named Best Choreographer by the Austin Critics Table—and we were invited to perform the dance at the Kennedy Center in Washington, DC. More importantly, working with John and Sozan led me to increase my focus on teaching inclusive, mixed-ability classes at Austin Community College, where I worked for a decade as an adjunct faculty member. Partnering with the Office for Students with Disabilities, I began offering regular dance classes through the college that were accessible to students who were blind, visually impaired, deaf, or had other disabilities. Together, a group of local dancers and I, with support from John Slatin and Celia Hughes at Art Spark Texas, organized a yearly mixed-ability dance workshop that eventually became Body Shift, a program of ongoing mixed-ability dance classes that continues to this day.

Soon after *Sextet, The Gondola Project* premiered in Venice. Once I was back home in Austin, I shifted focus to explore Elvis Presley, from both my own perspective and that of Elvis impersonators, many of whom had no formal arts training but had made a decision to perform as Elvis. I studied Elvis's life, but the story I wanted to tell was about the work of being an artist. I was interested in how the impersonators I met worked to become Elvis: how did they practice, what did it take to learn Elvis's moves, and who were they ultimately doing this work for? I settled on *The King & I* as the title, and in the dance I also traced moments of my own shared connection with Elvis—like how we both traveled to Hawaii and how I lived in Austin just miles from Del Valle, where Priscilla lived briefly as a girl. The cast included a local Elvis Tribute Artist, Donnie Roberts, aka Texas Elvis, as well as four trained dancers—Ann Berman, Theresa Fredley, Karly Loveling, and myself—along with additional local celebrities and dancers taking on cameo roles as Elvis impersonators.

I worked on *The King & I* for over three years. It was my first full, evening-length work, and I learned a lot from making it. It was also the last dance I made for the theater that included trained dancers. I didn't

Figure 2.1. Allison Orr, Karly Loveling, Sozan Schellin and his black Labrador Zeke, and John Slatin and his yellow Labrador Dylan in *Sextet*. Photographer unknown.

make an intentional decision at that point to leave the world of concert dance behind. But Deborah Hay's encouragement helped. She had seen *In Case of Fire*, and on a walk together a few years later, she told me that what I had created in that work was unique and choreographically intriguing. She suggested that I continue developing and honing my work with people at work, which she found more interesting than my theater-based work with other trained performers.

When our performance of *The King & I* concluded in 2007, I certainly didn't know that I would dive into five projects with city employees over the next ten years. But I did realize that the potential for impact and great artmaking was limited for me in the theater. I was ready to go bigger. At the same time, I was building the infrastructure of Forklift. In 2001, I settled on the name, Forklift Danceworks, and started to file the paperwork to form a nonprofit organization. By 2003, I had a board of directors, and in 2006 we held our first fundraiser. With each performance, our audience grew. In these early years, I focused a lot on expanding the board, adding members with development and marketing expertise. By 2005, with the help of a five-hour-a-week administrative assistant, I was sending out an end-of-year fundraising letter and had started a monthly supporter email newsletter. I took any low-cost class I could that addressed the topic of building a small nonprofit. I read about best practices and sought advice from local nonprofit leaders. For the first eight years of Forklift, I wasn't paid by the company; I lived off my adjunct salary from Austin Community College, and my husband's salary covered most of our family's expenses. I was lucky to be able to live that way—many artists can't.

I had my first child, Genevieve, in 2006, with my son, JoJo, following in 2011. Right away Genevieve taught me to focus and prioritize. I couldn't give all my time to Forklift once Genevieve was born, so I had to get clear on what I wanted to do most. Fortunately, it was also around this time that, reading about other artists who worked on issues of labor, I stumbled upon the work of Mierle Ukeles. I was blown away to learn that Ukeles had been the Artist in Residence (unsalaried) of the New York City Sanitation Department since 1977. Ukeles wrote her *Manifesto for Maintenance Art* in 1969 after giving birth to her first child. In it she proposed that the work of maintenance, including cleaning and caring for her child, is art. From 1979–80, she produced *Touch Sanitation*, a project where she shook hands with all 8,500 employees of the New York Sanitation Department, saying to each, "Thank you for keeping New York City alive." I was awestruck and buoyed by her brilliance and fortitude to intentionally make labor visible, to emphasize its relation to care, and to manage it all as a woman, artist, and mother. Her work gave me confidence. I decided that it was time, finally, to reach out to Austin Resource Recovery.

I told Palmer Buck, my friend from the Austin Fire Department, about

my hope of collaborating with sanitation workers, and he recommended that I call Jill Mayfield. Jill was the sanitation department's public information officer, and she was also Palmer's neighbor; he agreed to put in a good word for me. On our first phone call, late in 2006, Jill was clearly befuddled. She admitted as much years later: "At first I thought you were a bit out there." But she told me that I should pull together a clear proposal if I wanted her to take my idea up the chain of command. I prepared a three-page proposal and emailed it to her, including a draft timeline, needs from the department, potential benefits to the employees, and my bio. After a couple more months in which I waited and periodically followed up, she finally agreed to meet with me.

Sitting in her office, I immediately liked Jill's straightforward demeanor. I knew she was telling me the truth when she told me her biggest hurdle was perception. "My director Willie Rhodes grimaced when I told him about your idea," Jill confided. "He is afraid people will make fun of our employees." I explained to her what a success our project with the fire department had been, being sure to mention how pleased Palmer and his colleagues from public education were with the project. We wrapped up our meeting agreeing that Jill would ask for a pitch meeting with the leadership team.

That meeting eventually took place one afternoon in August 2008 at the main service center, almost two years after that first phone call to Jill and the department. I remember how excited I felt signing in at the front desk—I was finally at the truck yard! I caught glimpses of a few trash trucks as they rumbled out of the yard, and took in the employee notices and meeting announcements on the walls as I made my way to the conference room, where about ten staff members were seated at long conference tables. After a quick introduction, I began by showing a short trailer from *In Case of Fire*. I spoke passionately about creating a positive experience for the employees and garnering lots of great PR for the department. I could tell the leadership team connected to that idea—especially when one of the women in the room piped in with, "I want this project to win lots of awards!"

"We can do that!" I replied, getting a few laughs and encouraging nods. I explained that the participating employees would need permission to work with me while on the job, and I pledged to align closely with them on the project's key messaging. After about ten minutes of discussion, the group agreed to let me start my research by riding out. I could come to an early morning safety meeting in a month to introduce myself and begin to meet employees. We would decide the full scope of the project once I saw whether I got any buy-in from the employees.

Not everyone on the leadership team was convinced. "When this idea came up at a division manager meeting, we all thought it was a joke,"

admitted Richard McHale, deputy director. At that early stage, though, Jill, Richard, and others in leadership were willing to go along because of what they thought it might do for employees. Jill explained, "These employees do so many things, but our image of them is very one-dimensional. People think, 'Oh, he could do something better with his life.' So, I thought maybe this could give the employees some respect. These men and women have tough jobs, and if we could get them some more respect, now that would be good." The stigma of waste collection was certainly something everyone I worked with was aware of. They knew that other civil servants, such as firefighters, are often seen as heroes, whereas sanitation workers are looked down upon as those who do the job nobody else wants. And so management said yes. Or at least yes to riding out. I was told I needed to do a week of employee training to get up to speed on safety protocol. That sounded great to me, as it would be a useful introduction to the job. I purchased a pair of steel-toed boots, got some safety glasses, borrowed a high-visibility safety vest from the Safety office, and prepared my pitch for the employees' early morning safety meeting. I was ready to go to work.

■ In September, I showed up to take New Employee Orientation (NEO) from 6 a.m.–2:30 p.m. every day for a week. I was in a class with about eight new employees, led by a team of three safety trainers, Jesse Langley, David Morris, and Jesse Muñoz. As they taught us about proper protocol and procedure, I tried not to raise my hand too many times with questions. I had a lot of them, but I didn't want to take up too much space. All the men in the class were welcoming and patient as I awkwardly learned to work the hopper and ride on the back of the truck. On the last day of class, I showed up with donuts to say thank you to my fellow classmates, and by the end of the week I had a few friends at the yard.

All three instructors generously spent extra time with me, too, teaching me about the job and helping me understand how the department worked. David became an especially important ally. He was often a little grumpy, and always told me exactly what he thought. I came to rely on him to give me the inside scoop, especially regarding who in the department he thought could help me solve any problems that came up.

Management was clear that they wanted me to see all aspects of the work, and that whatever I created had to speak to all parts of the job — not just trash pickup, but also recycling, brush and bulk item collection, night crew, and even dead animal pickup. This early in the project, I had no idea how sizable the scope of trash collection was, but I wrote down what leadership told me to do, feeling both overwhelmed by all I had to learn and excited to meet more employees. For that, I needed a handler inside the department. Enter Valerie Francois, manager at Human Resources. I had met Val in my initial pitch meeting. A petite, energetic woman with

a sweet Texas drawl, Val loved spending time talking with the field crews and often showed up at 5:30 a.m. to check in with the guys.

When Val and I sat down together to talk about the process years later, she told me that management placed me with her because "nobody wanted to be the person who was doing it." She took a leap of faith and decided to help me because she felt like "the guys needed something to be proud of." With Val's help, I attended early morning "tailgates" where the operators came together for a monthly meeting. Val would stand up first, introduce the project, and give me a few minutes to explain what I was trying to do. I then asked if anyone was willing to let me go out on route with them.

Not many folks volunteered. Val remembered, "I actually did a lot of talking them into it. I would say, 'You need to do this and here is why,' or 'You will be great for this. I will be right here if there is a problem.'" When I told Val that I'd had no idea she was working for me and the project behind the scenes like this, she responded, "You didn't need to know *that*." Val described the role she took in the process as "a natural fit because I had the relationship with employees. I could talk with them about it, saying, 'Hey, you should try it. At least give her a chance. Do it and see how you feel about it.' The guys weren't scared once they saw that I bought into it."

By October, I had been showing up at the job for about a month, but many in the department, especially in leadership, remained reluctant about my idea. Some of that skepticism I was aware of, but much of it I only learned about later. I knew, though, that I needed to get to know the operators—the employees out in the field—and listen to them talking about their work. If I had to pick one thing that was most essential for this project with the sanitation workers, it was showing up, time and time again, and demonstrating that my interest was real. I had to put on my safety gear, get in the truck, and do the work without any complaint. I needed to arrive at any and all hours: 1:30 a.m. for the night shift, and 5:30 a.m. for the early morning routes, when I did most of my ride-outs.

For me, that meant getting up by 4:45 a.m., tiptoeing out of the house so as not to wake the sleeping toddler, and getting to the yard by 5:30 a.m. I tried to show up two to three times a week; I rode out at least twenty times during the course of the project. During those first few months, struck by the culture of early mornings, I was reminded that there are whole communities of people who get up early every morning so the rest of us have what we need when we get up. I had learned a little about that from my grandfather; he worked in construction, and long after he had retired he would be up by 5 a.m. drinking his black coffee at the kitchen table. For the folks at Austin Resource Recovery, there was a sense that if you didn't get to work until 9 a.m. or even 8 a.m. you were kind of soft and

lazy. I started to take pride in being able to handle the early mornings, and I was amazed by how much we would get done by 10 a.m. Typically, my ride-outs would last through lunch and sometimes up to 3 p.m. when the employees clocked out.

By January 2009, with Val's help, I had ridden out with most of the work crews, and I was learning each one's different rhythm. The group picking up yard trimmings raced fast, while brush and bulk collection teams worked their way slowly down the streets, hoisting large items with hefty cranes and tractor trailers. Rear-loading trash pickup was one of the most physically demanding jobs—riding on the back of trucks and loading cart after cart of trash—so it was where the new guys often got placed. Manning the monster-sized, automated trucks was considered a step up. Those operators worked alone, emptying hundreds of cans with the truck's robotic arm. The overnight crew was a tight group, whose work transformed our dirty downtown streets with street sweepers and hand blowers every morning from 2–6 a.m.

I carried a notebook, writing down insights from employees or facts about the job. I took photos and video of the equipment in motion and recorded short interviews with my phone. Sometimes I rode on the back of the truck, but mostly I was inside, where there wasn't much to do but talk. I listened attentively as people told me about their families, what they loved about the job, and how they ended up there. Riding out, I got to see all the neighborhoods of my hometown, both rich and poor, from a new perspective. I was impressed by how much the employees knew about the people who lived on the streets they serviced. I saw the daily rituals of the job—where employees liked to stop and grab coffee, the older people they kept an eye on, the kids they always waved to, and the customers they took special care of by walking their trash cans back up their driveways. I observed a real sense of teamwork. Sometimes a truck would break down and in an instant the pace of the work would get even faster as the employees split up the broken truck's route to get those streets serviced by the end of the day. Every ride-out was memorable, and each one contributed to the making of the show in its own way. With two employees—Virginia Alexander and Tony Dudley—my ride-outs showed me just how to cast each of them in the show.

When I met Virginia Alexander in 2008, she was the only female supervisor with Austin Resource Recovery. Virginia was famous at the job. She had long braids, boxed after work, and didn't let any man show her up or tell her what to do. Her crew respected her and she worked them hard. I knew I had to get Virginia in the show. I just had to figure out how to break through her tough exterior and get her to say yes, which I imagined would only happen if she saw me work hard with her. When I showed up for my ride-out with Virginia one early January morning, it was pouring rain,

barely above freezing (which is really cold in Austin), and I was wearing a flimsy lightweight jacket with just one layer underneath and no gloves or hat. I was going to be miserable on the back of the truck, and Virginia knew it. She looked at me in my pathetic gear and said, "You really want to do this today?" Enthusiastically I replied, "You bet!" "OK," she said, not looking impressed, and quickly hurried me over to the supply room. She picked out an extra-long high-visibility raincoat and waterproof gloves and reoutfitted me head to toe, lending her expertise—and showing her heart—right out of the gate.

As supervisor over yard trimmings, Virginia managed the collection of hefty bags of leaves, other yard waste, and Christmas trees after the holidays. During peak leaf season, she and her crew might pick up forty extra-large bags at one single stop, completing hundreds of stops a day. That January morning, we had lots of Christmas trees to pick up, so we moved fast as we headed out. Midway through the shift, she put me on the back of the truck where I threw bags as quickly as I could. Of course, I was way behind Virginia, who threw heavy bag after bag as she jogged down the street. My fingers felt frozen, and I could barely keep up. Virginia and I couldn't help but laugh at me and my meager skills, and this built a stronger connection between us. This happens in many projects: my lack of skill in doing a job that my collaborators do really well inverts the typical power dynamic between "artist" and "subject," and demonstrates that I really am there to learn from them.

By late morning, we had done most of the route. We were in my neighborhood, and when I told Virginia that, she offered to stop by my house and grab the Christmas tree that was laying by the curb for pickup. Virginia even agreed to a photo of the two of us putting the tree in the back of the truck. By the time we got back to the yard, I had an idea for her part in the show, a duet of sorts between her and a moving truck. She would run behind it, expertly throwing heavy bags into the back. I just had to convince Virginia to do it.

I told her we had to have the only female supervisor in the show—we just had to! She said no, but I kept showing up, demonstrating how much I liked her, and explaining how much she could bring to the piece. Normally, as a matter of good practice, I don't want to push people who say they don't want to participate, but Virginia's reception was so warm that I had a hunch I should keep at it. I made a big play of begging her to join, and when—cracking up—she continued to protest, I sensed that she was playing along. She laughed as she remembered this part of the process, too. "Everyone said, 'Go ahead and just do it,'" Virginia said. "But you *begged* me. You begged every day. And I told you no, no, no. And you just kept begging me." Virginia finally said yes. Her choice to come on board helped give the project legitimacy in the eyes of the many employees who

respected her leadership. For her, "it was a way to show people what we do on a daily basis. That we actually do a job. People always say we don't work, that we just waste people's taxes."

I was also lucky to work with Tony Dudley, one of two collectors responsible for dead animal pickup. Tony was a big guy, and he always managed to look fashionable on the job with his designer, gold-rimmed aviators. His booming voice would fill the hallway as he spun stories for his coworkers during the early morning paperwork pickup. Tony mostly worked in the north section of town, picking up animals who had been hit by cars. He also picked up deceased pets that citizens didn't want to bury themselves. His last stop was always the local animal shelter, which still put animals down at that time (but is now a no-kill shelter and has been since 2011), and his route would end after he had taken all the dead animals to the landfill. One early morning, he told me he didn't really like dogs because he had "too many relatives" and didn't have time for pets. I laughed. "So the dead animal collector doesn't like dogs?" I asked. "Maybe that's good!" "Well, Allison," Tony replied more seriously, as he pulled his aviators down to look me in the eye, "I see it as I am doing a service for the city, and that's OK by me."

For the first hour or two of our ride-out, I sat with Tony as, driving from stop to stop, he told me about the job, answered questions, and made me laugh. I found his work to be really hard. Many of his coworkers would never take the position, but Tony managed the work with grace. I watched him make the pickups, but it soon became clear that he wasn't going to ask me to pick up any animals myself. I wasn't really excited about it, but I knew I needed to try, so I asked him if he could coach me. He agreed that I could do the next pickup, a dead cat. I got out of the truck and picked up the shovel. The cat was lying on its side and the body had already begun to decay. As I moved toward the cat, something came over me and I just couldn't get myself to pick it up. I would move toward it, back away, move in, and then back away again. Tony shouted out, "Don't look at it! Don't look it in the eyes." "Why?" I asked. "Because then you get too attached, too emotional. Remember this is a job you gotta do. Don't be so sensitive!" Tony's advice worked, and I got the cat in the back of his truck. But as we went back to the yard, I remember thinking that I couldn't do this job every day. I don't think many people could.

■ At the same time that I was riding out, interviewing employees, and forming stronger ties with the department, I was beginning to form a sketch of the dance itself with two collaborators—Stephen Pruitt, production designer, and Graham Reynolds, composer. I had never worked closely with a designer and composer in this way before. But for *The Trash*

Project, I was ready to bring a full artistic team on board. I had met Stephen about a year earlier when he designed the lighting for the Austin Dance Festival, which I danced in, performing the work of my friend Ann Berman. I liked Stephen from the start—he was very hands-on and had been trained as an engineer, so he had the skills to design vast, outdoor projects like this one. Stephen not only designed the stage space and lighting; he also helped me think about how to make the entire event work. He figured out the parking plan along with where we would put additional production needs like porta-potties and power generators. We plotted out much of the dance together, especially how to elegantly move the trucks through our immense stage. Stephen created a site plan, and from that an architect friend of mine created a small-scale model that I carried around, practicing ideas on it with toy plastic trucks. Stephen also created a storyboard of the show, mapping out each movement of every truck. We spent hours talking through the show sketch, thinking about how to make it run more efficiently and smoothly.

Graham Reynolds came on board early, too. I knew I needed a composer—I wanted original and live music for this show—and my fellow choreographers recommended him. My budget was relatively small, but Graham had a reputation for saying yes to everything, and when I emailed him about the project, he said it sounded like fun. Since then, my team and I have collaborated with Graham on every dance we have made. Graham is a great composer for dance, and we work together well; he is comfortable with the chaos of the process, where decisions can be made last minute, and he knows how to use music to tell a story and develop characters. He understood that this was a show about the employees, not the music, and that the music needed to follow the action, not direct it. He also understood that the music needed to reflect the culture of the work group, and he spent time at the job site recording the sounds of heavy equipment and talking with the participants about what kind of music they would like to have in the show.

Together in his studio, we watched the videos I'd taken of the employees and machinery at work, and he tried out some musical ideas to match. He is a marvelous improviser—he can make any movement idea work, and when a truck takes a little longer to get to its parking spot, that is what you need the music to do. Gradually, we came to a consensus on what kind of instrumentations or style each section of the dance needed. Sometimes he had music ready to go before I worked with employees—this was the case with the automated trucks, street sweepers, and the recycling truck section—and I worked with the employees to set movement to specific timing or counts. At other times, he composed once we had the movement set. Attentive to pacing and arc, he also helped me place

the sections in the right order as we thought about how to build toward the finale. Both he and Stephen elevate our dances at Forklift—our work wouldn't be nearly as beautiful without their artistry.

Stephen suggested that we bring Tamara Klindt aboard as production manager, and she, too, became a key collaborator. Tamara is a petite, determined, and no-nonsense woman; when I learned that she had worked in both disaster management and for professional film shoots, I knew she was perfect for this project. After looking at the tight budget, Tamara told me, "You don't have enough money to pay me." But, she said, she would work for free. Tamara was remarkable. She helped me understand all the logistics we would have to address. We were planning for an audience of eight hundred to a thousand, which required fire and traffic permits as well as a safety plan. She went to all the permitting meetings with me, coaching me on how to talk about the project in those settings. She also interfaced with the vendors and contacts who supplied our power, bleachers, porta-potties, and other rentals, and set up a plan for volunteers to usher and assist in the parking lot. She made the production schedule and she thought constantly about safety for the audience and the employees, preventing what otherwise could have meant disaster for the project and for Forklift's ability to collaborate with others down the road.

The sanitation department and I agreed to a performance date of Saturday, September 13, 2009. Next we had to find a performance space with room for sixteen trash trucks, seating for eight hundred people, and plenty of parking, that would be free or really cheap to rent. Little did I know how hard that was going to be—it was a nightmare to find a site. Stephen and I visited a number of locations around the city but kept hitting roadblocks. I was holding out for the biggest parking lot operated by the school district, and made regular visits to the district office in hopes of getting an answer. When I finally sat down with the operations manager, he mentioned that he did rent this parking lot out to the circus, to which I responded that our show would be a lot like the circus. I remember feeling optimistic when I left. But sometime in the late spring, he finally got back to me: the answer was no. I was stunned, completely unprepared to be told no, and in trouble.

How was I supposed to start planning a dance for September, just four months away, without a stage? Luckily for me, local documentary filmmaker Andy Garrison had been shadowing me and the employees since September when I began my first classes of New Employee Orientation. Andy was interested in making a new documentary, had learned about my work with "non-dancers," and was familiar with community-based dancemaking principles and my mentor Liz Lerman. He approached me and I enthusiastically agreed to let him follow us with his camera. Little did I know he would make such an extraordinary film, *Trash Dance*, that

would not only beautifully document this project and my work but also win its own national and international awards.

But at that moment, just months from our show, I needed a stage. Andy suggested that I look at a space operated by the Austin Film Society: the tarmac of the old Austin airport. Andy was well connected there, and got us on the phone with the staff. Stephen and I rushed over to check it out, and we agreed that not only would it work but it was even better than the school district's parking lot. The Film Society agreed to rent it to me for one dollar. They were eager to support local artists and would have done it for free, but in order to get a legal contract to use the space, I needed to pay something. Finally, we had our stage, and I cried with joy and relief!

Of course, determining the performance site was not the only hurdle. I had to fundraise $30,000, the largest production budget I had ever managed. I needed to pay for a power generator, lighting and sound equipment rental, production supplies and a tech crew, musicians, food and drinks for the employees, plus small stipends for the artists on the project, including Stephen, Graham, the stage managers, a now fifteen-hour-a-week administrative assistant, and myself. Working with my board, we did a letter-writing campaign and hosted a fundraiser. My husband designed our first-ever company sponsorship materials, and reaching out to friends, family, the board's network, and local businesses, we raised the funds. At the show itself, volunteers, including friends and family members, collected donations and sold — in fact, sold out of — Forklift T-shirts.

Some of the funding had to go toward liability insurance. The sanitation department had already agreed to pay employees for the time they spent working on the project, which also meant they would be covered by the department's insurance when operating the vehicles during the show. My company agreed to oversee, pay for, and carry liability insurance for the artists and theatrical rental equipment involved. The contract took some work, but with the departments' lawyers and Val's help, we got it done.

When I first approached the department to make this dance, I had envisioned a dance about waste and the environment. I spent time educating myself about Austin's Zero Waste plan and wrote grant proposals where I pledged to address our city's need to divert more material from the landfill. I imagined a truck dumping trash out onto the tarmac so an audience could see just how vast one load of trash was, perhaps as a voice shared statistics about how many metric tons of trash was heaved into our city landfills daily.

But as I got to know the employees better, I realized that the story I thought I was going to tell wasn't the one my collaborators wanted to tell. Early on, I also assumed employees felt at times disheartened, or even depressed, by their work. On my initial ride-outs, I naively asked a few employees if they felt sad going to the landfill or picking up trash all day.

Their responses surprised me: "No—I like throwing trash. I like being with the guys." Or, "No—I don't feel sad about all this trash. It keeps me in a job." My assumptions were wrong, and unhelpful. Instead of projecting my own political and cultural narratives onto my collaborators' jobs, I needed to listen to them.

This was a lesson for me about leaning into the wisdom of the community, and working to notice my own cultural baggage. The employees wanted to talk about the job—what they loved about it, how they worked with their team, what they wished the public understood about their work. I refocused my beginning dance sketch on telling the stories of the employees and their work. In retrospect, I think the dance still offered the audience a chance to consider all that we throw away. You couldn't help but notice all the work and machines involved in funneling garbage from work and home to the landfill. But more importantly, you saw that the people who work closest with trash, in a job that many people look down upon, deserve recognition and respect. Perhaps, I realized as the dance began to shape under the leadership of the employees, understanding our inherent connections to one another will make us readier to care for each other and the world we share.

Austin Resource Recovery (ARR) requires a minimum of a high school diploma or GED for employment as an operator or field staff member. As a "Second Chance Employer," the department does not require criminal background checks to fill these roles. They recruit at federal institutions where individuals are looking for jobs. As I got to know the employees, a few told me they had been in prison. For them, this job was a chance at a new life. No, it wasn't their dream career, but it was a good job with benefits, including health insurance, paid sick time, and vacation leave. As of 2021, new operators start at $15 or $16.25 per hour, depending upon whether they have a commercial driver's license. Supervisors and crew leaders make $19.72 to $34.35 per hour.

Many other people ended up at the job because they had family members there. Fathers and sons, cousins and uncles, and even brothers worked together at ARR. Numerous employees had grown up together, knew each other's families, and had been part of each other's lives for decades. Others had found that kind of conviviality on the job. I could feel that sense of connection between employees almost immediately. It directed me, and underpinned our project all the way to the show.

■ To come up with a sketch, I needed to know what equipment we would be working with. I ambitiously requested thirty vehicles from the department, including rear-loading, automated and side-loading trucks, a crane, street sweepers, and even two tractor trailers. Fortunately, the department only granted me sixteen vehicles—how I ever thought I could

manage thirty I don't know! Apart from vehicles, I thought about how to show the work of particular jobs—like dead animal and yard trimming pickup and trash pickup with blowers and litter sticks.

I also sought out people within the department who were performers, including singers, musicians, and dancers. In my previous projects, I had discovered that people who had experience performing publicly are often relatively easy to bring on board. At Val's suggestion, I rode out with Orange Jefferson, a professional blues musician who agreed to play harmonica in the show, and Ivory Jackson Jr., a second-generation employee who rapped professionally. Graham and I agreed that a rap, especially if it was written by an employee, would be critical to include in the show. Graham and Ivory met, and together they worked out a track for Ivory to rap over, backed by Lee Houston, Tafari Johnson, and George Thompson with their recycling carts and trucks. Ivory suggested he write about a day in the life of an ARR employee (at that time called Solid Waste Services). Entitled "Solid Waste Go-Getter," it spoke of the physical challenges of the work and the respect it deserved: "Hey . . . this is Solid Waste, baby, and we know a lot of you probably think we lazy. But we not! We work when it's hot—all day, every day, even when temperatures drop."

I was ecstatic to learn that Anthony Phillips, with whom I had worked on a 2008 and 2009 production called *SKATE! A Night at the Rink*, was an ARR employee. *SKATE!* was inspired by the Tuesday night adult skate scene at Playland Skate, one of Austin's oldest roller rinks. When I walked in and saw that scene for the first time—people sailing around the rink, music blaring, and lights flashing—I thought, "Now here is a dance just waiting to be performed!"

The dance featured many of the skaters who frequented adult skate nights—including speed skaters, roller derby girls, the rink instructor, in-line skaters, couple skaters, and a group of jam skaters, including Anthony, who describes the mix of gymnastics, dance, and skating as "breakdancing on roller skates." I knew that I wanted Anthony to breakdance in *The Trash Project*, but I wasn't sure how that would fit in. One Saturday while I was hanging out at the service center, I asked Anthony and his fellow employees if they would try an idea with me. I wanted to work with the hand signals that I had learned in New Employee Orientation—movements that the operators use to communicate while working the trucks, like lifting two hands up and extending their palms to say "stop operation," or with hands in fists, extending their thumbs in the air and pumping their fists up to indicate "equipment up." As we were playing with the hand signals, Anthony remembers, he started "messing around with dancing, just being me." It sparked an idea: Could Anthony come out of the line to start a breakdancing routine after the employees had gone through their safety gestures? He could.

Figure 2.2. Jerry Wallace in his opening solo for *SKATE!* Photo by Amitava Sarkar (photographyinsight.com).

Ultimately, we sequenced the piece so that Orange Jefferson would pull up in his street sweeper, climb out to center stage, and play an upbeat tune on the harmonica. Then he called the entire cast out, leading them through a series of gestures: "Safety glasses on. Gloves on. Back to the left. Back to the right. Equipment up. Equipment down. Stop operation. Continue operation," and finally—as though dancing was always part of this routine—"Showtime!" That signaled Anthony to leave the group and come forward, tossing his work gloves on the ground as he broke into a solo of popping and locking. As he moonwalked across the tarmac, the rest of the cast dashed back to their vehicles, leaving Anthony alone to fill the space with a comedic robot routine, met by delighted whoops and hollers from the audience.

Confirming cast members takes patience, and I have learned in most cases not to ask the big question—"Will you be in the show?"—until I am pretty sure I am going to get a yes. I say this because I mostly want to avoid getting a firm no. I still often get a no, but I have learned that if I ask too early, and especially before the person knows me or has any idea what this project might require, a no is almost certain. Often cast members come from the people my team and I have worked and ridden out with. Sometimes we have to go through a list of possible participants with supervisors, balancing the workload and who they can spare to rehearse with us. It really depends on our partners, and each time, determining the cast is a delicate process. Some people need me to show that I am earnest in wanting their participation, so I have to go back and tell them more than once how much I want their help and how great they would be in the show. This is where reading people comes into play, knowing when to back off and when a little push might be welcome. Also, I sometimes save a spot for someone who I think wants to participate but might not commit until the last minute.

For the most part, people sign up once I get them engaged in solving the problem of how to represent their work, and this often comes out of a ride-out. This was certainly the case for Gerald Watson. A Sunday school teacher, Gerald Watson takes pride in helping people. Gerald also loves to talk, and on our ride-out we easily built a good rapport. Gerald operates a bucket truck, or what is more technically called a front-end loader. The bucket truck works in tandem with the street sweepers, ensuring that every Austin city street is cleaned six times a year. When their collection bin is full, the street sweepers dump their load. Gerald with his bucket truck then comes in to carefully pick up that load of leaves, trash, and other debris and transport it all to the landfill. On our ride-out, I asked Gerald to talk me through the process of picking up a load. When we got a break, Gerald got out of his truck and described the process with movement. With his arms moving up and back, Gerald showed how the bucket

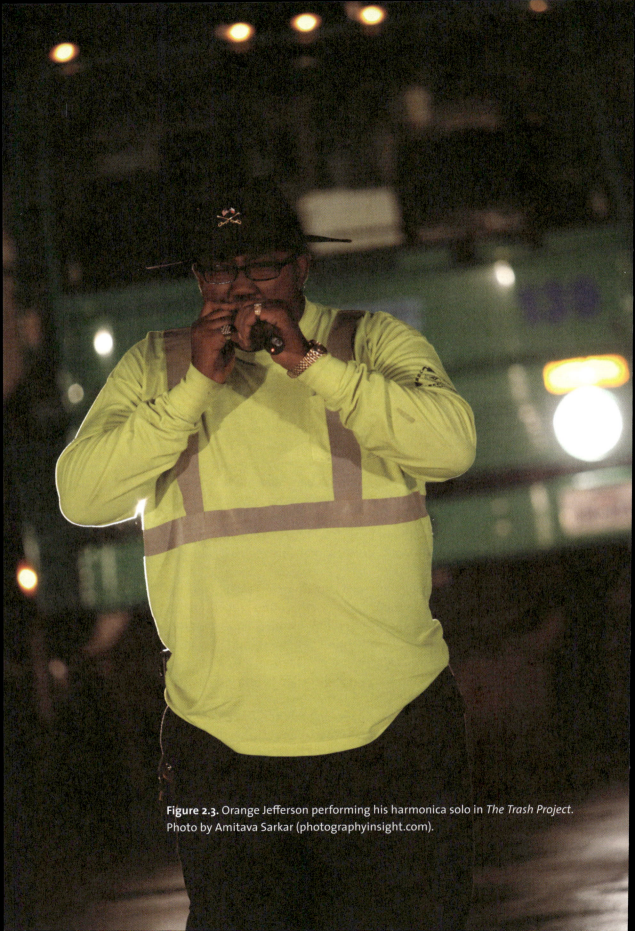

Figure 2.3. Orange Jefferson performing his harmonica solo in *The Trash Project*. Photo by Amitava Sarkar (photographyinsight.com).

worked to scoop up a pile, lift the pile, and drop it into the bed. He shook his arms to show how he bumped the bed to make sure all the debris had fallen out of the bucket, and he even opened his fist to show the bucket tilting back. I was mesmerized as I watched his solo unfold right before my eyes.

Luckily, Gerald was up for the show. "I love teaching and finding a way to show people things," explained Gerald: "I was honored to be asked to participate, and I wanted to do my part to make the show a success." Gerald told me that working a pile just right was like being a boxer—going in precisely for a punch. A recording of his poetic description accompanied his solo, which he performed sitting on top of his bucket truck.

A few people did volunteer outright, as was the case with crane operator Don Anderson. I had seen the crane, or grapple truck, in action on a bulk pickup ride-out. With a claw that could extend up to sixty feet on its boom arm and rotate 360 degrees, it could move slowly, gracefully, and with precision, offering something that the trash trucks did not—drama and elegance. This machine simply had to be in the show. One afternoon, I was sitting outside looking through my notes when Don walked up to me and said, "I hear you're looking for someone to work the crane, and I think I am the man for the job. You want the best—well, I'm the best."

I was thrilled. Don told me to come by on a Saturday when he and his crew wouldn't be as busy, so we could get started on his duet with the crane. Out at the yard, Don began by showing me all the possible movements the crane might do. I shot some video and studied that. The next week, which was only about a month out from the show, I went back and we sat down to come up with a basic scenario together. After Graham saw our initial practice video, he recommended that he write music that featured violin. The delicate nature of the violin would mirror the movements of the crane, while also juxtaposing the common conception of this piece of heavy machinery. That made a lot of sense to me, and I thought the duet would work well toward the end of the show, since by then the audience would be open to seeing the crane as more than a clunky machine.

I explained to Don that I wanted this dance to be elegant, intimate, and almost romantic; I wanted to pull at people's heartstrings before the grand finale. I played him the music and he began to come up with some ideas. We talked it through with a lot of back and forth and came up with a loose sequence. Then we went out to the yard to give it a shot.

He climbed up the ladder on the side of the crane and buckled himself in, sitting in a chair on a small platform that would rotate as he maneuvered the crane. We placed the boom box near him on the top of the truck cab so he could hear the music. His whole crew came out to watch. Don slowly moved the arm out, opening and closing the claw as if to pick up a heavy load. He then began to play with timing, slowly taking the arm

all the way up and extending it straight up in the air over his head. For a climactic finish, he circled as fast as he could in 360 degrees, bringing the claw down at a diagonal as he spun in his chair, circle after circle. By the end, he had turned the crane into something much more than a machine. He had made it move partly like a bird, partly like an extension of himself. Standing out on the tarmac, his fellow crew members and I knew we were witnessing something quite magical.

Don told me he thought of it like a beautiful slow dance, with a careful beginning that moved into an almost unreal finish. Like many trained dancers, he had a story in his mind that helped him follow a movement sequence. As soon as he finished, we all huddled around my phone and watched the video I had taken. We knew it was going to work. Between that day and the performance, we had at most three practices together, including a rainy dress rehearsal, but that was enough for Don.

Not every section came together this easily. Sometimes I came in with movement ideas I thought would work, based on what I had observed over months of riding out. I had lots of ideas that didn't end up making sense — like to blow a bunch of beach balls around with the hand blowers (that was a particularly bad idea!). But exploring these ideas was all part of the process of generating content for the performance, and little by little we began to get a sense of the show. David and Jesse from Safety spent lots of time talking my ideas through and thinking about how to make them work better. They also attended most of the rehearsals, making sure that what we were doing with the machines was safe and up to department standards.

Sometimes I would ask questions and employees would try different solutions, and together we would piece together the choreography. All the movement was set very collaboratively; we would discuss and try different options to make the dance work well. I would also take video with my phone, and we would watch it together, each employee shouting out ways to make the dance work better. We practiced on the tarmac, and by August it was often approaching 100 degrees by 11 a.m. Jesse, David, and the safety crew set us up with a small tent, and with coolers of cold water and Gatorade, along with my battery powered jam-box, we pressed forward.

For the sections with multiple employees, we had to work hard to coordinate schedules for rehearsals in a way that worked for the employees and the job. I tried to work with each group three or four times for about an hour at a time. I had to be very flexible, as rehearsals would often be canceled if a truck was down or the employees I needed had to help get a route finished. In the last few weeks before the show, I was ready to practice any time I got the call saying the employees could meet. For street sweepers, rehearsals were often first thing at 7 a.m. For trash and recycling, it had to be after the routes were done, which would be between 1–3 p.m.

Figure 2.4. Don Anderson in his award-winning duet with the crane for *The Trash Project*. Photo by Amitava Sarkar (photographyinsight.com).

Figure 2.5. Shonda Johnson in *The Trash Project*. Photo by Amitava Sarkar (photographyinsight.com).

One problem I still needed to solve was how to include a job that didn't demonstrate a straightforward choreographic solution: Tony and the work of dead animal collection. I knew I wasn't going to stage him picking up a dead animal, but his story had to be part of the show. It was important to me to communicate the relationship between Tony and the pet owners he served. I remember thinking that he and his truck were a little like the River Styx—a middle ground marking the transition between life and death. With Graham's help, I landed on the idea that Tony and his truck could be a theme repeated three times. Tony was such a good storyteller, and I imagined hearing him talk about his job while you watched him drive his truck across the tarmac. Each time he appeared, you would hear a little more of his story, and by the end of his three episodes, you would understand his job.

Tony was up for it, so one hot July day, we sat down in the break room at the end of his shift so I could record an interview with him. He talked about spending time with his family in the country growing up: "We were always doing something, pickin' pecans, having chinaberry fights, just havin' fun." He described what he liked about his work, how he tried to comfort bereaved pet owners, and told a story about a little girl and her family who had notified the department they had lost their dog. The dog didn't have tags, but Tony knew he had found it when he picked up a dead dog fitting the dog's description and with a pink, rhinestone collar. He gave the collar to his supervisor, and they were able to use that to identify the dog, giving the family some closure that the dog had died. In a section that played during the show when he drove across the tarmac his third and final time, he said: "I love my job. It gives me peace of mind knowing that I'm doing something. I wouldn't go to recycling, yard trimmings, or anything else. My name is Tony Dudley Sr."

■ The week of the show was finally upon us, and there was a definite buzz; we were featured on local radio shows, TV news interviews, and in a front-page above-the-fold feature in the *Austin American-Statesman* newspaper. The PR/marketing department at ARR placed ads in both English- and Spanish-language media and sent out press releases. Posters had gone up at the yard and all over the city. Val and her fellow HR staff set up an info table at the service center and talked to employees about coming to the show—it was free and didn't require a ticket, but we wanted to make sure that as many employees and their families as possible could attend.

The production team had its hands full, too. By Tuesday, Stephen, Tamara, our sound operator Bill Meadows, and their crew were out on the tarmac loading in sound and lighting equipment. We borrowed bleachers for an expected audience of eight hundred from the Parks and Recreation

Department, and Jermain Defreeze, building manager for the service center, developed a detailed plan with Tamara on how to set them up, as well as the tables and chairs we needed for our staff meal, production crew, and merch table. Other last-minute details included finishing the show program, which featured short employee bios; tracking down props; and, with the help of supervisors and vehicle manager Jimmy Miller, creating a vehicle checkout list for the show. Many of the employees had specific requests for the trucks—or, in Don's case, the crane—they liked to use, and we needed to make sure everything was washed and ready to go. Jesse and David from Safety wisely recommended that we have a mechanic on duty just in case a truck went down during the show—something that never would have occurred to me. It was a full departmental effort, and meant that many people who were not cast in the show itself still participated.

I was used to thinking of Forklift as moving from an "I" to a "we," but with *Trash Dance*, that carried beyond artistic vision and on into the concrete work of building capacity. The large scale of the show, in terms of stage space but also regarding numbers of performers and sections, meant that I needed help pulling it off. For the first time, I brought on a team of rehearsal assistants—Ashley Card, Leigh Robbie Gaymon-Jones, Christina Houle, and Molly Roy—paying them a small stipend. These women were dance majors at Austin Community College (ACC), where I taught on the dance faculty. They knew how a show worked, and about a month out, they started coming to rehearsals, learning the dance, getting to know employees, and helping prepare cue sheets and written materials for the cast. During the show, they were either in a truck or positioned somewhere backstage. I cued them on the radio—we borrowed about a dozen handhelds from the sanitation department—and they made sure that the employees made their entrances on time. They also worked one-on-one with cast members who needed extra support, coaching and guiding them with the choreography.

Leigh shared her reflections with me on her role in *The Trash Project*. "I was kind of like a space holder, somebody who had walked the road of performance before," she explained. She would help the performers prepare, giving them cues, tips, or reassurance. "It was chaotic at times," Leigh continued. "There was a whole lot going on and there was a lot that could not go according to plan. So my role was also to keep saying, 'Yeah, but it's cool. We're cool.'" Leigh, a Black woman raised in Austin, also spoke about what she brought to the cast as the only Black rehearsal assistant. "I remember interacting with the men the way I relate to my uncles. When they were nervous, there were certain things that I felt I could read and engage with that I don't imagine I precisely was hired to do. That was something else that fell into that bucket of being a support and a guide for folks who weren't as experienced with performing."

Leigh improved the quality of our work through her attention to people, process, and detail, and we continued to work together after *The Trash Project*. Our relationship taught me more about how to share leadership, delegate, and support other artists. She worked as an assistant choreographer on a 2012 Forklift performance with a hundred teen and preteen girls, and became the lead creative movement teaching artist at one of our partner preschools. Leigh went on to study with Urban Bush Women and Liz Lerman, earn three degrees, direct youth leadership programs in urban farming, and work as an adjunct professor. I am proud and inspired by Leigh's ongoing achievements as she has taken the principles of collaborative artmaking and interdisciplinary arts into arenas of youth education, community development, and environmental stewardship and sustainability.

■ On the Wednesday before the show, we had an all-cast meeting at the yard at 6:30 a.m. This was the first time all twenty-four participating employees were in the same room together, and a feeling of excitement was mixed with some palpable trepidation. People cracked jokes as I handed the employees folders with a show overview and their specific parts written out. Those who wished to study this carefully could, but they could also figure it out at the single, all-group rehearsal scheduled for Friday night. Val gave lots of encouraging words, and then we talked about the weather. It was forecast to rain—a lot.

The rain would begin later that Wednesday and wasn't supposed to stop until Sunday. Ironically, central Texas was in a drought, and it hadn't rained in Austin for months. We had decided early on that it wasn't possible to have a rain date. I didn't have the budget to cover that, and many of the employees wouldn't have been able to commit due to second jobs. We had to find a way to make Saturday's show work. When we talked Wednesday morning, the employees agreed they were fine to perform in the rain, since they work in all kinds of weather anyway. As long as there wasn't lightning, the safety folks agreed we could proceed. We settled on a possible rain delay, if, for example, a half hour could keep us out of the heaviest downpour, but we agreed that the show must go on.

At Friday night's dress rehearsal, we somehow managed to stumble through the whole show top to bottom, working as fast as we could to wrap things up before the rain—steady but still manageable—was due to increase. Many of the employees told me this dress rehearsal was the first time they really understood what being in this show meant. "When Graham started playing the music," remembered Anthony Phillips years later, "everybody at that moment got on board." Still, lots of things went wrong. Trucks couldn't make their entrances or exits in the ways I'd envisioned; employees didn't understand their cues; and my entire idea for

the ending had to be changed. I had drawn up an elaborate plan to get all sixteen vehicles lined up for the ending, which involved backing vehicles toward the audience. As soon as I started teaching it, I could tell I was in trouble. Backing up a trash truck isn't something that the operators are encouraged to do for safety reasons, and this plan was clearly going to take longer than the five minutes I had set aside for the finale. Huddling with Stephen plus David and Jesse from the safety team, we determined a simpler and more effective ending: having two vehicles enter from opposite sides at the same time, arch up away from the audience, and then come forward to park in sync, headlights facing the crowd.

On Saturday morning it was, of course, raining. After confirming with Safety and departmental leadership that we could proceed, my part-time office assistant sent out an email blast telling our audience to come out prepared to get wet: "If these employees can work in the rain, we can watch them in the rain for one night." I wasn't optimistic a big audience would show, but I knew our only choice was to move forward. That afternoon, the full cast and crew gathered for a last run-through, fixing many of the problems from the night before, and a cast meal. Then we circled up, and Don Anderson reminded people, "We have worked hard on this, so let's be professional." Gerald Watson said a prayer: "Lord, let us be at our best. Help us if we fall short on thinking straight, think for us. If we make a wrong move, move for us."

Around 7:45 p.m. Tamara called me on the radio: the show had sold out, and we had reached our safe capacity for seating. I was stunned. More than eight hundred people had already lined our bleachers, with hundreds more set up on the ground dressed in rain slickers and huddled under umbrellas. We had at least a hundred people lined up outside the gates and cars backed up for blocks waiting to get in. For safety's sake, Tamara made the tough call to shut the gate. As my brother-in-law swung the gate closed, he had to talk people down who began chanting, "Let us in! Let us in!" We just couldn't safely accommodate more people, even though many people did get in by hopping the gate and sneaking in a block or so down. Tamara estimated that we ultimately had close to two thousand people at the show.

A little after 8 p.m., Tamara radioed, giving me the OK to begin. I took my seat in rain-soaked cargo pants next to Graham and his two fellow musicians under a small pop-up tent, positioned in the center of the stage between the bleachers. I set my damp notebook on the music stand in front of me and went through my pre-show checklist, smiling nervously at the audience members behind me. Confirming Stephen was ready and employees were in place, I took a deep breath, looked at Graham, and gave him the go-ahead to start the overture.

Just at that moment, the sun began to peek through the clouds, setting

the tarmac ablaze with golden light. Throughout the planning process, *Trash Dance* director Andy Garrison had pleaded with Stephen and me to wet down the tarmac for dramatic effect, but it struck us as completely unrealistic. How could we justify using that much excess water, when we were in drought? Now I saw why Andy had been so convinced. The water reflected Stephen's gorgeous lighting design, mingled with sunshine. Introduced by a series of triumphant musical chords, the trucks began to parade out, one by one, gleaming. As they circled in front of the audience, they were met by enthusiastic cheers.

After the trucks took their places on the sides of the tarmac, we moved into the heart of the dance. A section for two rear-loaders and four operators showed the graceful work of tipping trash carts. A quartet for the elephantine automated trucks got the audience laughing as the operators deftly moved the robotic arms to the music. Don Anderson's duet with the crane inspired a collective gasp. Everything was unfolding as planned: Orange Jefferson's harmonica solo; the practiced safety gestures; Anthony Phillips's breakdance; Virginia's strength and speed as she hurled bags into a traveling rear loader, Ivory Jackson's rap; a meditative trio for street sweepers Mark, Jennifer, and Orange; Gerald's solo; and, punctuating it all, Tony Dudley's three passes across the tarmac.

At the end of the show, in the entrance we'd just honed the night before, the trucks drove in two at a time from opposite sides of the stage space. They crossed in the middle and circled around to park on opposite sides, eventually forming a line of trucks facing the audience. The pattern of the trucks delightfully reminded me of the elaborate horse ballets of Louis XIV, something I realized must have been deep in my brain from studying those old ballets. Once all the vehicles had arrived, the operators began honking their horns as the audience rose to their feet in applause. I wanted to end the show with one final recognition of the employees, and so as the music ended, the operators silenced their horns, turned off their vehicle headlights and turned on the cab lights in their trucks—lighting up their faces for the audience to see. In the quiet, I then played one last recording, the voice of longtime employee Steve Dixon, who had also opened the show with words from this same interview, saying, "It's an honest job, it's a good honest job." Graham and the musicians then played a final chord, bringing the show to an end.

The audience, many already standing, let out a roar of cheers, clapping loudly. The employees lined up to take their bows and I ran out to join them. Holding hands, we bowed multiple times, and then fell into a group hug overcome with emotion, many of us, including me, with tears in our eyes. The audience lingered for nearly an hour, collecting autographs, shaking hands, and thanking the employees for their work and remarkable performance. Children climbed in and out of the truck cabs

Figure 2.6. Opening quartet from *The Trash Project*. Photo by Andrew Garrison (trashdancemovie.com).

with help from employees, and people had their pictures taken with their favorite performers.

At the end of night, Tamara, for her part, looked me squarely in the eyes and said, in her most serious voice, "Never will you do a show like this again—with this inadequate budget and without more infrastructure. Your audience has outgrown your organization. You need to catch up!"

PowerUP
A Dance for Electric Utility Workers

It was hot—unbearably, sticky, Texas-in-July hot—and I was two months pregnant, nauseated and exhausted. I had dragged my husband and four-year-old daughter thirty miles southeast of Austin with me for the annual Seguin Lineman's Rodeo of 2010. They came begrudgingly, as it was an early Saturday morning, but as we approached the rodeo grounds, we collectively let out a gasp. In front of us were more than seventy-five wooden utility poles, spread out in a perfect grid, teeming with line workers—climbing up, suspended at the top, or stepping down the poles at a breakneck speed.

I had been talking with the leadership of Austin Energy, Austin's publicly owned electric utility, for over a year about collaborating, but I had yet to get close to linework. A number of people at the utility advised me to go watch the Austin Energy rodeo team compete in Seguin to see what the work entailed. Out on the field of poles, line workers worked in pairs, one at the top of the pole, changing out equipment and sending material down a rope, or handline, to the man on the ground. Others raced through solo speed climbs, shimmying to the top of the pole, grabbing an egg and placing it in their mouths, and then carrying it down to the ground without cracking it—all in under thirty seconds! I noticed how the line workers called out to each other, giving commands and directions from the top of the pole or shouting from the ground, "You got ten seconds—hurry up!"

This was clearly a community that understood time, space, and movement, with a sense of spectacle, grandeur, and massive coordinated action—"One hell of a show," I remember saying aloud, "just waiting to happen." I thought back to my early days on the drill team. Add some lights and music, I thought, and we could make an epic, only-in-Texas, dance power extravaganza!

Over the next few hours, my family and I took in the scene. Hundreds of competing line workers filled the grounds, dressed in jeans, hard hats, and matching, long-sleeve work shirts emblazoned with the names of their teams. Their families were there, too, cheering from the sidelines,

checking the timekeepers' work with their own stopwatches, and wearing T-shirts with "I love my lineman" and "Keep Calm and Climb On" written across the back. All men, from what I observed, these line workers clearly were a special group—for they risked their lives every time they showed up to work. This fact, along with observing the linemen with their families, each at their own tent, hanging out, listening to music, or preparing for the BBQ cook-off—inspired me. This seemed like one big extended family, and I just had to figure out how to talk that family into making a dance with me.

■ A dance with the people who keep the lights on had been on my short list of possible projects for a while. Austin Energy (AE) is one of only a few municipally owned power companies in the state of Texas, with a reputation for community involvement, so I was hopeful that they might be interested in working with me. A family friend named Neil Ashmore, who worked at AE, had seen *The Trash Project* in 2009, and understood how I collaborated with people who didn't think of themselves as dancers. Neil recommended that I reach out to Jeff Bradford, who then was a supervisor of distribution construction and maintenance, respectively the manager over field operations, for the north side of AE's territory.

Jeff welcomed me to his office with a warm handshake and offered me a seat. I was struck by his Texas twang, baseball cap pulled tight around his red hair, and the farmer's tan on his fair skin from many years of working in the sun. I could tell he had been raised to be polite, which is probably why he hadn't turned me away when I asked for the meeting. He listened attentively as I described what I had done with the fire and sanitation departments, dropping an occasional "yes ma'am" in response to my questions. But I could tell he was skeptical. Years later he laughed as he reminisced in a circle of his colleagues: "I thought there was no way this was going to work. This lady has lost her *freakin'* mind. There are some weird people in the city of Austin and now here is one of them—she done found me!"

Over the next few months, I kept showing up to check in—or, as Jeff remembers it, "You just weren't going away." I had seen the team in action at the rodeo a few months before, and the little more of the work I saw hanging out at the yard told me that we would be able to make something grand. We'd have some awesome machinery to work with, and the employees I had met so far had a real sense of pride and a strong work ethic. Many of them had come to the job because their fathers, brothers, or cousins had been linemen. And I had seen the wall of awards and trophy case displaying AE victories at past Lineman's Rodeo events, including prizes for "Best Speed Climb," "Best BBQ Brisket," and "Best Beans." It was obvious that they had talent and spunk, and I looked for ways to reflect that back to them.

Eventually, and somewhat reluctantly, Jeff let me give a short presentation to his crews. "I talked to the linemen in advance," he explained. "I said, 'This lady Allison Orr is going to come talk to you guys, and what she is talking about—it isn't a joke.'" But he was struggling with the idea, he recalled: "I thought there was some potential, but I didn't know how to coordinate this. I mean, is this even a possibility?"

I remember that first meeting with the crews well. I walked into a room of fifty or so burly linemen sitting at tables with empty expressions on their faces. As the only woman in the room, I felt like a total outsider. I began to talk about my previous work with city departments, and how it had successfully educated the public. Not one of the guys cracked a smile. I spoke about the potential to teach Austinites about the dangerous and invaluable work linemen do on a daily basis. Still no response. I then showed a short clip from *The Trash Project*. After an awkward silence, one of the linemen said—in a loud Texas drawl, from the back row—"Now our dance is gonna be *better'en* that one!" The room exploded in laughter and I felt a little bit of hope.

I knew it seemed ridiculous. "Linework isn't really synonymous with *dance*," remembers participant Patrick Blackburn. Benny Ray, another lineman, later reported that he worried that I might ask them to "dance on a pole." But I loved the challenge of standing up in front of these tough guys proposing that they make a dance with me. My grandparents were farmers and came from small-town Texas; the mostly White, working-class men at the yard reminded me of that branch of my family. I could relate to their love of work and "get 'er done" attitude—a way to survive a job that might make you get up in the middle of the night, in all kinds of weather, and work in dangerous conditions until the power is back on, no longer how long it takes. I respected their fortitude and tenacity, which I connected to, knowing what it took in the weeks leading up to a show. At the same time, I was clearly an outsider. A liberal artist who grew up in affluent West Austin, I knew from the beginning that the linemen were going to have a hard time accepting and trusting me. I was basically entering a giant man cave.

Working with the fire and sanitation departments, I'd had some practice walking into places and acting comfortable, even like I belonged there, no matter how I actually felt. But there were women in leadership positions at those other departments, as well as women who operated heavy machinery and put themselves in harm's way—none of which was true at AE. I did enjoy bonding with the women in the AE admin offices—we had lots of good laughs. But I had to prove myself to the rest of the department, and they had to get used to having a woman in their midst. Sexism plays out as a double-edged sword of sorts—some men would dismiss me (initially or for the long term) while others seemed readier to

engage with me politely because I was female. This meant I had to invest more time in relationship building, taking the process slow and showing up early, consistently, and ready to work.

For now, the meeting left me hopeful. Lineman David Teltow later recalled, "You showed up at that first safety meeting and of course no one heard a word you were saying. They were all just looking at you, thinking, 'Who is this blonde lady?'" But David was interested enough in talking with me that I wrote his name down in my notebook, along with a few others, as possible participants. David explained, "I thought your project had potential because it could give people insight into what I do and why I am so passionate about it. We do a dangerous job. It could be a one and done. To get more appreciation for our line of work, that seemed like a good thing to me." David couldn't really imagine what the final product might look like, he said. "But I thought maybe I could help you out and we could represent ourselves in a fair and accurate manner."

The chance to represent themselves on their own terms—that was what I was offering. I needed to tap into the linemen's pride to get them excited about showing people how impressive their jobs really were. Now I needed to sell the idea to the higher-ups. It was time to meet with the executive team.

■ Convincing leadership to invest time and money into the making of a dance was my biggest challenge, both at the beginning of the process and as the project progressed. Fortunately, I had some help. Carlos Cordova, project lead for corporate communications at the time, had years of experience working inside AE, and took me under his wing early on. Later, he told me why: "All organizations have trouble with communications, all have challenges with employee morale and getting people engaged. Your project let the public hear from our employees in a positive way—that was always your selling point." Carlos provided invaluable counsel about exactly how and when to approach key people who could advocate for the project. First up, Carlos said, was Cheryl Mele, then AE's chief operating officer.

Cheryl welcomed me with a firm handshake into her corner office with a view of downtown Austin. When I showed her a clip from *The Trash Project*, she lit up. "I understood from you personally that you were going to find the story to be told and put the spotlight on my team at AE," she explained years later. Unfortunately, Cheryl was about the only person in leadership who was sold immediately. Dan Smith, then the director of substation and transmission at AE, who I met later when the project was a go, shared his initial reaction: "I was really not able to visualize or understand your idea. It was just not computing. There was a lack of concreteness, especially from someone [like me] who comes from a very engineer,

practical, concrete perspective. Why? Why are workers going to be at all interested in this?" Luckily for me, Cheryl pushed back on responses like Dan's that she got from fellow leadership. Many years later, Cheryl told me some of what she had shared with her fellow executives: "Let's not make the decision for our employees. Let's let them decide for themselves."

Cheryl set up a meeting for me with David Wood, vice president of Electric Service Delivery, and his leadership team, in July 2011. This was a group of eight engineers, all of whom were men, and I knew it was a do-or-die meeting. I began by thanking everyone for their time and then gave a short presentation about Forklift, showing photos and footage from *In Case of Fire* and *The Trash Project*. At that time, we were two months away from performing a remount of *The Trash Project*. The employees and I had built such meaningful connections, and our reception had been so great, that it almost seemed a given we'd do it again. I shared the good press we had gotten, and our goal of having four thousand audience members see this encore performance over two nights. I talked about what benefits something similar could bring to AE, quoting past city employees and leaders who had worked with me. I also showed sections of my dances that focused on the stories of the individual employees—I wanted this group to see how our performances showed the human being behind the job.

One engineer asked me, "I understand what it might bring us, but what does this bring you?" The dance, I said, could make me a millionaire many times over. This made the room laugh a little. Then I explained that even though I would have to fundraise for the artistic costs, believe it or not, I really enjoyed the work of showing audiences the art inherent in something not usually thought of as dance. I also loved the chance this would give me to embed myself within another work culture, learning about a part of the world I knew little about. If they agreed to let me try, we could make a show like no other.

Slowly the group began to talk about what this project might do for AE. They were interested in two key things: the opportunity to educate the public about the work of AE employees, and the way the project might get groups from across the utility company working together. At the Lineman's Rodeo I had witnessed the pride people had in this job as I watched the way the line workers and their families cheered and rooted for each other. I knew we could celebrate that. But the management team was very clear that if this happened, the performance had to be about *all* of Electric Service Delivery—not just the distribution linemen. At that time, I didn't know anything apart from the little distribution work I had seen, but I took notes as the team explained we had to include Network, Substation, Engineering, Relay, Transmission, Distribution, office staff, and training. Without really knowing what I was agreeing to, I said yes. I was not about to give them a reason to back away!

Trying hard to convince them, I shared my desire to celebrate and honor the work along with this once-in-a-lifetime opportunity for me to direct the kind of show only they as utility workers could perform. This would be the biggest project I had ever done, and I said—appealing to their sense of competition—we could easily reach an audience of five thousand or more, topping turnout for *The Trash Project*. At that point, David Wood planted his fist on the table and boldly exclaimed, "If we do this, then it has to be the best thing anyone has ever seen!" The men around the table nodded their heads in agreement.

At that moment, a man across from me raised his hand and declared, in a booming voice, "I would like to volunteer to be Allison's liaison, because this would marry my love of dance *and* electricity." Stunned, I tried to figure out whether I was being played. I'd noticed this man when I came in—he'd smiled at me, and an empty notepad in front of him suggested to me that he might be both serious and interested. Now, he introduced himself as Sonny Poole, and explained he had been a professional square dance caller—one of the best. *What?!* I was jumping up and down inside! The meeting closed with David Wood and his fellow engineers agreeing to move forward, with Sonny leading the way on drafting a timeline and budget with me. Dan Smith later told me that after I left the room, Sonny told his fellow team leaders, "I have been waiting for this chance my whole career!" After months of uncertainty, it was clear that I was moving forward.

We settled on a performance date in September 2013, which would give me two years to fundraise, and ensure that *PowerUP* was at the center of our annual city arts funding proposal. Forklift had continued to expand, and I now had a true choreographic partner: Krissie Marty. I had met Krissie in 2010, when she moved to Austin from Washington, DC, where she had also worked with Liz Lerman's Dance Exchange. Krissie had a deep understanding of community-based artmaking, and I was eager to have her work with me at Forklift. First, she did so for free, helping me remount *The Trash Project* in 2011. I had just had my second child, and we were rehearsing on the tarmac in the August afternoons, where it was probably more than 110 degrees. Krissie brought cold water and tuna fish sandwiches, and forced me to eat and drink. When I needed to run home to nurse my son, she kept rehearsals moving forward. She also fixed some of the choreography, elegantly cleaning and trimming a couple of sections that had long perplexed me. She reworked the overnight crew's section, taking out some movements with blowers that never really worked, and adding in more choreography for break-dancer Anthony Phillips. She refined Gerald Watson's solo with his front-end loader, and tightened up the street sweepers' trio. Krissie volunteered through 2011, was paid a stipend in 2012 to work on some small projects, came on as a part-time contractor in 2013, and finally became a full-time employee in 2014.

Apart from being a great dancemaker, Krissie is a systematic thinker and an extremely hard worker. She brought a new level of organization to the teaching of choreography and the entire production, and she never grimaced at our 5:30 a.m. call times or rehearsing all day in the sun. With her partnership, the scope of the dance widened and the quality of the artmaking improved. Having a partner in Krissie meant that I never felt alone—I had someone to think through ideas, vent with, and process what went on in rehearsals. We rehearsed sections simultaneously, looked at video to troubleshoot problems, edited show text together, and brainstormed dance solutions late at night on the phone or early in the morning on the way to practice. She worked closely and easily with linemen and other employees, too, including a group of women engineers, designers, schedulers, and administrative staff whose contributions she helped spotlight in one section of *PowerUP*. Her presence improved not just the dance but the whole group's experience, and I couldn't have dreamed of a better partner.

▪ By early 2012, with help from many supervisors, I began riding out. Krissie joined me as she could, as she was still juggling other part-time work since Forklift was still not her only job. Eventually, she and I made our way to all the work teams at AE: fourteen separate groups including distribution north, distribution south, streetlight, network, relay, transmission, substation, design, dispatch, troubleshooters/on-call crews, metering, system control, training, and admin. I knew I was fighting a lot of skepticism and discomfort. I did have a few interested linemen, but most were very wary, which meant I was going to have to hang out, and ride out, a lot. But I tried to show up at each location, or yard, every week—even if just to say hello or shoot the breeze. Hard work and commitment to the job were part of the line workers' creed, so I knew persistence mattered. One lineman told me later: "You were like a bug that would never go away." Another described me as "seriously driven." By showing up time and time again, I was honoring their work and finding my way into it.

Apart from early morning ride-outs, I studied all I could about linework. There was so much to learn, and I could barely keep up with all the vocabulary I was hearing at the job. Jeff Bradford told me to pick up a copy of *The Lineman's and Cableman's Handbook*, which I kept by my bed, picking it up every few nights over many months. I read about safety procedures, how to rig and string wire, and learned the names of basic equipment like bolt cutters, cable crimpers, high-voltage hot sticks, ground rods, and steel hooks for climbing poles. Soon, I was noticing all the power lines in my neighborhood and along the roads when I drove around the city—I couldn't stop looking up! I also attended as many social gatherings held by the utility company as I could. I even made it to

Figure 3.1. Austin Energy employee D. K. Kellogg giving Allison a tour of a substation. Photo by Sarah Fusco.

two Thanksgiving meals on a single day, at both the south and north yards —first, because I never miss a chance to share a meal with collaborators (it's one of the best ways to build relationship), and second (perhaps more importantly), because if I was going to one, I had to go to both. As Allen Small, who was then distributor director at the south location for AE, explained, "There's always been some kind of angst—officially or unofficially—between the two distribution yards." Linemen, I learned, are a competitive bunch.

Jeff recommended that Krissie and I take climbing class in order to really understand the work. New line workers take a team-taught, four-week class on pole climbing, and Krissie and I were given permission to attend for the first week. Our primary teachers were Eric Olenberger and Ray Cook. Standing nearly seven feet tall, and full of enthusiasm for teaching about electricity, Eric seemed to fill the whole room. Krissie and I loved his lectures, and we'd hang out after class was over to ask more questions.

Ray Cook was our lead climbing coach. Ray was in his fifties, but—tall and trim—could still climb up the pole with such grace and ease that his fellow linemen nicknamed him "Baryshnikov on hooks." As dancers, Krissie and I could understand the mechanics of climbing pretty quickly, but the physical strength it required was daunting. We wore harnesses so we couldn't fall and hit the ground, though there was still the risk of smashing our faces into the pole. Ray's sweet smile and persistent encouragement helped us face our fears. "I remember how timid you were," Ray told me later on. "A lot of times, in your mind, you were fighting us, not always trusting what we were saying. But you kept listening, kept listening, kept listening . . . and at the end, you made it to the freakin' top!"

He was referring to our third day of climbing, when I made it up the 45-foot pole myself. My legs and feet were aching, and I have an intense fear of heights—or, as Ray says, a fear of falling—but by the middle of my climb, when I hadn't slipped or "cut out," I just decided that I was going to go all the way up. Ray and Eric, along with the other linemen, started cheering me on. Once I got to the top I wanted to come right down, but Eric yelled out: "Relax! Let your shoulders down and enjoy the view." I was surprised to feel the pole swaying, which did little to lessen my terror.

Krissie had smartly whipped out her phone and filmed my ascent. When it was time to start presenting at each yard's large-group safety meetings to recruit performers, I nervously projected Krissie's video. To my utter surprise, the linemen in attendance hollered out shouts of encouragement, chimed in with tips and comments on my technique, and, as they watched me make it to the top, some even cheered. It was then that I knew that my months of riding out were paying off. I'd shaken hundreds of hands, visited all the work groups, learned what I could about

their jobs and been present in their space, and, finally, proved myself at a physical level. Now, more of the linemen were beginning to take me — and the project — seriously.

■ Making *PowerUP* required Forklift to scale up as artists, for the project required more planning and coordination than any of our previous projects. We learned to use the unique resources the utility provided, and to ask for help — lots of help. Because linemen would be climbing, our set had to be engineered and approved to meet department safety standards, an extra step I had not encountered before, and that required me to make decisions about choreography much earlier in the process than usual. Leadership had agreed to a September 2013 date; now we needed a site, and a very specific one at that: about three acres of empty space where we could install power poles and bleachers, plus parking for at least a thousand. We hoped to get it for free.

Former square dance caller Sonny Poole led the way; as head of real estate and public involvement, he knew what the land options were throughout the city. By late 2012, having looked at dozens of places, we found the perfect spot — the Travis County Exposition and Heritage Center. The Expo Center was accustomed to hosting huge events like the annual Austin Pro-Rodeo, so we knew it could accommodate our parking needs. It took a couple of months of talking with the staff and a personal meeting with the county judge, but eventually Travis County granted use of a big field on the north side for a much-reduced fee, and allowed us to install our set months in advance so we could practice. To top it all off, Decker Power Plant and a line of transmission towers sat in the distance, framing the space and suggesting the larger systems in which the AE workers were embedded.

Everyone wanted this show to be big. Stephen, our production designer, mapped out a site plan that accommodated three thousand people per night. With an invited dress rehearsal and two shows, we could seat nine thousand audience members over the weekend. We needed to create a stage that would give all the work groups the chance to show their work in the most authentic way possible. Stephen began drafting a plan with 45-foot wooden poles positioned around a gigantic site — 350 feet wide by 500 feet long — and together he, Krissie, and I made lists of possible equipment to use, along with ideas for choreography for each work group. I started with the movement ideas that were most obvious to me, took my ideas to each group for feedback and refinement, and learned to play the teams against one another to increase their ambition. I knew the distribution linemen could do lots of climbing and hang a line using bucket trucks, for example, and when I mentioned this to transmission construction and maintenance superintendent Jesse Esparza, he told me

Figure 3.2. Austin Energy instructor Ray Cook with Allison at climbing class. Photo by Krissie Marty.

that if Distribution was climbing, Transmission was, too. Due to the intensely competitive nature of the linemen, and much to our delight, a 100-foot-tall repurposed transmission tower was soon found and set aside for our show.

We knew the music needed to match the awesome scale of the stage and the work performed upon it. Graham suggested a full string orchestra, which immediately felt right to me. I invited my friend Peter Bay, conductor of the Austin Symphony, to conduct, and he accepted enthusiastically. Peter explained that working with a live orchestra would bring a new set of challenges: they can't stop suddenly or move quickly into a new musical idea the way a small group of musicians can. To build in more flexibility, Graham and I decided to divide the dance up into sections—some that the orchestra would accompany, and some for which Graham and a smaller, core group of musicians would play. The orchestra sections had to be exact and timed well in advance—as did our choreography. Krissie and I had to make choreographic decisions much earlier in the process than usual, to be sure the movement fit what Graham was writing for the musicians.

The production budget for *PowerUP* was the biggest in Forklift's history: $110,000. That included artist and design fees, cost for the string orchestra, production and tech crew, along with cast meals, extensive lighting and equipment rentals, the site fee, and insurance. Sonny convinced AE management to underwrite time for fifty field crew members to participate, as well as the cost of the bleachers. My board was led by a fundraising professional, and she crafted a development plan and helped me implement it. We secured $13,500 in business sponsorships, and for the first time, $55,000 in regional and national governmental and foundation funding. With Krissie's help, we also did a Kickstarter online fundraiser and held a fundraiser at a donor's home, raising $26,800. With $11,500 in online and door donations plus $3,200 in merchandise sales, we hit our target.

We did hit some precarious moments in 2012. As a publicly held utility, AE is frequently under scrutiny during our state legislature session, and a proposed rate hike set off a fair amount of public debate. Critics were examining the utility from all angles, and AE leadership was concerned that the public would consider our project to be a waste of taxpayer dollars. I had encountered some of this before, when a pair of early morning DJs on a local Austin radio made fun of *The Trash Project* as one more ridiculous thing that the city was spending money on. That blew over, but there were a few months when I wasn't sure AE executive leadership would continue to move forward with the project. I enlisted some help from a local city council member, who called AE leadership to express her support for the Forklift project, and I know I had some allies in

AE leadership who went to bat for this project. It was a huge relief when, by the end of 2012, they assured me that the project was safe and we were good to go forward with a September 2013 show.

■ That spring, Sonny informed me that all of my choreographic ideas — or, as we called them in lineman talk, "events" — had to be approved by him, the heads of the departments, *and* Safety. I had never been asked to send my choreography up for approval before, much less months in advance of a show, and at first I was annoyed. But I quickly learned that this could work to my advantage because now supervisors *had* to meet with me to talk through ideas. I also had to work with them to determine the participating cast, respecting the command and control structure in place — a hierarchy that had been established to keep the utility functioning safely. I learned to work with seconds, the people who actually go and get things done for the people in charge, like Jeff Trevino, who, because he managed supplies and materials on the ground, called himself "the man in the rear with the gear."

In my experience, it's important for those of us collaborating with large institutions to understand how they work, and to develop the project in alignment with their processes. Yet *PowerUP* subtly challenged the culture at AE, too, in that it required collaboration between groups that typically didn't work together. Before we could rehearse, we had to build the stage — which now included eighteen distribution poles, two underground holes, and one towering 100-foot-tall metal transmission pole. This demanded a lot of coordination across departments, as well as between the north and south distribution yards. As Allen Small recalled, "We tried to bring in people from both yards so that they could see each other and work with one another." He called such collaboration "rare"; I sometimes wanted to call it family therapy. I would talk about the set design with Jeff at the north yard and then run down and talk to Charlie Pease at the south yard, who was the distribution superintendent. Charlie would mention something I hadn't thought of, so I would run back up and talk to Jeff or David. I went back and forth like this for a while, until I finally got everyone to sit down together to confirm the final plan. I'm happy to say that after the show, these leaders continued those meetings, allowing for better coordination and communication between the yards.

When install day arrived, I was in awe of how expertly the twelve linemen from Distribution put everything together. The ground had been measured and the pole positions had been marked with spray paint. The linemen used a huge pressure digger to make the holes into which, with the help of a boom truck, they placed 45-foot poles in the ground, one by one, until all eighteen poles were up. Later that week, transmission came in to set their tower, and the underground crews installed their two

manholes. By the end of the week, we had our stage. Now it was time to start having rehearsals.

■ An image that guided Krissie and me throughout the process of making *PowerUP* was the countless hands that had to touch some part of the system for someone to turn on a single light in a house. We wanted audience members to leave the show with a new and deeper understanding of the enormous job of power delivery. We also wanted to represent the distinct culture of each work group. Distribution guys, the show-offs, were the core cast members. They were rowdy and loud and liked to do the rodeo competitions. They were also the largest crews in number and could execute a variety of choreographic ideas—including climbing up the 45-foot wooden distribution poles with their spurs on and flying up in their bucket trucks to heights of sixty-five feet.

The ten or so transmission or "high line" workers were quiet, a little shy, and struck me as deep thinkers. They built and repaired transmission lines, which run from the power plants to the substations, and logged long hours, frequently out in rural areas. They toiled at extreme heights, with gargantuan equipment and heavy lines that carried 345,000 volts of electricity; their jobs required them to be slow and considerate as they assessed tremendous risk. When I'd ask one of them a question, I sometimes would have to wait a minute or so as he looked off in the distance, took a drag off a cigarette, and then came back to me with a thoughtful reply. But they laughed hard when one of them took me 125 feet up in the air in their biggest bucket truck, nicknamed the Brontosaurus or "Bronto," and in pure terror, I had to sit down and grab the lineman's ankles. I knew we should show the great heights at which they worked, but, as a small crew that worked on multi-week jobs, often outside the city, rehearsal time was limited. Jesse Esparza, superintendent of Transmission, suggested that someone from Transmission free-climb a hundred-foot tower in the show, and Terrell Watson volunteered.

Substation was another small, tight-knit crew, divided into two groups, construction and maintenance. Substations reduce the voltage carried by transmission lines to a voltage that can be distributed to our homes and businesses. When I visited them, I was in awe of the towering power coils and numerous switches. My eyes got lost following the dozens of power lines leading in and out, and the constant hum of high-voltage power was unnerving. The technicians worked so close to lethal danger every day. I kept my hands in my pockets and stayed near the truck.

The movement of building and repairing substations didn't easily lend itself to choreography, especially when extracted from substations themselves. So, one morning around 7:30, I went to the substation maintenance crew's weekly planning meeting to solicit ideas. Using my tried-

and-true method of talking about their fellow employees to stir up interest, I enthusiastically explained how Transmission would be free-climbing a tower and Distribution would be hanging a power line to music. At least a few guys peered out from under their baseball caps, looking curious, and I asked them how we should show their jobs. I waited. Silence. A few shifted in their chairs. More silence. I began to worry—maybe this wasn't the right approach. But then a voice came from the back of the room: "Why don't we just roll in the mobile sub?" "What?" I exclaimed, "You mean you have a mobile substation?" "Yep," answered Johnny Martinez, a crew leader who had taken me out on route one day. "We have it just in case a substation goes down." The group murmured in agreement, and supervisor Todd Campbell piped up, "I'll take you over right now to see it, and then you can decide." When I saw the mammoth machine—fully loaded, sitting on two eighteen-wheel tractor trailers—I knew my decision was *Yes*.

The relay crew were detail-oriented individuals who worked inside the substations, which they called houses, installing, repairing, and maintaining the circuits that keep power moving from one place to another. They aligned and tested the positions of the relays—the switches that moved the power from one line to another—in what was effectively the nerve center, or brain, of the whole system. Unlike the boisterous linemen, the relay crew were understated, introverted, strategic, multi-step problem solvers. We bonded over our love of Thai food, and I became especially fond of Cindy Ellis, the only female field technician at the time. Cindy's sweet Texas twang made her ever-frequent cussing sound charming, and I loved listening to her and her fellow relay techs call through their charts during their daily checks in the relay houses. It sounded like number poetry to me, and I thought there had to be a way we could use that, and Cindy, in the show.

Network is a distinct group of ten or fifteen linemen who repair downtown Austin's underground power system, and who, as supervisor Aaron Hansen put it years after we worked together, were used to not getting the credit they were due. "We're underground—we're unseen. We don't do it for the glory. We just keep the lights on and nobody cares about us—until the lights go out, and then everybody cares about us." These linemen worked underground in tunnels, usually in tight, close quarters, often in the dark. Their work was nearly impossible for ordinary residents to see, and they had a formidable responsibility to ensure the downtown grid never went down. In these ways, they were unique even inside AE, and this seemed to bond them together. They also had something else distinct about their work culture—they were always cracking jokes. I seemed to never stop laughing with Network, and their playful spirit encouraged me to try something more comical with their section.

As we got deeper into ride-outs and began to conceive of each choreographic event, I realized that the dance was going to need some kind of narrative arc. Many of the employees wanted the literal work shown. This was a challenge I had met before, and even though I did remind the linemen that this was art, so it could be abstract, I took it to heart that they wanted the piece to be tethered to the reality of their work and the issues they confronted on the job. I thought this through with Charlie Pease at the south yard, who became a key adviser in all aspects of the show. Charlie came up with the idea of starting the show with a "trouble call": a streetlight was out. Later in the show, a crew would complete a transformer change out, repairing part of what needed to be done to get that light back on. Near the end of the show, a streetlight operator would come back to switch out the fuse and turn the light back on. This frame helped ground the whole performance, and I think it helped rally employee support, as well. After all, I was working with technical, engineering minds. I needed to show I could be flexible and make it work for them, too.

Some of the movements remained straightforward. The transmission crew was working out in the country a few hours from Austin during August and could only have one rehearsal before our show. So on that one day, the whole crew showed up and we practiced, timed, and filmed them as they performed their standard work. Once we had the elements on video, we showed those to Graham and Stephen, who designed music and lights to suit those actions exactly.

But we pushed for more flexibility, and less literal performance, in other places—and many crews embraced that. Stephen had designed two underground holes for Network, placed close to the audience, but fifty feet apart from one another, so that people could see the faces of the linemen as they went in and out. So much of the dance involved huge equipment and had to be set back from the audience for safety reasons, so this section was a rare chance for the employees' faces to be seen more clearly. But we weren't sure how to show the work that took place underground until Krissie, the linemen, and I started playing around together.

I asked Patrick Blackburn, the informal lead comedian of the group, to climb into one of the holes and try out some different ideas. Network supervisor Aaron Hanson remembers Patrick moving "like a little prairie dog," popping up quickly, then slowly, looking to his left and then his right, disappearing down and popping up again. I couldn't have gotten the distribution or transmission groups to do something so intentionally comical, but it fit Network's playful vibe perfectly.

During our second rehearsal together, Aaron Hanson shared a plan he'd concocted for the second part of their piece, and all four linemen worked together to make it happen. (I later learned that his wife is a dance instructor, which may help account for how he knew to put movement

together so well.) He devised a scenario that made it appear as though the two manholes that Network used as their set were connected by an underground tunnel, even though they weren't. With two linemen at the manhole on the audience's right, they fed one end of a rubber-wrapped power cable, coming off a large metal spool, into the manhole, continuously rolling the spool so it looked like the cable was tens of feet long. Then, a minute later, two linemen at the second manhole on the audience's left pulled out what appeared to be the end of that line—greeted by cheers and laughter from the audience. "We taped up a reel of cable so that it looked like it was feeding continuously into the hole, even though it wasn't. And then we had another piece of cable stashed in the second manhole, ready to be pulled out on cue," Aaron remembers. The magic of theater and linework were coming together again!

Again and again, as we worked out the choreography together, trying to show each work group's story in an efficient and compelling way, the problem-solving abilities of collaborators like Aaron carried us forward. One day, for example, I was stumped about how to get a streetlight, installed on one of the unelectrified poles on our set, to light up at the end of the show. When I came back to the yard the next morning, the linemen had figured it out, putting a battery from one of their big flashlights inside the streetlight and wiring it so that a lineman could turn it on manually.

At other times, someone would voice a problem, and we would all stand around at the performance site, pausing rehearsal to brainstorm until we solved it. Krissie and I tended to show up with a plan of a work event we wanted to see. We would throw out questions, see how people responded, try what seemed to make the most sense, and make adjustments as we went along. It was a collaborative process, but Krissie and I served as the directors, or final editors. Often we were looking for moments in which we could create unison and clear spatial design, attributes that the linemen were too deep inside the dance to see.

After months of riding out and learning as much as I could, I had to start being more directive, especially with the rowdier crews like Distribution. David Teltow actually called me and Krissie on the way to practice one morning to tell us that we needed to get on the megaphone and take charge. "You need to yell more. These linemen need to know you mean business." So we did. "You made us work hard!" said distribution lineman Eric Brown. Joe Alvarado recalled, "It was just like when I went to boot camp—I was like, 'Oh my god, what did I get myself into?'"

Krissie and I also brought in assistants Rebekah Bolls, Ashley Card, Jennifer Sherburn, and Larkin Wynn to help run rehearsals. Choreographers themselves with considerable dance experience, these women ensured the show ran smoothly by memorizing the sequences, coaching the employees on the choreography, and staying "backstage" with the

employees to make sure they entered on cue. They also helped by building cue sheets, listing every moment of the dance and indicating who is calling which cue. As with *The Trash Project* and many Forklift projects since, we used handheld radios to communicate with performers, many of whom were working with such loud equipment that they couldn't hear the music. Calling out cues on the radio—when to enter, when to turn a vehicle on, and so forth—makes a smooth performance possible. AE employees, like the sanitation workers, were used to communicating on radio, and all had their own, which made this method particularly easy. But *PowerUP* was so complex that we had to write down every moment of the dance to make sure we called the right cues, radioed the trucks to enter on time, and kept everyone in sync with the music. Detailed cue sheets and support through assistants are two of the many things I now can't live without on any project.

▪ The days got longer and the work more intense as we got closer to the show. The entire week leading up to the performance, my team members—Krissie, Graham, Stephen, Tamara (back again as production manager), our four stage managers, and I were all working eighteen-hour days to get ready. A kind of miniature city went up out at the Expo Center, with porta-potties, generators, scaffolding, lighting, and sound gear loaded in. We had planned to have a full, daylong rehearsal Friday, for over fifty performing employees, then would come back that night for an open dress rehearsal for friends and family. But as the day approached, the forecast, much to my disappointment, called for rain.

Always quick when disaster is looming, Tamara drafted a revised production plan. She encouraged me to rent an extra-large tent so the band could have coverage, and we could still have some kind of practice on Friday under that tent. Together she, Sonny, and Carlos made a communication plan in case we had to cancel our dress rehearsal or a show. In the meantime, we told all the participants and performers that they better not be late for their 8 a.m. start time Friday morning.

When the morning came, it was humid, and you could see the rain clouds moving in over the horizon. I was so excited to have the whole group at the site together for the first time, but I was also exhausted, running on fumes, barking orders to the crowd. I paused to scarf down part of a breakfast taco, but after one bite, I threw up in the trash can, in front of a group of linemen. I lifted my head out of the trash can, wiped my mouth, and got back to work. I was delighted by the shocked but slightly impressed looks on their faces. It was time to focus and get 'er done.

"You've changed, Allison . . . you ain't nice anymore!" said one lineman to me that morning. "Yep," I said. This transition happens with every project, but it kicks into high gear by the time we are in final rehearsals.

Fellow community-based artist Marty Pottenger puts it like this: "Keep the art bar high, not only out of respect for each participant but to encourage everyone to explore the challenging, exhilarating gifts that creativity brings. We all want to be expected to do our best." I push all of us, both professional performers and our collaborating artists, to perform the material with polish, so we can feel proud, coming together as our best—and inherently creative—selves. I have found that people respect and appreciate this push. After all those months of building relationships, the employees want the show to be good just as much as I do. The final rehearsals are where those relationships are put to the test, and I have learned to prepare my choreographic team accordingly.

Now, with just about ten hours until our open dress rehearsal, it was time for Krissie, our assistants, and I to turn into drill sergeants. I marshaled my most convincing authoritarian voice to tell the linemen that "we are only as strong as our weakest member." Years later, David Teltow laughed as he recalled, "I don't know how she did it, but she made us feel like our asses were on the line, as far as 'Guys, how good do y'all want to look? You wanna look like asses, then keep it up! If not, let's go! Let's go! Step it up. Where are those steps at?' . . . I mean she was pretty good—she put the onus on us. And that made us really want to perk our ears up and do right."

Up until this point, we had practiced exclusively in small work groups, so most of the performers didn't yet have a sense of the show as a whole. Few of them had experience performing, and even fewer had attended a dance or theater performance. Many of them said they didn't think anyone would show up, but we kept repeating: "Yes, you are going to have three thousand people here on Saturday night!"

We started Friday's dress rehearsal at the top of the show, moving forward in order, but by noon the rain was too heavy to keep working outside. We didn't want to rut up the field or get a truck stuck in the mud, so we moved under the tent, marking what movements we could. At some point the heavy rain started leaking through the tent, threatening the musicians' gear. Distribution lineman from the south yard Darrell Singleton, a big, tall guy, hoisted David Teltow up on his shoulders to tie up the place where water was coming in. I grinned happily: the group was coming together in a way even I wouldn't have expected months before.

At 6 p.m. that night we reconvened for a cast meal: a BBQ dinner. Over the years, I have learned how important such gatherings are, allowing the cast to bond, rest, and get sustenance for the long rehearsal or performance ahead. We ask our institutional partner to help us cover the costs, and we solicit donations from local restaurants. At some point during the meal, we hold a pre-show circle, giving the performers a chance to share how they are feeling, what they are hoping for, and, if it makes sense for the group, to say a prayer. That kind of togetherness was especially important

Figure 3.3. *PowerUP* cast members (from left) Jamil Kelly, Darrell Singleton, Tony Mendez, Joe Alvarado, and Cesar Hernandez applauding during the pre-show cast circle. Photo by Leon Alesi (leonalesi.com).

for *PowerUP*, because these AE employees didn't all work together on a regular basis. Many of our collaborators later told us it was one of the high points of the whole experience.

By the time we gathered under the tent to eat, Sonny and Tamara had decided to cancel our open dress rehearsal. The field was too muddy to run trucks in, and with the rain still coming, it seemed unlikely audience members would want to sit through an outdoor show anyway. This was devastating, because we had intended Friday night to be for family members and fellow AE employees, but we did our best to get them tickets for the Saturday or Sunday night shows.

After dinner it was still raining, so we decided to just walk through the whole show under the tent, calling through the cues so our four choreographic assistants could practice. With Graham, drummer Jeremy Bruch, guest violinist Todd Reynolds, and conductor Peter Bay there to play and watch, the linemen walked through their parts under the tent, on our mini stage. By 8 p.m., the rain and wind were so intense that our five transmission guys had to leave rehearsal because they were called away to repair power lines. Work needed to come first.

By noon on Saturday, the rain had cleared and the field out at the Expo had, by some miracle, dried. Since we had to cancel our Friday night open dress rehearsal, we called the cast back at 2 p.m. on Saturday. With the core band, Peter our conductor, and about ten of the thirty orchestra members, we ran the whole show through for the first time in its entirety with the trucks, but still without lights and the full orchestra. After another cast meal, as the audience began streaming in, we gathered in one big circle behind the bleachers for last words of advice and a group prayer. We dedicated the show to Mike Matus, a distribution lineman who had died in a motorcycle accident going home from work just a few months before our show. Mike's wife Donna led us in prayer, and we headed out to perform a show we had never completely practiced before for an audience of three thousand.

■ The string orchestra played an overture that concluded with a burst of sound, intended to sound like a fuse blowing. Then a recording Krissie and I had made, of two dispatch operators making the standard radio call for a residential power outage, rang out over the loudspeakers. Dispatch was officially in the show. Our first performer, troubleshooter Garrett Gutierrez, drove onto the field in his pickup truck to assess the situation. Troubleshooters are the linemen who respond first when an outage call comes in, and I had ridden out with Garrett observing as he repaired fuses and drove distribution lines looking for problems. For the dance, Garrett performed his typical work sequence. He found the pole where the fuse had blown, using an "Extendo"—basically a long pole that telescopes

out—to reach thirty-five feet up to the fuse. After failing to get the fuse to close—meaning that the transformer was bad—Garrett pulled the Extendo back down, returned to his truck, and while driving off the field alerted Dispatch in another radio call the whole audience could hear.

While Garrett exited, Graham played a series of dramatic piano chords, and six electric utility trucks appeared out of the darkness, three from the left and three from the right. Dust billowed from the trucks' tires as they crossed perfectly in front of the audience, looped upstage, and lined up behind the four distribution poles, leaving clouds of smoke and a feeling of anticipation in their wake. The four bucket trucks with 55-foot booms parked facing the center, each in front of a pole. The two additional trucks, one carrying a great coil of wire and the other a rope machine used to pull the wire across, parked on opposite ends of the poles. With the sun setting behind the trucks, the sky lit up orange as the linemen got into their buckets and, on Krissie's radio cue, lifted off the ground in sync. Graham's music built in tandem with the rising buckets, the violins playing slow, repetitive bowing chords back and forth as the buckets rose into the air. The arms of the bucket trucks angled up in coordination, unfolding in perfect symmetry until they reached their uppermost height. Krissie paused for a moment to wait for her musical cue, then shouted to the linemen through her radio to turn their buckets in unison just as the orchestra broke into a lyrical, lilting series of chords. Each bucket spun to the strings of the orchestra like a toy ballerina turning on top of a music box.

As Distribution continued their work of getting that line installed, two spotlights fell on Cindy Ellis and Eric Porter, from the Relay team, standing on manholes. Their actual work—sitting in the relay houses and communicating in coded language back and forth while looking at circuit maps—wouldn't translate well for performance, but even on its own, the language was incredibly evocative, so they used it here. Writing the exact words together, their lines featured technical directions including:

> Cindy: "Relay testing 138KB line between Decker plant and mobile substation. Performing A checkout prior to energization check cable DC 100 a four conductor number 12."
>
> Eric: "DC 100 is a four conductor number 12 from DC panel number 1 2 the DC battery charger. Check cable C200 on panel 2TB1 is connected to panel 3TB1 main bus overcurrent trip to 984."
>
> Cindy: "Cable C200 on panel 2TB1 is connected to panel 3TB1. Check cable C16."
>
> Eric: "Cable C16 is connected to from 123 switchgear unit 4 to panel 2TB6. Check open test switch 6 A-J."

What had struck me as a kind of found poetry was followed with a more deliberate composition: Allen Small, an award-winning slam poet who helped run the south yard, performed the first of three pieces he wrote for the show, entitled "The Phenomenon":

> You don't really see it.
> Sure there are momentary sparks or flashes of brilliance.
> But you don't really see it.
> You see its effects and uses. And the truth is it makes the world
> a better place.
> Though unseen most would say its best color is green.
> But through it we see the world through power windows.
> 50-inch, 60-inch screens of all different sizes.
> It opens doors. It opens cans. It keeps us online and connected,
> tossing the angriest of birds or talking with the friendliest of voices.
> It flows—pumping water
> pump pump pump pump up the volume . . .
> Pumping hearts.
> It pushes back the veil of darkness—streetlight, moonlight,
> green light.
> It goes from here to there; carrying us from here to there
> by car, bus, or train—rain or sun, from home to work and back.
> It is AC for our AC, and if you need AC/DC,
> FOR THOSE ABOUT TO ROCK . . .
> it powers you.
> So hopefully no sweat to fret—guitars, keyboards, and drums.
> A distinct hmmmmmmmmm
> making the world know that power is on.
> I touch. iPad. iPod. Aye yi yi. I think it will never end.
> I sing the utility electric and what it provides 24/7.
> Charging recharging
> charging forward the wheels of progress with potential.
> You don't really see it, but it is all around us.
> It is us.
> Electricity. Life.
> Life. Electricity.
> And the trick to both is not to be shocked and be safe
> in the daily effort to PowerUP!

Next came "Johnny Substation"—named by and for the performer himself, substation construction crew leader John Barsch. I'd watched him and his crew at work one day, and the Genie lift, a drivable crane that could lift a technician forty feet up to work inside the substation, caught

my eye. I liked how smoothly this machine moved, and thought that, with its capacity to propel an operator up and out, we could use it to make a nice solo. John was an extrovert, and it didn't take much to talk him into working with the Genie for the show. We met out at the Expo Center to come up with a movement sequence about two weeks before the show, and spent about an hour setting a 4–5-minute bit of choreography. As we retreated from the heat to sit in John's air-conditioned truck, John told me more about the job, noting that "nobody sees what we do. We're behind the fence. We're like invisible." I was floored, and elated—emphasizing invisibility would be excellent storytelling. "Wait!" I yelled. "Say that all again so I can record you!" When I shared John's solo and interview with Graham, his impression was that John and his fellow substation techs were like mystery guys—here, and then not. Graham began to play with a crime jazz theme, which brought the whole piece together. John agreed. "The best part of the whole thing was the music you picked," he recalled later. "It was like the god dang Pink Panther music. It was dang sneaky —like I am!"

After John's piece, the lights shifted to the distribution guys working the far back line, ready to do their final maneuver. Krissie directed a duet for two bucket truck operators, with the dramatic backing of the orchestra. The arms of the bucket trucks extended up and away from each other, and then arched back toward the center, where the two linemen in the buckets, Jamil Kelly and Zach Janowski, met for a fist bump about twenty feet off the ground.

Next, Terrell Watson and his fellow transmission linemen got into place by the 100-foot transmission tower to a bass drum that mimicked the sound of a heartbeat. Under a spotlight, Terrell began to climb with no ropes or safety lines to support him—just him, free-climbing a pole. It was nerve-racking for many of us to watch, and you could feel the tension in the crowd, but Terrell and his crew made such climbs on a regular basis. When he reached the arm of the pole, about seventy-five feet up, he harnessed himself onto it and dropped a handline down to his fellow linemen on the ground. They attached an 8-foot ladder to the line, and on Terrell's cue, began feeding it up the line to him. Once the ladder arrived, Terrell attached it to the arm of the tower, just under where he was sitting. With the ladder in place, he climbed down it, dangling about seventy feet above the ground, to secure a bell, or insulator. I had recorded an interview with Terrell a few weeks before the show, and his responses—poetic, thoughtful, and vulnerable—played across the PA as he worked on the arm of the tower:

> *The view is the best. When there's no wind blowing, it's pretty quiet and peaceful. Once you start climbing and you get up to the top*

of the pole and you look down, everything just seems very small. Trucks look small and people look even smaller. I see a lot of stock tanks, see deer running, cows grazing. Couldn't ask for much more.

Yeah, it's tough, it's heavy, it's hard work. Pretty much exhausts you. A lot of distribution guys will say, "Transmission — strong back, weak minds." But there's a lot more to it than that. You got high tension wires. If something breaks or a pole falls, you will get sliced in half by the wire when it falls. Yeah, the work is hard, but you keep coming back.

Growing up I liked to climb trees, get on top of roofs and jump off. I just did it to see what might happen. I liked to ride motorcycles — always went as fast as I could. I just held it wide open to see how high I could get.

My mom always told me I would probably get hurt doing the things that I do. But I don't really think my mom knows exactly what I do. She might have an idea, but yeah, I don't even really think the public, the people in the city of Austin, know what we do and how we do it.

I've said one of my favorite moments was out in the country on top of the pole. It was real foggy . . . early in the morning. Sitting on top of the pole the sun starts coming up. Seeing it glistening through the fog, and I mean that moment right there, that's the moment when you tell yourself, "Man, I really love my job. Wouldn't want to be anywhere else but here."

To me, it was essential that the audience witnessed Terrell's remarkable climbing skill along with his honest talk about the risks of the job. Throughout the project, I kept coming back to the extraordinary dangers that these men (and they are mostly men) face just to keep the power on for all of us. Between the 1890s and 1930s, approximately one in three line workers died on the job — mostly from electrocution. Today, conditions are much improved with modern equipment and extensive, union-created and industry-led safety protocols, but linework, like other essential work, remains hazardous. Sanitation workers, and people who drive large vehicles, also have a high rate of injury and fatality on the job, and firefighters and other emergency responders are at an increased risk of cancer and heart attack due to their work. Creating moments in our dances, like this solo with Terrell, helps audiences contemplate the dangers of the work, and provides a more complete and human picture of the laborers who support their communities.

Figure 3.4. Terrill Watson climbing the 100-foot transmission tower. Photo by Amitava Sarkar (photographyinsight.com).

While Terrell continued his work on the ladder, the lights shifted focus back to the pole where, at the beginning of the show, a light had gone out. Four linemen—Jeff Trevino and Jared Maness in a truck, and Tony Mendez and Joe Alvarado on foot—entered, going back to that same pole to replace the transformer. After our first rehearsal, the quartet realized they didn't need to lift a functioning transformer, which—filled with copper wire and oil—would have been very heavy. Instead, they put up an old, empty one, which helped them move through this fairly mundane work of pulling it off the truck, attaching it to a handline, Jared and Joe climbing up the pole, and then working together to hoist the transformer up the pole, as quickly as possible. After about five minutes they completed their job, returned their tools to the truck, and left the way they came in—Jeff and Jared in the truck and Tony and Joe on foot. By that time, Terrell was finished with his work on the transmission arm, and the audience got to watch his elegant descent, breathing a collective sigh of relief when he finally got back to the ground.

The next section, "Linemen's Conjunto," involved all the distribution linemen: eight climbers, each on a pole, and eight groundsmen. Hanging a line together across our downstage poles was one of the first ideas Stephen and I agreed upon for choreography, and it took about four long rehearsals to get this six-minute section just right. Trey Longoria, a third-generation lineman, played accordion, accompanying his fellow distribution crew members for this section. Trey and I had our first real conversation at the 2013 summer Lineman's Rodeo, a few months before the show, where he cheered on his fellow employees. Standing tall and sporting his typical two-day stubble, he listened to me describe some of my ideas for the show, and his easy grin and warm brown eyes suggested a friendly resignation to joining the cast. When Trey told me that he'd grown up playing the Tejano and Mexican-influenced accordion music of South Texas, I wanted to know more. Krissie and I consistently look for ways for employees to share their culture and artistic talents during our performances. More and more, we have learned to give cast members multiple ways to contribute to the art—not just as experts at their work, but as musicians, poets, singers, dancers, and visual artists. This means they can lead in artistic curation, and that I and other trained choreographers are no longer the "artistic experts." I had a sense that this might happen here.

"I talked too much—that's how you found out about the accordion," Trey remembered years later. "It's what I love to do in my free time and I don't play it for money. So I figured, why the hell not?" After much discussion Trey recommended he play a conjunto, which he describes as the music of blue-collar working folks from the Texas Valley. Trey began the section alone, lit by a spotlight, wearing his uniform and hard hat, and

Figure 3.5. Trey Longoria performing in the "Linemen's Conjunto." Photo by Leon Alesi (leonalesi.com).

playing his accordion as he walked into the center of the field. When the band kicked in to join him, the lights went up and his fellow linemen took their positions at the poles across our stage.

The linemen then ascended and hung their handlines, assisted by the men on the ground who sent up a cross arm together. We had played with the timing of some elements of the work—like a great moment when the linemen on the top of the poles threw their handlines down one after another in a wave, spanning 150 feet across from one end pole to the other. Trey's choice to play conjunto was just right for the distribution linemen's rowdy spirits. The section felt like a party or family reunion as the linemen, smiling ear to ear, yelled back and forth to each other while performing their steps to the music. To my surprise and delight, Joe Alvarado improvised for a few moments, dancing with the rope in his hands like it was his partner. "I like Tejano music and so I started rolling up the handline and dancing with it. My wife was right in front and she figured I was showing off for her—which basically I was. Just like whenever I go dancing, my legs just started moving for me."

"One of the biggest joys for me," remembered Trey, "was at the after-party when a woman came up to me and told me her husband started crying when he heard me playing. He grew up in the Valley and hadn't heard that kind of music in a long time." Drawing out the skills and hobbies of the cast meant that the show celebrated these linemen not only as workers but as whole people with talents, interests, and histories. When Trey ambled out onto the field, the spotlight following along and Tejano music gloriously spilling from his accordion, the audience connected to another side of him, and likely many got a fuller picture of who a lineman just might be. By giving Trey a chance to share his family's culture and love for Tejano music authentically, he gave audience members the opportunity to look beyond stereotypical images of the people who do linework. Also, and perhaps most importantly, Trey loves playing the accordion. Giving him a chance to share this love was essential—because it was in that moment of sharing and putting himself out there that Trey transcended the label of his job and let the audience see him in his full humanity.

As Trey and the distribution linemen exited, Allen Small returned to his spot in front of the orchestra to deliver his second slam poem, entitled "Watts UP." Focusing on the scale of the job, and with a running joke about the difference between "what" and "watt," Allen's words included:

WATT?

A measure of power, calculated by the hour.
Now our electricity is transmitted on electrical highways
 of transmission lines.

620 miles of transmission lines within the system.
Structures reaching into the sky—high voltages kept safely away.
Poles 80, 90, 100 feet tall. And there are spidery lattice towers.
Now do you know the equipment and materials Austin Energy uses
to get electricity to you no matter what?

WHAT?

Transformers—in substations, on poles, on pads transform
 amps and voltages to usable levels.
Conductor and cables enable the distribution of electricity.
5,400 miles of overhead poles and conductors; 6,000 miles
 of underground conduit and cable
to carry electricity around town, downtown, and surrounding
 service area.
420,000 customers and growing and growing and growing each day.
Hi-tech fab plants to homes. Commercially and residentially.
Essentially that's how power gets from place to place,
placing equipment safely. Safety priority #1.

So I guess that's it. So now what?

WHAT?

Only one way I can wrap this part up . . .
HEY YOU GUYSSSSSSSSSSSSS!!
We're gonna turn it on and bring the power to you and me
all through the courtesy of your electric company.
And that's what's

WHAT?

Watts?

WHAT?

Oh yeah, you're right. My mistake.
That's PowerUP.

It was about midway through the show, and a good time to turn the audience's attention to a group of employees we had not heard from yet. "From Desk to Field," directed by Krissie, was performed by twenty-five women employees in a duet of sorts with the tallest vehicle in the utility, the 120-foot transmission crane. There was only one woman in the field

crews at that time, but Krissie had put out a call to the women who worked in engineering, design, dispatch, and administration. We didn't want the contributions of the women employees to go unrecognized. Krissie got ideas from dispatch right away, and started collaborating with them in their office, stealing moments between calls to come up with choreography together, and then traveling from location to location, slowly recruiting more women and teaching them the movements. Now, recorded interviews with some of the women, sharing their experience of working at AE, played over the PA as they came forward onto the field, lined up in two rows facing the transmission crane. Starting with their backs to the audience, the women performed a series of gestures inspired by the crane's angular arm. As they pivoted to face the right and left, their arms, bent at the elbows, folded down and then extended up, as if they were directing the movement of the crane. The women's bodies in motion symbolized their work, which is essential to the field-worker and electrical service delivery. As they lowered their arms, a lineman landed the crane's weighty bucket on the ground. Two of the women then walked a set of rolled up paper plans to the linemen, passing off the plans and shaking hands with the field crew.

Next, Network, the group that serviced downtown Austin's buried power system, performed "The Underground Animal." As two trucks hauling spools of cable drove in, the voice of Roberto Reyes explained: "Network—it's a different animal. You know most people don't want to do it. You work in confined spaces. You're always in traffic, you're always downtown. We're in a different world down there." The band then kicked in with a bass-driven rock beat, and Patrick Blackburn and Michael Gomez surprised the audience as they popped out of the manholes downstage. To roars of laughter, Patrick and Michael went through their routine of popping in and out of the ground, ending this section with the Network group appearing to feed the underground cable through one manhole and out the other.

It had struck me that shifting from underground work to the up-in-the-air bravura of linemen would be a good contrast, and their section of choreography, which came next, was all about pattern and timing. We had selected the three best climbers from the south and north yards for a total of six, all of whom had to memorize the sequence of movements and count the music—something I don't often ask collaborators without formal dance training to do. It was extraordinarily taxing physically as they went up, down, and back up the pole. But it was so much fun to create this kind of choreography with them—utilizing all the movement elements of climbing to build this sextet, titled "Hooking Made Easy."

Nearing the end of the show, we returned to that initial light out once again for a solo entitled "Lone Streetlight" that featured Tony Mendez. As

soon as I began working on this dance, I knew we had to include the 1970s country ballad "Wichita Lineman," written by Jimmy Webb and recorded by Glen Campbell, in the score. The song described a man at work, away from his family, and alluded to the sacrifice line workers' jobs require. Graham and I had been hunting for the right place for it. When I learned that Tony had worked for AE for thirty-five years, and that he had done just about every other type of linework in the industry, I knew I had found the spot for this existential anthem. Tony, who now worked alone repairing and replacing streetlights, ascended in his bucket truck to get high enough to replace the fuse and close the circuit, repairing the light that had gone out at the start of the show. As Tony closed the fuse and the light came on, I played the last bit of his interview, where he shared, "Yes, I probably got ten more years and that will give me about forty-five years, and I think that's enough. But it's been good to me, so I can't complain." Peter then brought the orchestra in, with ethereal violins playing the chorus of "Wichita Lineman" as Tony soared out in his bucket, adding melancholy strength to Tony's solitary movements as he descended to the ground.

"Hurt Man Rescue," the last section before the finale, drew from an annual drill in which each line worker has four minutes to climb a pole and safely lower a dummy—standing in for an electrocuted line worker—down the pole with a rope. To give this section context, we played an interview with distribution lineman Philip Floyd about the purpose of the exercise and the real risk he and his fellow line workers face every day at the job. Phillip's last lines were especially poignant: "You don't have to like everybody, but when you're at work, you gotta love everybody. You gotta get your fellow employees home safe to their families every night."

Allen Small then took the stage one last time. His poem "Our People PowerUP" ended with these lines:

> So the next time you turn on a light, or see a substation, or
> transmission line or distribution pole.
> The next time you see us, know that even when things seem to be powering down, we are there.
> We're Austin Energy and we'll leave the lights on for you.
> We'll keep Power UP.

For the twelve-minute finale, our task was to bring all elements of the utility together in concert. Coordinating each work group's movements was so complicated that Krissie and I created a spreadsheet to map it all out. We were grateful to have Trey Longoria, who wasn't needed in the finale, sitting next to us and calling time, so we could be sure to cue each group at the right moment. We opened with the entrance of the mobile substation, which was so enormous that we just included part of it: the gas

circuit breaker, which consists of a metal sphere fifteen feet in diameter with six sprouting insulator bushings, and the disconnect, or switch, with three giant blades that swung down to close the gate, and with it, the circuit. Driver Denver Taylor maneuvered it into position just in front of the transmission tower. Once parked, Denver and his three fellow substation technicians, José Berrelez, Johnny Martinez, and Thomas Frazier, each took a corner and turned the monster breaker, moving the 2,500-pound unit on its rollers to face the opposite direction. Showing the strength of these employees while giving the audience a full view of the machine, this slower movement allowed for a moment of quiet, musical tension before a cavalry of bucket trucks entered.

Kicking up dust as they sped past the audience, the six bucket trucks entered downstage to line up across the front distribution poles, put down their outriggers, and prepared to send their buckets up in the air. Our cast of twelve distribution linemen entered and began to climb. With the buckets and climbers in motion, the 125-foot transmission Bronto began to extend its bucket straight up. Johnny Substation entered with his Genie lift and slowly began extending himself up in the basket. Network worked in and around the two manholes and moved with their flashlights in the foreground. Downtown locator Roberto Reyes entered after the Bronto, walking a pattern and then raising his locator stick in the air on my cue and signaling to the climbers to descend and then go back up one by one.

Everyone was in motion now, moving themselves or their equipment up as high as they could go. Distribution linemen were free-climbing to the top of the 45-foot poles, the bucket trucks were reaching their full heights, Transmission had the Bronto extended to nearly 125 feet, and John Barsch was maneuvering the Genie lift up to its full 40-foot height. Eric and Cindy entered, lit by two spotlights, and most of the movement stopped as Cindy called, "Confirm mobile to close." The substation operators hand-cranked the hefty switch down to the close position. "Power UP!" Eric's voice rang out through the speakers. Miles out in the distance, four live transmission towers, spotlighted by the crew stationed underneath them, lit up with blue and purple light one by one, in time with piano chords that Graham played in coordination with Peter and the orchestra. With the climbers at the top of the distribution poles, linemen in the buckets, and the Bronto and Genie lift extended straight up, the cast and crowd cheered.

Eric Brown remembers this moment: "Everybody was going through their dance themes, and we got to the end and everybody just went 'hoo rah!' and screamed. Being on top of the pole, overlooking the city, and people out there just clapping and laughing—it was a good feeling. It was all of us. My fellow linemen were screamin', and the audience gave us a standing ovation. It was awesome."

Figure 3.6. The final moment of *PowerUP*. Photo by Leon Alesi (leonalesi.com).

■ The impact of *PowerUP* on my fellow artists and me, Austin Energy, and the Austinites in the audience was far-reaching. Years later we are all still talking about it. We won many awards, including a national award for Austin Energy from Americans for the Arts acknowledging their contribution to the arts. Surveys, which we collected a few months out and two years later, consistently showed a positive impact on morale, communication, and sense of pride in the job. Distribution lineman Eric Brown summed it up well: "It was about Austin seeing what we do every day—you know, that made a lot of guys feel good." Eric continued, "What touched my heart about it is the crowd of people. I remember you telling us 'OK, guys, there's gonna be a lot of people here.' And I didn't expect it—I'm gonna be honest with you, I didn't. And then, when I looked out and saw the stands full—wow! I really felt like we were respected for what we do every day."

Giving the employees a chance to tap into creativity was vital. "We very rarely get the chance to be entertainers, or creative, in that way," reflected Allen Small. "This was a way to kinda let that out, let that loose, and let our creativity and personalities come to the forefront. We cultivated something, and now that personality and that creativity is a part of our culture here." I especially think that as men, working in a macho culture, the chance to do something like this, where they got to perform for each other and show their skill, was critical. They got to show off to the general public, but also to each other, and this built respect and appreciation across the work groups.

One of the biggest impacts was on improving communication and understanding between the work groups. David Teltow reflected, "It was an opportunity to come together and to work through things, to do stuff together that we normally wouldn't do." For Denver Taylor, getting to demonstrate his actual work in the show helped his fellow linemen from other groups understand his work. "It gave us some credibility," said Denver nearly six years after the show. "They were surprised that was our work because they had never seen what we really do at the substations."

Dan Smith, executive vice president, had been one of the most skeptical people in leadership when I first pitched the project. But reflecting back, Dan puts *PowerUP* "on the top-ten list" of his career. "Ideally all million-plus residents in the Austin area [would see the show], to see what their electric utility does and what the work actually involves and the value we deliver to our customers and community," shared Dan. "*PowerUP* was a seminal experience that has helped us as an organization focus and unite around our core principles and with values of safety and care for one another. *PowerUP* cultivated the pride of what we do and how it connects us with one another and our community." Dan also said that being part of *PowerUP* helped him more clearly see and

understand his daughter, an artist, connecting him to "her heart and her passion."

Audience members were moved, as well. One mother wrote to us: "My four-year-old daughter was deeply affected by the performance. Linemen, which she also calls 'power dancers,' permeate her play, as she pretends to set and climb poles and string wire. When she plugs something in now, she talks about where the electricity is coming from and the people who make it possible. She will never see electricity in the same way again." And a utility worker sitting in the audience shared: "Until *PowerUP*, I never thought of utility work as an art form. Forklift Danceworks turned the subject matter that I love into a work of moving art before our eyes."

■ People still ask me, "How the hell did you pull this off?" As with all my projects, I was connecting to something bigger than me. I was "seriously committed," as the linemen said, but at times I was also afraid we weren't going to raise the money, and terrified that leadership would pull the plug. I had to lead with a grand vision and deliver on what I think all of us artists know is so precious: the chance to create awe, wonder, and magic. But it didn't happen magically. It happened through showing up over and over again, connecting to my grit and steadfastness, and not taking no for an answer.

Years after the project, in preparation for writing this book, I went back to talk with the linemen. I asked Jared Maness why he'd stuck with me through *PowerUP*. "Well that's a stupid question to ask a lineman!" he replied. "Why?" I asked. "Because, once you start somethin', you have to finish it," he said. "There's no option." "Say more," I pushed. He explained, "Because you have to. It's what keeps you in this industry, or else you wash out real quickly. You can't stop. You can't get a phone call in the middle of the night and decide halfway through, 'You know what, I really wanna go back to watching TV, just go home,' and everybody's lights are still off. You have to go, and work until you finish it. We're first responders, we have to finish. That's what we do." What a gift it has been for me to work with such remarkable people, who love their work as deeply as I love mine.

Dances for Places and Their People
Baseball Fields, City Pools, and More

It was easy to see how much Coach Alvin Moore loved Downs Field, where, from the 1950s until the mid '70s, Negro League and then Black semi-pro baseball was played for a bustling crowd. Standing next to me in 2014, he gazed across the emerald grass and explained how it got so green. "We start in late October, planting the winter rye. This year we planted three thousand pounds. We lost quite a bit due to weather, but the field still came out pretty good." With his white and gold baseball cap sitting squarely on his head, Coach described the steps of his work. "Daily watering, cutting the grass on a weekly or sometimes daily basis, claying the mound, adding fertilizer, and aerating to make sure the water gets into the ground." As we walked together to the maintenance shed tucked in by the wooden, forest-green stands, Coach didn't even look at his sizable set of keys; he chose the right key by feel, unlocking the padlock and opening the creaky wooden door to reveal an aged Craftsman riding mower. He mumbled a few words of encouragement to it, climbed on, and turned the ignition key. As the tractor rumbled to a start, he began his work.

Pulling a rigid steel mat behind him, Coach followed his well-known route, traveling through the infield to grade the dirt and leave the surface smooth and level for playing. Wiping the sweat from his brow as he turned off the tractor, Coach painted a picture of Downs Field in its heyday. "Sunday afternoon was baseball at Downs Field. A thousand people packed into the stands and the park, rooting and cheering. If you came late, you couldn't get close to the park as teams from across Texas came to play —from Austin, Dallas, Fort Worth, Houston, San Antonio, and Corpus Christi. Families brought ice chests and picnics, coming right after church in their suits and dressed up. It was something to see."

Coach Moore had spent much of his life on Downs Field. As a young man in the 1950s and '60s, he played baseball on the field during high school and college—first for L.C. Anderson High School, then the segregated high school for Black Austinites, and later while attending Huston-Tillotson, a private, historically Black university and the oldest institution of higher learning in Austin. In the 1970s, he was the youngest player for

the Austin semi-pro Black baseball team, the Palominos, and while working for the Parks and Recreation Department, he ran the baseball league that used the field. In 1981, he became head coach for the Huston-Tillotson Rams baseball team, and it began to seem that he'd been fated to be the lead advocate and caretaker for Downs Field.

Lisa Byrd, a longtime friend of mine, invited me to meet Coach Moore in 2013. Lisa was the founding executive director of Austin's African American Cultural Heritage District (now called Six Square—Austin's Black Cultural District). The district encompasses six square miles in East Austin, one of the fastest gentrifying neighborhoods in the country. The question of cultural preservation is extremely urgent, for this is a neighborhood that was built by the Black community, many of whom have been forced or chosen to leave. "The formation of the Cultural District is not just about preserving the physical space," Lisa explained. "It is about claiming space and saying we have a right to this space as Black people."

Lisa was on a mission to preserve and restore the field. "It was falling apart and it looked like a prison yard—with a tall barbed wire fence around it and no signage of any kind telling people what it was." As she listened to longtime residents share remarkable stories about Downs, she began to think, "How can we share these stories? What can we imagine for this space? And how do we get people here?" Lisa had long worked in the arts, so commissioning artists seemed the next natural step. "And when I looked around," she said, "I thought of Forklift. Because you all at Forklift were making work far beyond what I could imagine. I mean, who makes art with trash trucks?!" What's more, she said, "I had seen the way your dances lifted up the voices of people whom we don't often hear from. I knew that was what we needed here. There was no one else I had experienced in Austin that was making work like Forklift. But then the issue was, well, they're White. So then that became my problem."

Lisa was up-front with Krissie and me about her concerns. Commissioning a White-led arts organization to create a dance about a historical Black community site, she said, felt dicey, and she was clear that we could not primarily employ White artists in the band and on our production team—we needed to diversify. She was right. But she trusted our community-based process. "You're able to hear and let the story evolve from the community," she said, letting community members—not ourselves—lead the way.

Lisa's invitation to make a show that shared the story of Downs Field was our first foray into place-based performance, and specifically creative placemaking through dance. Place, and more particularly, performance sites—the skate rink, the steps of the Texas Capitol, the tarmac of the old airport—had always influenced our choices choreographically. But now we had a larger job to do—to not just tell the story of how people work,

but to share the specific, textured history of a place, so that residents could engage it with more awareness, attachment, and depth. Lisa framed this not as "placemaking," which, she said, suggests that "you are creating a new place," but as "placesaving."

Krissie and I started by listening. Lisa and Coach Moore introduced us to longtime neighborhood residents, community leaders, and others who had grown up on the field; some of them joined us by the field, and others invited us into their homes to share their memories. I had the honor of visiting Stella Wells—daughter of baseball legend Willie Wells—who lived in a little pink house in East Austin. Her walls were essentially a museum of Black baseball, covered with her dad's memorabilia, including photos, awards and plaques, old bats, gloves and baseballs, and countless newspaper articles. Born in Austin in 1906, Willie Wells was a baseball icon, considered to be one of the best shortstops ever. "He was fast on the bases and he could really hit the baseball," remarked Coach, who got to meet Wells, one of his heroes, in the 1970s when Wells was coaching a semi-pro team at Downs Field. "He was nice, but serious. Willie Wells just lived, died, and ate baseball."

Krissie and I became regulars at Huston-Tillotson baseball practices and games, casting the players as our primary performers, and getting thirty minutes from Coach at the end of practice for rehearsal. Enlisting help from two other trained dancers—Azure Brown, who grew up in the neighborhood and had been a student in two of my dance classes at Austin Community College, and Ashley Card, an ACC dance program graduate who had assisted with *The Trash Project* and *PowerUP*—we gave short assignments to the team. Inspired by their drills, we asked the pitchers and catchers to try a sequence in a circle where each player simultaneously threw a ball across the circle to a partner. After a few days of trying, the players were able to repeatedly toss all twelve balls without an in-air collision. With the batters, we asked them to show us all the movements that could be done with a bat. When one player stood behind his bat, placing the tip on the ground like a cabaret dancer might use a cane, and shook his hips from side to side, we laughed with delight. These college guys were easy to work with, and up for just about anything.

Krissie and I studied Negro League Baseball history, watching documentaries, reading, and looking through newspaper articles Coach had in his office. We learned that Downs Field was home to the Austin Black Senators, which hosted other Negro League teams into the 1950s when they came through Austin barnstorming. The field's heyday continued though the 1960s and into the early 1970s, when people filled the stands to watch semi-pro Black teams from across the state, including the Austin Palominos (later called the Greyhounds) and the Austin Indians. "If [a Black person] wanted to play baseball, the only place you could play was Downs

Field," recalls Coach Moore. "You couldn't play at any other fields in Austin because of segregation."

Lisa set out to find people who had been members of the semi-pro teams or had relatives who had been players, inviting them to the show. She also learned about a group of retired Central Texas Negro League players in San Antonio, and she invited them to come to Austin to be part of the weekend's events. They were honored at our Friday night opening gala on the field, and throughout the weekend signed autographs and talked with fans. My highlight was when this group of old-timers sat down with the Huston-Tillotson players Friday afternoon. The enrapt college players sat motionless as the men shared stories from their careers and gave advice to the young men who hoped to play professionally one day.

We collaborated with Lisa and the Cultural District team on marketing, fundraising, and strategizing about how to use the project to meet Lisa's original goal of cultural preservation. The District paid Forklift a commissioning fee, but we also raised money and used our City of Austin arts grant dollars toward the project. We did joint press conferences and collected donations for repairs to the field and for Forklift over a full weekend of events in May 2014, which included a family-friendly Saturday festival with musical entertainment, exhibition baseball games, and food trucks.

Play Ball Downs Field was a dance in nine innings. Production designer Stephen Pruitt recommended we stage it like a baseball game, but instead of sitting people in the stands, where space was limited, place the audience in the outfield. The Huston-Tillotson players presented pitching drills to a hip-hop beat, tossed baseballs high in the air in a choreographed wave, and showed off their swings as the band played a merengue. We commissioned two slam poets, Allen Small, who had performed in *PowerUP*, and Huston-Tillotson alum Robert Smith, aka Scot Free, to create original poetry to accompany choreography and serve as announcers during our "shadow ball" sections—three moments of staged play that nodded to the Negro League tradition of warming up before a game by playing without a ball. Local jazz legend Pam Hart led the audience in the National Anthem and performed her version of "Take Me Out to the Ball Game." Ephraim Owens, one of Austin's most highly regarded jazz musicians, played a riveting opening trumpet solo for the overture.

Our challenge was how to authentically share the history and vital role of Downs, knowing that our primary performers, the college players, had not lived that history. Even though they were attending an HBCU and knew the names of baseball greats like Satchel Paige, Smokey Joe Williams, and Willie Mays, they, like many of the new residents to the neighborhood, had not known that those legends had played on Downs Field. Coach Moore took on a leading role as our bridge to the past. As

Figure 4.1. Huston-Tillotson players performing shadow ball with slam poets Robert Smith (aka Scot Free) and Allen Small. Photo by Amitava Sarkar (photographyinsight.com).

Figure 4.2. Coach Moore dragging the field in *Play Ball Downs Field*. Photo by Amitava Sarkar (photographyinsight.com).

he dragged the field twice, in a duet with his riding mower, recordings of his memories played over the loudspeakers, accompanied by Graham on piano.

> We were having a routine baseball practice at Downs Field. I noticed a limousine pulled up in the parking lot. A gentleman got out and slowly walked in, looked around right field and started hollering "I'm home at last, home at last!" He said, "Gather round," and as we all stood around second base, he said, "I'm Buck O'Neil."

O'Neil, a legend of the Negro Leagues and the first Black manager in MLB, had played on Downs Field in the 1950s when he had traveled through central Texas with the Kansas City Monarchs. Coach Moore smiled remembering that day, in 2004, when O'Neil was in Austin for a statewide celebration for Willie Wells: "O'Neil was happy to be back in Austin, happy that youngsters were playing baseball again. Most of the kids on the field with me were Black, and he was glad that these kids loved baseball because, he told them, 'it was a great game to play.'"

Returning to the field for community, continuity, and tradition—not unlike rounding the bases to go home—emerged as an abiding theme. Downs Field represented the home that the Negro Leagues, semi-pro Black baseball and East Austin had provided to Black central Texans. At the same time, Coach and many other community leaders feared the history was being forgotten, with so many residents moving away, and comparatively few people coming by the field, alone or with their families. Lisa hoped that by sharing the stories of the field's vibrant past, we could spark a desire in the community for people who had grown up there to return. Kenneth Thompson, longtime East Austin leader, shared after the show, "A place I call home is rebirthed. A place where a lot of good things took place and were cultivated is still known to have value."

Play Ball Downs Field also sought to share the value of the field with the new people—mostly White, and mostly with higher incomes than longtime residents—arriving in East Austin. As Lisa explained, "There is this Christopher Columbus syndrome when people move into a new neighborhood, that they have discovered something new. But as new residents, you are really just the last one to walk in the door." Lisa was clear that these new residents needed to be educated. "This is our responsibility as storytellers—to tell people that this place has a history and they need to know about it." She was pleased by our success. "In Austin, you are hard-pressed to get public acknowledgment of Black stories that are Black-centered. So I was pleasantly surprised by the support that we received and the money we raised as a result." After the project, the city of Austin pledged funds for much-needed upgrades to the field. Final

restoration of the historic stands is still underway, but now when visitors arrive, they are greeted with a new green wooden fence with artfully crafted signage, a series of colorful murals celebrating the Black players who graced the field, by artist Reginald Adams, and a plaque designating the field as a Texas Historic Landmark. Downs was the first baseball field to get historic designation in Texas, in 2015.

More and more, I understand our role at Forklift as means of resistance to cultural and historic erasure. This is one of our most important jobs as community-based artists. We cannot put a halt to the forces remaking local demographics; over the next ten years, Austin is expected to become both richer and Whiter. But we can support the people who, through their skill, expertise, and commitment to community, have made Austin into the city that it is. As artists, we can help long-standing residents share the stories of their neighborhoods and history on their terms and set up opportunities for newcomers to listen and learn. I credit Lisa with pushing us to explore the work of maintaining, building, and sustaining a community. Krissie and I continue to work with many East Austin leaders we met for the first time while working on this project, and our collaborations have pointed us toward what have become Forklift's guiding questions: How can performance be a catalyst for something larger? How is this dance not the end, but the beginning of something for the community and for us as artists? As we have expanded our sphere of collaborators, to include not just Austin city departments but also neighborhood groups, colleges, and organizations around the world, we endeavor to use our dancemaking practice to inspire, activate, and build capacity for community-led change.

■ "Interested in trees?" That was the subject line of the email I received in the fall of 2013 from Angela Hanson, then urban forester for the city of Austin. Angela knew about our collaborations with AE and ARR, and wondered whether Forklift might want to create a production with Austin's Urban Forestry employees. "We use some very unique motions in our daily work and use large, specialized equipment. At times, we even use ropes and climbers to do our work." Not only did Angela know how to speak directly to my choreographer's heart, but—in a reversal of how our collaborations with city departments had gone thus far, with their series of pitch meetings and efforts to drum up support—she was inviting us. This felt like a breakthrough, and Krissie and I jumped at the chance to visit with Angela and her team and learn more.

Upon meeting the urban forestry crews, we immediately felt the distinct culture of this work group. These arborists and technicians were somewhat reserved and introverted—they liked spending hours in the trees alone—and they approached their work with deep love and care.

Figure 4.3. Ray Avilez in *The Trees of Govalle*. Photo by Leon Alesi (leonalesi.com).

They were stewards of our city's largest, tallest, and oldest living organisms, and when beloved trees died, they sometimes found themselves consoling residents. I was struck by the fact that, unlike other groups of employees with whom we'd worked, the foresters nurtured living things through both life and death. At the time, I was reckoning with the cycle of life myself: my father was diagnosed with cancer while we were making this dance. A lover of trees and the outdoor world, he managed to hang on through the show, sitting in the audience in his wheelchair under the limbs of the majestic trees in East Austin's Govalle Park.

We had decided with Urban Forestry and our friends at the Fusebox Festival, who were featuring the dance in their annual spring lineup, to stage the dance in Govalle Park, where a stunning heritage pecan tree became the center of our stage. Entitled *The Trees of Govalle*, the dance included arborists climbing the tree—using ropes to ascend into the tree's colossal canopy—swinging from branch to branch in coordinated timing. They also performed a group dance with wheelbarrows, circling the tree and winding around each other in figure eights. Toward the end of the show, every employee mulched the great tree in coordination with the music, demonstrating to the audience the beauty of this essential work.

Turning to this project after our work at Downs Field, Krissie and I wanted to root the dance in place, so we decided to incorporate neigh-

borhood voices along with those of the arborists. We got to know three longtime residents who had all grown up in Govalle Park: Sylvia Donley, Johnny Limon, and Pete Rivera. Their voices served as a running narration, sharing in both Spanish and English what it was like to grow up with the trees there. Sylvia also performed as a musician, playing guitar with her father, musical legend and longtime neighborhood resident Manuel "Cowboy" Donley. In the 1950s, Donley was Tejano's first rock star, with his *orquesta*-inspired band *Las Estrellas*. Manuel and Sylvia performed four songs in our performance, including *Las Estrellas*' biggest hit, "Flor del Rio," which accompanied the foresters with the chipper machine, as they converted branches into mulch. The duo also played "Sin Ti," a *trío romántico*–style ballad, as master arborist Maurizio Seguro, who himself often sings Mexican love songs to the trees, carefully climbed the branches of the giant pecan tree.

With the help of intern Clara Pinsky, at the time an undergrad student interested in combining art with civic action, we created a partnership with Tree Folks, a local nonprofit that leads urban forestry education, community tree planting, and reforestry efforts in central Texas. Their staff arborists greeted audience members as they arrived, answering questions about how to care for local trees. Tree Folks also set up mulching stations where audience members, before or after the show, got a chance to mulch a tree and experience some of the physical care our city trees need. We hoped the audience would come away not just with a deeper appreciation for the labor that goes into protecting the parks, but with a greater desire to become stewards of our urban forest themselves.

■ Moments after the performance of *The Trees of Govalle* ended, then director of Parks and Recreation Sara Hensley walked right up to Krissie and me. With a gleam in her eye, she got straight to the point, saying, "Will you do pools next?" Shocked and a little befuddled, I thought to myself: "Pools? How can you make an interesting dance at a pool? I mean, how many times can you watch someone jump in the water?!" But Krissie and I were not about to turn down a department director, so we met with Sara to understand more.

Austin Aquatics was in a crisis. Austin has grown tremendously over the past two decades, and as climate change heats up the summers, the city needs safe places for people to cool off, and more of them. Austin has one of the most sizable public pool systems in the country, but the pools are old—on average over fifty years old. A pool typically has a thirty-year life span, and even Austin's newest pools, built in the 1990s, were pushing past their expiration dates. The small maintenance team struggled to keep up the pools, many of which were routinely closed with leaks or in need of other repairs. Aquatics was also short-staffed, and struggled to hire and

retain a sufficient number of lifeguards. Residents on the wealthier, west side of town were frustrated, but could often access private and country club pools instead. East Austinites, on the other hand, felt ignored and dismissed: neighborhood public pools tended to be their only options, but across the full aquatics system, those pools were most in need of upgrades, and likeliest, on any given day, to be closed for repairs. This was a hornet's nest of a problem, and there was an undeniable feeling of hopelessness among city staff, aquatics advocates, and neighborhood leaders.

After a few meetings with Sara and the department leads, talking with local pool advocates, and consulting with some of the East Austin leadership with whom we had worked on *Play Ball Downs Field*, we proposed *My Park, My Pool, My City*, a multi-year collaborative project. Krissie and I had been looking for a way to work with a city department beyond just one show. We wanted a chance to really dig in, with sufficient time to build relationships and seed conditions for change. Aquatics agreed, and together we decided to make three dances over three summers at three different pools in East Austin. East Austin was most affected by the Aquatics crisis, and we wanted to change that. The racial inequities around access to water are part of why, both nationally and locally, drowning rates are higher among children of color compared to White children. Aquatics staff agreed with us that they needed to do a better job of engaging East Austinites in swim lessons and swim teams, and of training and hiring youth from those communities and neighborhoods as lifeguards.

As outsiders, we knew we had a lot to learn about Aquatics and the history and current issues surrounding public pools in East Austin, so about nine months before the first dance premiered, we formed a Citizens Advisory Committee. Laura Morrison, a past city council member and longtime public pool advocate, chaired the committee, which was made up of East Austin leaders and citywide Aquatics advocates. They provided valuable advice about how to build relationships and design our programming. We also read about the violent desegregation of our nation's swimming pools, and how the racist reactions to integration, including both White flight and changes in funding priorities, led to drastic decreases in government money for urban pools that served families of color. In Austin, "swim-ins," led by Black high school students in the summer of 1960 at Barton Springs, Austin's iconic, spring-fed watering hole, led to its becoming, that fall, the first integrated pool in the city. In 1963, the Austin City Council finally integrated all city playgrounds, pools, and Parks and Recreation programming. But from the 1970s onward, city dollars did not make sizable investments in public pools and parks, especially in East Austin. "The legacy of discrimination created a lack of resources, and as a result, those parks deteriorated over long periods of

time," explained local NAACP president Nelson Linder in a 2018 article for the *Austin Chronicle*.[1] "Because they didn't invest in those parks, they didn't invest in East Austin." Austin's Parks and Recreation Department has remained underfunded for decades. Upgrades to park and pool infrastructure can only be paid for with public approved bond money, and between 1998 and 2018, Austin voters only passed three recreation bonds.

With Aquatics leadership, we chose Bartholomew Pool for our first performance site; the dance would be titled *Bartholomew Swims*. Located in northeast Austin, Bartholomew Pool has served the Windsor Park, Mueller, and Pecan Springs/Springdale Hills neighborhoods since 1961. We began inviting neighborhood residents who had grown up swimming at the pool to join our committee, along with the swim coach and some of the high school students from Northeast Early College High School, where we held our committee meetings. The high schoolers were part of a program called SWIMATX, which works with East Austin high schoolers in their PE classes, supporting them as they learn how to swim and train to become lifeguards. A number of these youth joined our production as lifeguards; one went on to become a pool manager and performed again in our third-year production.

Right away, Krissie and I began shadowing the Aquatics maintenance team, headed by Paul Slutes. We rode out with the staff in their trucks, getting to know them, observing as they did daily pool maintenance, and learning about the challenges of keeping up such an old system. We got multiple pump room tours, and watched Paul and fellow staff member Juan Hernandez scuba dive to repair cracks in a pool. The team had a hands-on understanding of the Aquatics infrastructure crisis, and they came on board with the project quickly. Paul even called me one morning and asked me to come over to the office. He had watched *Trash Dance*, the documentary about our collaboration with Austin Resource Recovery, and had ideas for choreography to show me!

One morning in 2008, Juan and his fellow maintenance employee, Jonathan "Tap" Tapscott, walked into the underground pump room at Bartholomew Pool, adjacent to the deep end, and saw water from the pool cascading through a quarter-inch-wide crack in the wall. As Tap put it, in a recording he shared in the show: "Part of the ceiling was caving in, and this was right next to the pit. All I could think was that there were five hundred thousand gallons of water on the other side of that wall." He and Juan alerted Parks leadership, and the pool was closed. Fortunately, Aquatics had money from a 2006 bond package, and after five years of construction at a cost of $5.7 million, the redesigned pool opened in 2014, with two water slides, a zero-entry pool, lap pool, and diving well. It became a destination for swimmers of all ages from across, and even outside of, the city, and annual attendance was triple that of its pre-closure

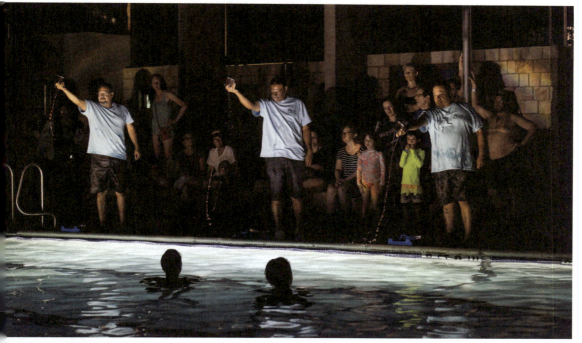

Figure 4.4. Paul Slutes, Jonathan "Tap" Tapscott, and Juan Hernandez performing a chemical test in *Bartholomew Swims*. Photo by Lynn Lane (lynnlane.com).

numbers. "It's the Rolls Royce of Austin's Aquatics system," shared Paul, "Bartholomew is the jewel in our crown."

Tap had grown up swimming at Bartholomew Pool, and told Krissie and me that long before the pool was spruced up, it had been a central gathering place for northeast Austin, especially for Black students from area schools. He recalled, "The last day of school you saw everybody at Bartholomew—even friends from junior high. It was a huge pool party with good friends having fun." The love Tap had for the old Bartholomew resonated with what we had heard from other longtime residents, too, and we wanted to begin the show grounded in that rich history of place. Paul, Juan, and Tap became our lead storytellers, and at the performance, they guided audience members through an interactive section where the audience held hands to form the border of the old pool, embodying what had been there and connecting people, literally and figuratively, to one another and to the site.

Involving the audience in this way also solved a choreographic dilemma: the design of the new Bartholomew did not include a large-enough expanse for an audience to sit. By having the maintenance team guide the audience from place to place, we could ensure everyone could see all three pools as they took in different choreographic actions. Krissie and I didn't know how to fully do this until we had our dress rehearsal

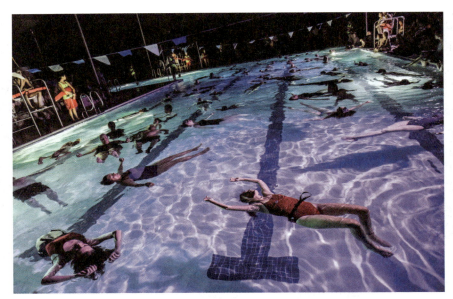

Figure 4.5. Audience members joining the performers at the end of *Bartholomew Swims*. Photo by Amitava Sarkar (photographyinsight.com).

and tried it with two hundred fifty people. Immediately, we saw where the structure wasn't working, and on opening night had new lines and directions to give Juan, Paul, and Tap. Luckily, they had excellent memories and adjusted quickly!

An image that came to us early in our days hanging out at Bartholomew was of floating on one's back, the first thing one masters when learning how to swim. We loved watching people float—children and adults alike. Nearly everyone could do it, and it suggested such ease, as people were supported by the water, trusting both it and themselves. For the end of dance, the maintenance team invited the audience to join them in the largest pool to float on their backs. "I trust our pools, I trust our pool system," said Paul, via the soundscore, as he took off his maintenance shirt and, in his swim trunks, waded into the pool. Juan and Tap followed, and the pool gradually filled with audience members, all floating on their backs. The music faded as Tap's voice ended the dance: "Everyone deserves access to pools, that's why we do our jobs. So everyone can have access to pools."

As we worked on *My Park, My Pool, My City*, local and national grants, including an Our Town award from the National Endowment for the Arts, an Engaging Dance Audiences award from the Doris Duke Foundation, and funding from the St. David's Foundation in Austin, allowed Forklift to expand our team substantially. Miriam Conner, who had worked with artists and community members in East Austin for years, came aboard as community engagement coordinator for the full three years. Clara Pinsky

returned each summer, supporting the artistic team as a rehearsal director and choreographic assistant. For years two and three, we hired San Antonio–based choreographer Fabiola Torralba as an assistant choreographer and master community organizer. Fluent in Spanish and a seasoned cultural worker, she guided the team in our relationship building with Spanish-speaking participants and recent immigrants. In the second two years, we also added a youth leaders program, managed by assistant choreographer Gretchen LaMotte, to hire, train, and incorporate neighborhood teens into our dancemaking, marketing, and community engagement. In 2015, Forklift had two lead choreographers; by 2018, the second year of *My Park, My Pool, My City*, we had expanded to a team of six artistic staff members plus three administrative members and three interns. Aquatics selected the Dove Springs neighborhood pool for our second-year performance and Givens Pool for the third year, and we prepared for a level of community engagement that transcended anything Forklift had endeavored to date.

As always, we needed to show up ready and willing to listen. This meant sitting down with neighborhood leadership in the fall to introduce ourselves, talk together about the project, and hear their needs and concerns. We did multiple home visits, attended school PTA meetings, participated in park clean-ups, showed up at important neighborhood events like the massive Thanksgiving meal at the Dove Springs Rec Center, and were guests on community radio station programs. We met with groups who have long worked in the Dove Springs or Givens neighborhoods, and ended up partnering with a few, including Dove Springs Proud (a neighborhood-based advocacy group), GAVA (a grassroots community health organization), and the Givens Park Hands Full of Cash Car Club, whose members joined our neighborhood block walking, shared stories, and even performed in the show.

We also held advisory committee meetings to ensure that we could work closely with neighborhood leadership on an ongoing basis. Gathering at the neighborhood recreation centers at times that would accommodate our committee's often changing schedules, we worked hard to set a welcoming tone. We built in plenty of time for people to settle in and connect informally before the meetings revved up, always providing food to boost a sense of conviviality, and only ended meetings once everyone had time to share their thoughts. Early in the Givens project, Miriam reached out to a number of Black community leaders, successfully recruiting some to come to our meetings, including longtime track and field coach and past Aquatics district supervisor Carment Kiara. Carment was clearly skeptical of us and our project—here was one more White-led organization coming into his neighborhood saying they were going to do some good. He was honest about these concerns; when we first met

at a meeting, he looked me in the eye and said, "I don't care about what you say—I want to know what is your heart." I took a deep breath, then answered, "This is your community, your pool, your story. If at the end of our project, you say 'Allison, I am proud of what we made,' then I will be happy. I am hoping I can earn your trust." I knew it would take time.

Carment wasn't the only one who was concerned about whether and how our project would truly benefit his neighborhood. After other East Austin activists raised important questions about how our project could support and bring resources to local, neighborhood artists, we answered with a new component for the third year of the *My Park, My Pool, My City* collaboration in Givens. Krissie, and Miriam, with support from ongoing adviser Lisa Byrd, worked with the City of Austin Arts in Public Places Program to commission two neighborhood artists, photographer Cindy Elizabeth and muralist Ernesto Hernandez Ramirez, to create temporary visual art pieces installed at Givens Pool. These artists created their own works inspired by the history and community of Givens Pool, expanding the range of voices and perspectives for audiences while contributing to the city's understanding of place as it made plans to redesign Givens Pool.

Cindy Elizabeth's project, *Allegiance*, featured videos and portraits of Givens community members flying high on flag poles, and stood, as she put it, as a "representation of a people staking claim to their cultural landscape, ancestral memory, and communal well being."[2] Ernesto Hernandez Ramirez's mural *Perspectives on Givens* featured colorful images of park community members, including park namesake Dr. Everett H. Givens, Ada Harden and her sisters, and Hands Full of Cash Car Club, accompanied by African Adinkra symbols in the background. A 4D augmented reality mural, people could hold up their smartphones to the mural to see images and videos about Givens Park and Pool. For Ernesto, "These images represent the hope the community has that this park and pool can be enjoyed for generations to come."[3]

Working with Cindy Elizabeth and Ernesto gave us the opportunity to collaborate with other artists, getting their unique viewpoints on the role of Givens Pool and Park in the lives of the community. They also reached additional community members through their process and projects, inviting them to the Forklift shows while bringing them into the larger questions around the future of the park. Givens is Cindy's home park, and we sought her feedback on components of our show. Also, both she and Ernesto created visual art pieces that remained installed long after our show weekends concluded (Ernesto's mural is now permanently displayed in the Givens Recreation Center). City staff's experience witnessing their work also gave staff members a new perspective on how a permanent public art piece could function, sharing the stories of the long-standing community at the future, redesigned Givens Pool.

Figure 4.6. Artist Cindy Elizabeth presenting her artwork *Allegiance* as community participant Kurtiss "Mr. Oowee" Colvin Sr. installs the flag with his portrait. Photo by Jonica Moore (jonicamoorephotography.com).

Figure 4.7. Muralist Ernesto Hernandez Ramirez with collaborator David Flores in front of *Perspectives on Givens*. Photo by Justin Humphrey (justinhumphrey.com).

Figure 4.8. The opening *paseo* with the cast of *Nadamos Dove Springs*. Pictured from left are Ofelia and Tim Zapata, Raquel Ramos, and Destiny Hastings. Photo by Jonica Moore (jonicamoorephotography.com).

■ Once summer hit, we shifted into high gear, recruiting neighborhood residents to perform in the shows. We started by hanging out at the pools — all the time. We talked with people who, we noticed, used the pools frequently, including children with their parents, teens, and adult swimmers. We attended pool swim team practice, befriending swimmers and their parents. Some days we gave out popsicles, telling whoever took one that we were making a dance and looking for help. We explained that anyone was welcome to participate and all would be paid a stipend. People who came back got a part in the show. We also walked door-to-door in the neighborhood, inviting people to participate while also sharing information from Aquatics about free swim lessons and registering people to vote. All this time we were listening to whatever residents wanted us to know about their beloved neighborhood and its pool.

Thanks to these efforts, *Nadamos Dove Springs* featured four Aquatics maintenance team members, eleven lifeguards, and thirty community members. Community involvement in *Givens Swims* was even more robust: in addition to five maintenance staff and nine lifeguards, the cast expanded to sixty-one community members. Their levels of comfort with swimming varied considerably. As choreographers, we saw this as a chance to eliminate barriers to participation, and we found ways for people who were new to swimming to get in the water, be supported, and feel safe. Working with the cast, we designed choreography with kickboards and ensured that people could stand easily throughout their sections. Young children were given special roles to splash in the pool or jump

Figure 4.9. Members of the community cast performing in *Nadamos Dove Springs*. Photo by Jonica Moore (jonicamoorephotography.com).

off the edge safely to their parents. Those who loved to dive were given a chance to perform their favorite jumps off the diving board. We worked to make space for all to show their expertise and skill, making it easy for people to say yes to joining in.

Nadamos Dove Springs celebrated the community of Dove Springs, a diverse neighborhood of Latino/a, African American, and White families. Responding to the neighborhood's culture and language preferences, we created a bilingual show, with all of our marketing materials, rehearsals, audio narration, and post-show talk in English and Spanish. In the 1990s, Dove Springs had some of the highest rates of juvenile delinquency in the state, and grassroots organizers rallied for much-needed resources and support for their youth. This pool and accompanying recreation center, which opened in 1998, were the results of their efforts, a victory that residents were eager to celebrate. The dance featured many community leaders, like longtime organizer Ofelia Zapata, who performed a solo walking and swimming in the shallow end as she shared her love for water and movement via a soundscore. Ofelia is visually impaired, and she memorized her choreography exactly so she knew how to get back to the pool steps effortlessly for her exit. About midway through the show, neighborhood teens, elders, and other leaders, including Ofelia, Constable George Morales, neighborhood organizer Ricardo Zavala, and community police officer Rosie Perez, gathered on the steps of the pool to share their stories of Dove Springs. The recorded narration, which played over the loudspeaker, included:

> Había mucha oscuridad en nuestra comunidad.
>
> We had a bad cloud over us, a troubled neighborhood. You think about it—how do you change something like that?
>
> What we had to do is step up. We had to commit.
> Tuvimos que comprematir a trabajar juntos.
>
> The people are what make this neighborhood. We get a lot done with a lot less around here. And this neighborhood's really resilient.
>
> Gente por gente en Dove Springs.
>
> We've come a long way. This is no longer the Dove Springs of old. We deserve to shed the shadow of the past. Cause we're only moving forward.
>
> Mi sueño para Dove Springs es que nuestros hijos y nietos continúen trabajando juntos.

As this voiceover concluded, the band kicked into the opening of the classic ranchero song "Volver Volver," a song about love lost, which was sung by Paul Sanchez. Teenager Rowan Rodrigues, longtime member of the Dove Springs Ducks swim team, elegantly dove into the water just as Paul began the first verse. Rowan swam across the full expanse of the pool as his fellow community members, still gathered around the stairs and lit up by spotlights, watched and applauded. Just as Paul approached the chorus, Rowan turned onto his back, paddling his long arms languidly through the water in rhythm with the song's passionate pleading. This swim and accompanying song was a means to acknowledge the struggle the community members had just shared, with the understanding that, for better and for worse, they could not return to what had been before. The entire crowd joined in, shouting *gritos* (a common interjection in Mexican culture that expresses joy or excitement, often accompanied by trailing vocal trills) and belting out the chorus with gusto, demonstrating a communal pride in the neighborhood and all it has undergone.

Givens Pool, the site of our third and final performance with Aquatics, was the second pool built for Austin's African American community, in 1958. (Rosewood Pool, built with WPA funding in the 1930s, in the then city-mandated "Negro District," was the first.) At the time, Givens was a middle-class neighborhood, home to many Black families. The pool was a beauty when it opened, with long lap lanes, two low dives and a high dive in the deep end, and a concession stand. But now it was over sixty years old, cracked and leaking, and had been allocated no city funding for the major upgrades it needed. The maintenance crew had taken us and our advisory committee into the old pump room and underneath the pool to see the wet ground and rusted, cracked pipes for ourselves. The crew, I realized, was working to keep it on life support.

Fortunately, the passage of the 2018 bond package meant that Aquatics was finally allocated the money it needed to upgrade Givens Pool. By early 2019, as we were preparing for our summer performance there, conversations about what the next Givens pool might look like were underway. The stakes were high, as Givens Pool and Park is one of the last public gathering places for Black residents in East Austin. "Givens is that legacy that was passed down — the activities, the communion. It represents Black fun and Black love," explained Nook Turner, hip-hop artist, activist, and commissioned *Givens Swims* performer. But due to decades of systemic racism, many Black Austinites deeply distrust city leadership and staff, and feared they would not lead the effort to redesign this historic community treasure with sufficient care. How could they ensure that a new pool would reflect the history of the original Givens Pool? Besides, neighborhood residents told us, the Givens neighborhood was quickly becoming home to more affluent, White homeowners. Would an upgraded Givens

Figure 4.10. Nook Turner, featured musical artist, in *Givens Swims*. Photo by Justin Humphrey (justinhumphrey.com).

Pool mean that even more such newcomers would flock to the neighborhood? Was Parks and Recreation finally getting around to putting Givens on the upgrade list just to serve these newer, White residents? Parks and Recreation leadership knew they had to answer these questions, and that without buy-in from the community, their responses would not be trusted. They needed not just to build a new pool with meaningful local input, but also a way to understand and share how important Givens Pool was and could continue to be. We were ready to help.

We began by learning the history. Our community engagement coordinator, Miriam Conner, contacted longtime Givens Black leaders, who emphasized how important Dr. Everett Givens, one of Austin's first Black dentists and the park's namesake, had been to the community, advocating for civil rights activism from the mid-1940s on. Partners from our Downs Field project introduced us to residents like Ada Harden, an actress and producer who grew up across the street from Givens Pool. She described the pool as a gathering place, a place to see and be seen. Every Sunday after church, she and her sisters would head over to the pool and the park (if there wasn't a game happening at Downs Field). Ada encouraged us to keep looking for people who had grown up swimming at the pool, even if they had left the neighborhood. We tracked down men who were lifeguards at the pool in the 1970s, including Robert Freeman, Carment Kiara, Billy Owens, and Tracy Smith, who all described their jobs at Givens as highlights of their lives. They each appeared in the show, climbing up on the lifeguard stand in uniform and shouting out orders.

We also hired Azure Brown, a professional researcher and certified records manager who was born and raised in East Austin, and who had worked with us on the *Play Ball Downs Field* project, to guide us into the

pool's past. Azure immersed herself in the archives at the Austin History Center, where she learned about the Miss East Austin beauty pageants that had taken place at Givens Pool in the 1960s. Azure activated her network to find Miss East Austin beauty pageant participants who agreed to share their memories. I remember how easy it was to identify these pageant winners when they walked into Givens Pool to meet with us, just by the confident, elegant way they strode through the pool gate and extended a hand to introduce themselves. Of the many memories they shared, we were all struck by the fact that pageant organizers had built a bridge for contestants to walk over the pool during the swimsuit competition. We wanted to acknowledge that fabulous feat of stage design in some way, so Stephen Pruitt designed a floating catwalk for the five beauty queens who performed—Creola Shaw Burns, Bernadette Cay, Midorie Clark, Pearl Dilworth-Cox, and Mary Miller—to walk out on. These women crafted the choreography for their entrance, costumed in coordinated bathing suit wraps designed by Midorie and crowns fashioned by Azure. As the band kicked in to an upbeat Louis Jordan–inspired jump blues number, the women skillfully promenaded down the catwalk, pivoting and waving as the audience applauded. One by one, they walked to the side of the pool and stepped into floating pool chairs, held in position by young men from the cast, who ferried the ladies to the center of the pool. At the same time, twenty community cast members, wearing matching pink, yellow, and blue bathing caps, created group designs, holding kickboards in their hands. From two straight lines facing the audience, they arched sideways one by one in canon, moving into two circles and then into four. The dance ended as the cast formed a large half-circle behind the beauty queens, holding their kickboards high as the beauty queens poised in their chairs and the horns hit their final notes.

That sequence was a pleasure to design together, but the question of how to address the end of this version of Givens Pool, which Juan, Paul, and Tap had told us would likely close less than a year after we mounted the show, sat heavy with Krissie and me. The new pool would be structurally superior, of course, but how could we reflect on the end of this era, thoughtfully and ethically, as part of the dance? We took the question to Jodi Jay, head of Aquatics, and got the OK to allow Juan and Paul to explain the structural issues the pool was facing through a scuba duet. We had included the choreography in *Bartholomew Swims*, but the reprise for *Givens Swims* featured new recordings of their voices. To begin the duet, Juan and Paul, dressed in full, black scuba gear with their masks already on, walked backward into the long pool from opposite sides and submerged themselves in unison. Graham played descending piano notes as Juan and Paul settled on the bottom of the pool and swam back and forth in opposition, traveling the full length of the pool in parallel

Figure 4.11. Mary Miller, Miss East Austin beauty pageant winner, with community cast members in *Givens Swims*. Photo by Amitava Sarkar (photographyinsight.com).

lines before coming together and swimming in a circle in the center. As they swam, the audience heard their reflections on maintaining Givens Pool, including:

> The amount of work that the mechanics are doing right now to keep that pool afloat is a job in itself.

> Until you go into our pump room and you see the actual problems that we have . . . Uh, yeah, it's a miracle that we've kept it afloat this long.

> You know, my job is to save pools. That's my job. Save pools. And this one is, Givens is, uh . . . it's at the end, you know, uh, leaking wise, it is a struggle every day. It's at the end.

When Juan and Paul came up from the water and took off their masks, the audience applauded with what struck me as a feeling of collective recognition: this firsthand assessment made sense. They knew it was time for the pool to change.

In the last section of small-group choreography before the grand finale, performed by the community cast, the full maintenance team—Paul, Juan, Tap, Allen Catterson, and Marcus Gutierrez—walked out onto the pool deck, one by one. To emphasize not just the work they did but the love that they brought to it, short clips of their voices played in time with their entrances, describing their affection for Givens. Then, in canon, they bent low to dip their test tubes into the pool, knelt as they added a few drops of chemicals, and stood to swing the test tubes, their left arms arching forward and back, mixing the pool water and chemicals together. They joined each other with the test kits held high in front of them, and in unison tossed the kits to flip them in the air, the water catching the light as it spun from their hands. Walking behind his team members as he traveled toward the opposite side of the pool, Tap's voice shared:

> I used to hang out there, because I pretty much knew everybody over there, too, like my own neighborhood.

> Everybody coming out on a Sunday, you gotta look good, you gotta have your car clean, you go ride through the park about a mile an hour. That's the Sunday thing. If you wanna get up and swim, you can, but sometimes you're looking too good for that, that day. Sundays were special at Givens.

> You know, a lot of people moved, and that don't mean you can't come back. I do. Sundays, I drive home that way. And I roll

through the park. Nine times out of ten, I'm gonna see at least fifteen people I know.

As Tap approached the diving board, his fellow team members continued on, exiting. But he lingered, climbing up on the diving board and walking carefully out to the edge. Lit by a spotlight, Tap bounced a little as he came to the edge of the board, as if he just might go for it. Instead, he lifted up his eyes and gazed across the giant pool as a recording of his voice stressed how attached he remained to this place:

> They had good diving boards at Givens, yeah. They had two lows and a high.
>
> I turned to flip, and I turned too fast. And that was the last time I ever did it, a flip off the high board at any pool.
>
> When I come in, I'm going straight to the board. I might go to the shallow end, but eventually I'm going to be back on the boards. So that's what, that's my thing.

These closing words from Tap were followed by the entrance of the community cast to lead the finale, suggesting that the larger community all had their own attachments to Givens and to one another.

Givens Swims helped reconnect a community, including those who had been dispersed by gentrification and displacement. Many of the cast members subsequently came together to form the Givens Park Working Group, a group that is presently advising Parks and Recreation staff on the renovations and improvements to Givens Park and the new Givens Pool. Parks and Recreation developed deeper relationships with long-standing Givens community members who continue to engage in the park processes and with greater confidence and willingness to make sure Parks and Recreation follow through with their commitments.

Early in the Covid-19 pandemic, Steven Brown, a cast member and longtime resident who chaired the Givens Park Working Group, organized with Austin Public Health to make Givens Park a Covid-19 testing site. Brown, along with his fellow cast and Working Group members, was eager to address the devastating impact of Covid-19 on Austin's Black community. In June 2020, Black Austinites, who made up just 8 percent of the Travis County population, made up 13 percent of deaths.[4]

Spurred on by Brown's efforts and others in the community cast, Forklift hosted an online event in July 2020, one year after the premier of *Givens Swims*. We worked with cast leadership to virtually gather many of the cast members for an online event titled *We Are Here—Living into the*

Legacy of Dr. Givens. We paid stipends to all who participated, and we collected donations for Brown's nonprofit, which provides financial support to Givens Park community members. The event concluded with a virtual panel discussion with Black community leaders about Givens Park's successes and challenges, particularly the continued racial disparities the pandemic was amplifying in Austin.

Across all three years of *My Park, My Pool, My City*, the outcomes were extraordinary. We partnered with local urban planner and researcher Dr. Lynn Osgood, who with her team created a three-year comprehensive evaluation study. This included audience and participant written surveys, project evaluations completed by collaborators, in-person interviews with Aquatics staff and community leaders, as well as post-show story sharing with participating lifeguards, maintenance staff, and neighborhood residents. The information that was collected was compiled with an eye toward naming the specific outcomes that were created by the participatory creative process. Across the board, Osgood and her team documented improvement in swimming skills, a greater sense of self as a creative individual, heightened sense of concern for local pools, and expanded desire to take action in support of city pools for performers, community residents, and audience members. For city staff, the project increased morale and pride, improved communication, and brought the Aquatics team closer. For neighborhood residents, the project elevated community pride, positively impacted communication among community members, brought the community closer together, and enlarged understanding of community history. Citywide, the project expanded knowledge of the City of Austin's Aquatics system and its challenges, raised interest in pool advocacy, generated support for the eventual passage of a forty-million-dollar Aquatics bond package (the largest bond ever passed to support Austin Aquatics), and helped lead to an increase in Aquatics's annual maintenance budget. After a city budget manager came to one of the performances and understood for the first time the extraordinary challenges Aquatics was facing, she proposed that the city slightly raise admissions at the fee-based pools to increase the budget for pool maintenance. This led to an increase of $1.2 million annually for maintenance and repairs. Amazing!

City leaders and elected officials attended every year, and some even chose to participate in the show. The mayor and his wife joined the cast in an opening promenade around Dove Springs Pool, and a county commissioner volunteered to float on her back for one of our audience participation moments in *Bartholomew Swims*. Council members went off the diving boards at Bartholomew and Givens Pools, and joined in the finale for *Nadamos Dove Springs*. Physical participation in artmaking gave elected officials an opportunity to connect with the public they serve,

without the typical trappings of political power or protocol getting in the way.

The performances were full of information, but they also gave people a sensory experience of the value of the city pools and the people who care for them. The dance helped all of us, performers and audience alike, understand what it means to be part of these publicly funded, publicly stewarded spaces—all of us outdoors together, many in bathing suits, on sticky July nights that allowed for openness and acknowledgment of all that we hold in common. As a city councilwoman jumped into the water with her daughter, holding onto an oversized swan float for the dance's finale, she joined the rest of the cast in an exuberant celebration of the beauty of gathering, coming together on count with the music under the dazzling golden show lights.

■ Since the Forklift team began to expand, our production output has increased dramatically. For the first twelve years of the company, I produced a project at most every other year. Once Krissie joined me full time in 2013, we began to present new work every year. Since 2018, we have done as much as two large-scale projects every year. Much of that new work has taken place in Austin, but we have also been invited by arts presenters and other institutions to perform in new places. Touring, however, presents a conundrum. We are certainly not going to take the trash trucks on the road! So our questions have been: How can we tour our process? How can our presence as artists serve the local community? How can we maintain relationships once we have finished our dance and returned back home?

Our first touring projects were relatively small scale. I was invited by the Kyoto Arts Center to travel to Japan in 2014, as they were looking for a community-based choreographer to come and work in their city. They had worked with Liz Lerman and the Dance Exchange, and selected me both for my connection to Liz and what they said struck them, when they watched *Trash Dance*, as my "hopeful attitude." When they asked who I would like to work with in Kyoto, I had no idea. Back in Austin, Forklift was busy working on the Downs Field project, and when I learned that Kyoto was home to the world's only women's professional baseball league, it seemed like kismet. The leadership at the Kyoto Arts Center (KAC) took a leap of faith and called the Japan Women's Baseball League, and lo and behold, they agreed. They saw the value of creating an event to celebrate women's baseball, and they liked that a performance would be a unique way to garner attention for the team. Krissie helped me draft the sketch based on *Play Ball Downs Field*, making some adjustments and additions to incorporate the unique style and story of these women. We included a Japanese pop–inspired finale, a batting section that showed off the team's extreme athleticism, and a series of solos for star player Mika Konishi that

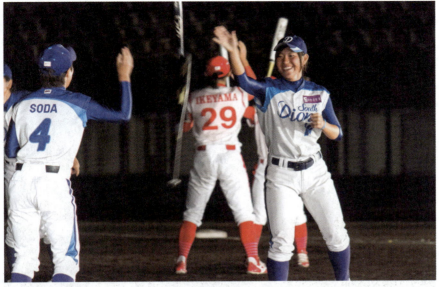

Figure 4.12. Members of the Japanese Women's Baseball League in *Play Ball Kyoto*. Photo by Takuya Matsumi (© Kyoto Art Center).

broke down the movement of pitching and shared a recording of her describing what she imagines she will think when she throws her very last pitch. I packed up my family, went to Kyoto, and had four weeks to pull a dance together, with the help of KAC organizer Eriko Kamimura, choreographic assistants Miyuki Kobayashi and Natumi Sadayuki, and translator and fellow dancer Kayo Fischtrom. The baseball players were extraordinary, enthusiastically learning choreography and even asking for more. Graham came over a week before the show, and with his keyboard and drum set, accompanied the show, which we called *Play Ball Kyoto*. The show was a success, with more than five hundred fans packing into the Kyoto stadium to watch. I was stunned that, on such a condensed schedule, the process had worked!

In 2017 and 2018, when Krissie and I traveled to Rotterdam and later to Barcelona to work with the International Community Arts Festival (ICAF) for two residencies in partnership with local sanitation workers, we condensed the process even more. We embedded with each group of sanitation workers for seven days and created a short performance. We knew the movement of trash collection from our work in Austin, so generating choreography was not hard, but as outsiders, we depended upon support and guidance from a seasoned team of locals to pull everything off. Thanks to months of advanced preparation by artists and organizers from ICAF in Rotterdam and comuArt in Barcelona, administrative staff and field-workers were ready and excited for our arrival. Wherever we tour, we have learned to ensure such leadership is in place, with the capacity

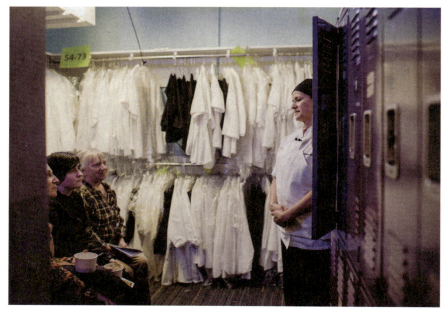

Figure 4.13. Leticia Guzman performing her solo in *Served*. Photo by Jonica Moore (jonicamoorephotography.com).

to support the local collaborating community both before and after our residency.

With encouragement from national dance leaders including Liz Lerman and Pam Tatge, currently the director at Jacob's Pillow, we applied for and won a National Dance Project Award to help fund a multi-year touring project called *On Campus*. Inspired by my graduate school choreographic project with employees at Mills, while drawing on decades of fine-tuning our process and approach, we created distinct dances for staff at three schools: Williams College, Wake Forest University, and Wesleyan University. We worked with dishwashers, cooks, custodians, maintenance teams, grounds crews, and physical plant employees—community members who are often employed for far longer than the four years most undergraduates are on-site. At the same time, we trained students to work side by side with us, shadowing staff on the job and building relationships of their own. We developed ways to make sure the campus community understood our process, and shared leadership not just with our direct collaborators but also with students who are forging their own identities as artists and leaders.

Together, we designed dances to reflect the unique people and work at each school. At Williams College, we used the campus's largest dining hall as our performance space, and began the dance, entitled *Served*, with small group tours of the kitchens and dishwashing areas, where employees performed group dances and solos. The show ended with the cast

Figure 4.14. The finale of *Served*. Photo by Jonica Moore (jonicamoorephotography.com).

Figure 4.15. Judy Dunovant in *From the Ground Up*. Photo by Ken Bennett.

presenting a choreographed buffet setup, extending down three large tables that they piled high with platters of food. The audience enjoyed the meal after the show as they mingled with the performers. At Wake Forest University, we created *From the Ground Up* with over sixty employees, including custodial staff, grounds crew, construction and maintenance crew, and the fleet crew. They performed their dance in the center of the main quad, with the iconic Wake Chapel as their backdrop. *WesWorks*, a performance with Wesleyan University facilities staff, premiered in October 2021 as the first in-person performance event offered to the general public since the beginning of the Covid-19 pandemic. A fully outdoor experience for audience members, the dance included small-group and solo performances at campus spaces including the power plant, a loading dock, and a glass-windowed art gallery. The cast of thirty-five employees then gathered on the terraced lawn in the center of campus, the space typically used for commencement, to present their finale, accompanied by lawn mowers, maintenance vans, custodial rolling trash bins, and a moving truck.

The process of making each dance created pathways for new connections. Students and faculty in the dance department got to know custodial staff, science professors learned about who repairs the plumbing, and employees shared their pride and skill with campus leadership. The

outcomes for the participating employees and wider campus community were consistent with our past projects—improved communication, pride, and morale, and greater recognition of the value of the work of these employees by students, faculty, and the administration. After our performance at Williams College, a group of students organized, prepared, and served an appreciation meal for staff. At Wake Forest, conversations have begun about whether and how to alter a decades-long tradition of toilet-papering trees on the main quad to celebrate sports victories, a mess that the grounds crew begrudgingly cleans up many Monday mornings. At Wesleyan, students have continued job shadowing employees through our ongoing partnerships with faculty and student leaders.

In all, the *On Campus* series spanned seven years, and over this time, we learned how to better engage students in our campus residencies. At Williams, our first campus site, we focused primarily on designing the project and developing the dance. A handful of students participated in job shadowing and as stage managers during the show, but we realized we could have engaged more students if we had attached our performance residency to a course. We set this up at Wake Forest, where two separate courses supported students to job shadow, get to know employees, and work on the production as rehearsal assistants and stage managers.

Figure 4.16. Mark Shouse, Bruce Avelar, and Mark Beckerdite from the fleet crew in *From the Ground Up*. Photo by Ken Bennett.

Figure 4.17. Custodial team members Felix Rosario, Victor Rosario, and Camilo Ramirez in *WesWorks*. Photo by Jonica Moore (jonicamoorephotography.com).

Figure 4.18. Employee Lloyd Jones with musician Manuel J. Perez III performing in *WesWorks*. Photo by Jonica Moore (jonicamoorephotography.com).

Because I had been in residence at Wesleyan in the 2015–16 academic year, our long-term relationships there positioned us well to implement some additional opportunities. We established an advisory committee, a network of students, faculty, participating employees and other staff who met throughout our two-year residency and will support additional organizing now that the performance has passed. Our project was part of a dance department course where students job shadowed and made their own creative projects with employees, and during the semester leading up to our show, Gretchen LaMotte and I taught a class where students led in the making, rehearsing, and presenting of the dance. With the relationships and momentum created by the project, students have begun to lobby for residential-life initiatives to connect with custodial staff, have suggested that there be student workdays at orientation, and are beginning the process of joint problem-solving with physical plant staff to advance environmental sustainability initiatives.

Each project was an expansive, cross-campus collaboration, and we worked with our campus presenters—Randy Fippinger of the '62 Center for Theatre & Dance at Williams College, Cindy Gendrich and Christina Soriano with IPLACe at Wake Forest University, and Fiona Coffey and Rani Arbo with the Center for the Arts at Wesleyan University—for over two years in advance to set up each project. We at Forklift had to learn how to explain our producing process, a process that we had always done on our own before, to our presenters. Jane Hirshberg came on early as our *On Campus* project coordinator, helping us negotiate budgets, timelines, and protocols with our host campuses. We figured out that we needed to prepare a document for our partners, laying out details from marketing to ticketing, cast meals to video capture. In all, the process taught us a lot about how to work outside of our home community. Our partners on each campus learned, as well. Rani Arbo at Wesleyan shared that "Forklift showed us how to deepen our commitments to long-term, collaborative projects that have the potential to transform not only our campus conversations but the way we, ourselves, can imagine and embody a more connected community."

■ As Forklift has evolved and changed over the past twenty years, so has my role as founder. When I first decided to form a nonprofit organization in 2003, I did so to earn teaching income; the first grant I received was to teach creative movement classes to preschoolers. I decided early on that I never wanted to devote myself to running a dance studio full time, for it was clear that I was happiest out in the field, learning from and making performances with others. But I believe that teaching will always be part of what we do at Forklift, too. It allows us to practice our craft as artists and is itself an important community-based practice. Krissie and I like

to say that if you can teach toddlers, you can teach anyone, and we learn countless lessons from all of our students, no matter what age. Teaching always gives me a chance to hone my skills and practice being in the present moment, as Liz Lerman advised me to do so many years ago at the Dance Exchange.

Since 2012, we have received funding from Austin Public Health to offer ongoing creative movement classes to children at partner preschools and elementary schools. This grant, along with additional fundraising, allowed the company to hire Krissie full time in 2014. Krissie and a team of teaching artists also work with area schools offering professional development to classroom teachers in how to incorporate movement into their lessons and teaching. We have learned to balance this work with our performance calendar, ensuring that we have the time and bringing in more administrative help so that we can check in with our teaching artists and our collaborating schools, keep up with necessary paperwork, and do regular project evaluation and training for our teaching artists.

I remain Forklift's artistic director and unofficial executive director, which means I am ultimately responsible for ensuring that everyone gets paid and that our work takes place in a healthy, well-run environment. Fundraising remains about 50 percent of my job, and I am the lead face of the company for our substantial fundraising efforts with donors, funders, and other institutional partners. I am also the principal visioning officer — I am looking five to ten years down the road, dreaming about projects but also strategizing about, and meeting with, potential partners as we develop future large-scale, multi-year collaborations.

I have spent and continue to spend a lot of time building and nurturing Forklift's board of directors. A successful board can support a nonprofit to thrive while a dysfunctional one can bring an organization to an end. I have learned to recruit not just people who love Forklift but also people who have the specific skill sets we need, such as an accounting background, connections with East Austin leadership, or fundraising expertise. We recruit by tapping into the networks of our partners, donors, and other supporters, and also by participating in citywide programs that support local nonprofits to diversify and build their boards.

Increased support from both full- and part-time staff has freed me up from managing some of the everyday details I had to consider in Forklift's early days, such as communications, marketing, and administrative tasks. Delegating is powerful work, though it has admittedly not always been easy for me. I am a typical founder: a first-born, type A, overachieving perfectionist with a relentless drive to work and an unwillingness to cede control. But the collaborative work we do perpetually teaches me to step aside and let others shine. So has Krissie, for she has worked diligently to design efficient processes and structures with plenty of time for planning

and implementation. I like to move quickly, often getting a moment of inspiration and wanting to follow through immediately. Krissie has taught me to slow down, provide clear context and clear information to other people, let them catch up both on their own and with my support, and enable them to implement ideas themselves. I have learned how important it is that others on my team have opportunities to try, make mistakes, learn, and succeed.

I am very proud of what we as a team continue to accomplish. I have learned to put more effort into nurturing this team as we have expanded, building community in the office just like we do out in the field making dances. Artists often feel bogged down by administrative work—the artmaking is the fun part, the reason we're in this job to begin with. But we ignore our other responsibilities at our peril. We need clear budgets and fundraising plans. I love my Excel spreadsheets, and I take pride in knowing exactly how every dollar is spent at the company. Overall, I have learned that the business of making our dances is central to the success of our artmaking, and I have learned to embrace it all as the work of being an artist.

■ Nurturing my family alongside my company has been instructive. When my daughter Genevieve was born, I was forced to get a little work/life balance. Admittedly, I had lots of help. My entire extended family lives in Austin, my husband has a flexible job that allows him to work less when I am in production or go out of town, and I have the financial resources to pay for child care. I couldn't have continued my work with Forklift without all of this support. My two primary jobs—mothering and artmaking—never end. There is always more I could be doing, and when I am doing one, I feel like I should be doing the other.

With my second child, JoJo, I hit a wall. He was born in March 2011, just six months before I remounted *The Trash Project* for an encore performance. I remember sitting in my bed, only three days after JoJo was born, exhausted and depleted. My midwife came in, saw the look on my face, and said: "Allison, your life will not always be shit in a can." I laughed ... a little. It was especially hard for a few years because JoJo barely slept. I remember sobbing on my kitchen floor, telling my sister-in-law that there was no way I could do it all. I couldn't, and that finally forced me to bring in more help, plan farther out, and in the end, build a stronger organization at Forklift.

I have done my best to keep my artmaking from taking me away from my family for extended periods of time. My family has traveled with me to Japan, Spain, and across the United States for my work. I packed up little JoJo and took him with me for a weeklong residency at a university in Louisiana when he was eight months old. I actually planned my pregnancies

around my shows (yes, I am an Aquarius), making sure I would have time both to recover and offer our fans steady performances.

When I have talked with my family members about Forklift, they all agree that the company has in many ways been a family project. My parents were Forklift's first and longest donors, and my sister, brother, and in-laws have all donated and volunteered at our shows. My husband and children have had to live around my work schedule, and it often seems that the company is like my third child. My children, one now a tween and the other a teenager, have seen this as good and bad. I wasn't always there to pick them up after school, and I missed special events and other activities that other parents, and my husband, attended. But, Genevieve explained to me, she and her brother have gotten to know people like sanitation workers and line workers whom they likely would not have met otherwise. Many of the people I have worked with in our dances have come over to our house for cast parties and remained friends long after the show was over. This has been perhaps the biggest gift my work has given me and my family—a life full of varied and interesting people, and a rich and complex understanding of the world.

■ Living through the Covid-19 pandemic reminded me that Forklift's work, at its core, is about giving people the opportunity to be in authentic connection with one another. Even though we couldn't assemble people together in person, we still found ways to gather. Our collaborators were eager to talk with us. We started by making phone calls, checking in on our dance partners who were essential workers. They told us about picking up double the amounts of residential trash as others shifted from offices to homes, maintaining our much-used parks, feeding college students in to-go containers, and keeping electricity running to our homes (especially after our state suffered massive power outages in February 2021). We wanted these stories to find a wider audience, so we contacted past institutional partners—including Austin Energy, Austin's Parks and Recreation Department, Austin Resource Recovery, Williams College in Massachusetts, and Urbaser, the sanitation company we worked with in Barcelona—and secured permission to record interviews with employees at work. Those conversations were the foundation for an online project entitled *On the Job* that allowed these essential workers' voices to be heard by audiences across the world.

For 2020, we had planned to present a yearlong series of in-person tailgates, performances, poetry slams, and story circles to celebrate the legacy and future of historic Downs Field. The project built upon our 2014 production of *Play Ball Downs Field*, and kicked off with a short reprisal of *Play Ball* in February, featuring players from the HT Rams baseball team and softball stories with Ms. Ada Harden. Photographer Cindy Elizabeth,

Figure 4.19. Huston-Tillotson baseball players reviewing performance notes with associate artistic director Krissie Marty. Photo by Hakeem Adewumi (hakeemadewumi.co).

whom we partnered with on *Givens Swims*, was on-site to take portraits of visiting Negro League Baseball players from the San Antonio region, who signed autographs and shared stories. Little did we know that this would be our last in-person, live performance for a year and a half.

When the pandemic shut down our city in March 2020, we had to pivot this project quickly. We held story circles on Zoom, connecting Downs Field community members who wanted the chance to come together safely and focus on a place they all loved. Most of these participants had worked with us either in the original Downs Field project in 2014 or for the 2019 Givens Pool project, though a few new people, including two recently hired baseball coaches from Huston-Tillotson, joined us, as well. With spring baseball canceled, Krissie and Gretchen LaMotte, our assistant choreographer, worked with Black community radio station KAZI 88.7 to present *Take Me Out to Downs Field*, a radio show in nine innings. We commissioned slam poets Allen Small and Robert Smith (both of whom had been part of the 2014 performance) to write a new poem together in honor of Downs Field, which was filmed at the field for an online broadcast premiere. Photographer Cindy Elizabeth created *A Beautiful Symphony*, a series of life-size portraits of community members and retired Negro League players that were installed on the field's wooden fence.[5] Audience members could visit the fully outdoor exhibit on their own and in small groups, giving people a safe, new way to engage with the history and community of Downs Field.

We continued to gather stories from Downs Field as well, now with

an eye not just for performance but for long-term preservation. Forklift artists, our advisory committee members, and project collaborators collected stories from longtime community members who grew up on Downs. kYmberly Keeton, Austin's African American community archivist, was on our project advisory committee, and suggested these stories could have a permanent home at the Austin History Center. Keeton helped us conceive of an oral history project where some of our advisory committee members and collaborators recorded interviews with people they knew who had grown up around Downs and with other former baseball players we had identified. After talking with our partners at Six Square, Austin's Black Cultural District, and Huston-Tillotson, we realized these stories could also be donated to the Huston-Tillotson Archives and the Carver Museum. This new focus on capturing history and connecting our community around historic research met our collaborators' ongoing need to document and share their history and stories. And in the long months when in-person gatherings were unsafe, and people lived through isolation and, in many cases, hardship and grief, our collaborators seemed to appreciate the opportunity to connect. Even when it is easier to meet in person again in the future, we may well continue some of these practices so that audiences and partner community members can engage with our work outside of our limited number of annual performances.

As I write these pages now, we seem to be coming out of the pandemic, and are in the process of launching new projects, including a multi-year collaboration with Austin's Watershed Protection Department and partnering neighborhoods. This partnership comes out of our desire at Forklift to engage with the perils of climate change, including Austin's increased risk for flooding. Austin has always been a city of creeks and rivers, but neighborhoods across the city will be facing new challenges as climate change brings heavier rains. I personally have much to learn about the science of this issue, the work of the Watershed Protection Department, and the neighborhoods who might wish to partner with us. I know that we will need time to build and nurture relationships, educate ourselves and each other, and make the kind of art that can address the complexity of the issues at hand, so we are planning for this project to unfold over five or possibly even ten years. I envision multiple performances and ongoing collaborations. I have learned that one dance can do a lot, but one dance can't do it all — and for a problem this tough, the collective work of job shadowing, advisory group meetings, community story sharing, oral history collection, and commissioning work from other artists matters just as much as, if not more than, what we present to an audience.

■ As Forklift continues to share our methods across the country and world, we have been fortunate to add Don Anderson, whose pas de deux

Figure 4.20. Softball player and Downs Field community leader Ada Harden performing her solo in *Take Me Out to Downs Field*. Photo by Hakeem Adewumi (hakeemadewumi.co).

Figure 4.21. Artist Cindy Elizabeth photographing retired Negro League players at Downs Field. Photo by Hakeem Adewumi (hakeemadewumi.co).

with his crane was a high point of *The Trash Project*, to our team. In addition to working full time, Don serves as a part-time community engagement specialist. Don grew up in East Austin, and though he never saw himself working in the arts, he has ended up contributing to them in significant ways, as both a performer and as an adviser as we continued to work in the part of town where he grew up. His lived experience, as an East Austin community member and as a collaborator, guides us in our project development and in our ongoing work to share our process with artists and non-artists alike. Krissie and I have learned that we cannot tell the story of our process alone. We need to tell it with our collaborators, together, just like we make our dances.

At a Dance/USA conference a number of years ago, Don and I were doing a Q&A after a screening of the film *Trash Dance*, and the audience included a number of nationally known choreographers. I was nervous, wanting to impress this group of artists with something smart and witty. Don, though, was relaxed, and shared with the group: "You know, before now, I never even knew you all existed!"

This, I realized, is exactly what we as artists need to be reminded of! Yes, we shouldn't take ourselves too seriously. But also, have we worked

to make ourselves known to, and valued by, the communities we want to serve? Because we can! Our communities need us—they need our imagination, determination, and skill at creating beauty and awe. But we can't simply wait for them to come to us. We have to put ourselves out there, even in places where we may fear we don't belong, so that we can learn from the communities we want to support and help address their needs.

Years after *The Trash Project*, Don's colleague at ARR, automated truck driver José Tejero, reflected on what it had meant to take time away from work, at work, for creativity. We sat in his office, where his desk was full of work orders and requests. Leaning back in his chair, he looked up at the ceiling for a moment and then said:

> A lot of people here are blue-collar, hardworking men. They just know one thing and that is to work and provide. They don't have time for other things—the inner things that they may have loved at one time. But the show allowed our inner child to come out and let us use our imagination. We get lost in being an adult sometimes and tend to forget that we do have imagination, but making the show reminded me we always have imagination.

José's reflections reminded me that play is very serious, and indeed vital, work. People, in all kinds of places and from all kinds of backgrounds, need a chance to reconnect to their inherent creativity. It gives our lives richness and depth in the moment, and it also allows us to imagine new ideas and new futures. When we do this collaboratively, led by our hearts, we can ignite our imaginations together, and we emerge transformed.

Appendix 1: The Steps

Forklift's Practices for Collaborative Performance

Collaborative, equitable partnerships take work. I have distilled a set of best practices, drawing on what I have learned from my own experiences as well as my mentors, fellow artists, and collaborators. I think of these as steps in the process, even though they don't always follow a clear linear order. Sometimes I stay with one step for a long time, or leave it and come back to it again. My hope is that these can assist you in your own efforts to build relationships within and across communities.

1. Be curious.
Curiosity, from a place of respect and humility, should guide every project. It can be what both starts and grounds a process, a mindset to return to when you hit obstacles or are not sure about where to go next. Take time to follow your curiosity before you sit down with a potential collaborator. Do initial research on the department, job, community, or organization to ensure that you have a sense of who you will be meeting. Make lists about what you want to know, or even what problem you are most interested in learning about. I read all I could about conducting while getting to know Austin Symphony conductor Peter Bay and making a dance with him.

Curiosity is also at the core of relationship building. When I show up curious, I bring my full self to an interaction, ready to give my full attention to the person I'm working alongside or interviewing. Be intentional, listen well, and keep yourself in the present moment. If you begin to feel anxious about what you don't know, return to curiosity, which can buoy you through the uncertainty. Remind yourself that "not knowing" can be an asset, a tool, and a chance for growth. Curiosity can give you the forward-facing energy to consider what you might learn, and how you might learn it.

My own curiosity tends to amplify as the project develops and my team and I begin to conduct more detailed, or deep, research. Don't lean solely on your collaborators or interlocutors to teach you all you need to know about their work or community. Keep seeking out information on your own, too. And as much as possible, learn what it is like to do that work yourself. I study it all—from seemingly mundane safety protocols

to lifesaving lifeguard drills. Research gives you a fuller, and often embodied, experience of the work, bringing you into sympathetic relation with your collaborators and spurring further questions and new ideas.

2. Nurture and work with warm connections.

When starting a project, think carefully about the first point of contact. This is a vital step, and if you don't put time and resources into it, the project might never get off the ground. We don't ever walk into a potential partner's office or neighborhood cold, and we certainly don't just send an email out of the blue—you can't build trust through email! Instead, we look for our warmest connection—someone who knows Forklift and can vouch for our credibility with our potential partners. If there isn't anyone like that in the organization, school, neighborhood, or community group we hope to work with, we look for who we know who could help us find a warm connection. I use this strategy time and time again, and at all stages of a project.

When beginning one project, I learned that my aunt was close friends with our main institutional contact—that helped! During another, I asked a long-standing community leader to come with me as she introduced me to an elder in her neighborhood. While working with gondoliers in Venice, I got to know a native Venetian choreographer who guided me in talking to the city arts office. For numerous city projects, staff have generously called their counterparts at other departments on our behalf. Find a warm connection and don't go alone. Also, think about how you are compensating and supporting the people who are helping you. We pay stipends to community advisers and are careful that our requests for introductions don't overly burden people or only serve ourselves.

Once a project begins, keep your eyes open for people within the organization who can be allies to your project. Look for people who have the capacity and expertise to take you under their wing and guide you as you work to build other trusting relationships. Sometimes such a person comes forward, seeing a way to support me and the project. More often, I am noticing the leaders in the organization—among the field employees and in the administrative group. I then thoughtfully approach people with small asks, gauging their capacity to help. Only when people demonstrate that they are interested and have the time to help me do I ask for more.

Of course, relationship building should extend beyond your key allies; my team and I endeavor to connect with all parts of the collaborating organization, at all levels. In working with the City of Austin, we have engaged with the field crews, supervisors, administrative staff, safety directors, human resource staff, chief executives, marketing staff, dispatch operators, garage mechanics, city council members and staff, among others. I have learned through mistakes not to ignore any group, especially

people in leadership. This group is often the most pressed for time, and it can be hard to find ways to authentically connect. But cultivating trusting relationships with these individuals will serve the project and all involved.

3. Listen for need, and work to meet it.

From an initial meeting with a potential partner and on through the rest of the project, listen closely for need. At our first meetings, my team and I ask questions like: "What do you most want the public to understand?" "What would make your work go better for you and your staff?" "What would you like to be different here in five years?" Essentially, notice how to craft your value proposition. What do people need, and how can a collaborative artistic process help to meet that need?

Staying attentive to need will help you shape a reciprocal relationship with your partners. Typically, members of institutional leadership are interested in working with us because of the benefits our projects bring to employees and the work environment. Our work improves morale at the job, enhances the public's understanding of the workforce, and fosters collaboration and cooperation among employees. Even though I am doing a lot of listening in these early meetings, I come prepared to speak about the positive outcomes we have seen in previous projects. And I listen to make sure that leaders do indeed voice this need, for it is important that we will have their support to spotlight often underrecognized employees and their expertise.

During this beginning phase, learn each other's languages: talk about what you are proposing in ways that make sense to the group, so that they can consider this new and potentially unusual proposition that none of you can fully picture yet. Go slowly in order to create a shared vision, which for us has meant coming back to the table over several months (or even years) to discuss and think about our potential project together. A good collaboration will require a lot of investment from everyone involved, so it is important that the pace enables you and your partners to stay with each other.

Keep listening for need once the project has officially begun. We continually check in with community participants, leaders, and field staff, ensuring that the project is on track to meet their own self-identified needs. And sometimes we don't have to ask, because if we are paying attention and really listening, people will share their concerns and hopes as we move forward together.

4. Set clear, mutual expectations, and check in over time.

Be rigorous about logistics, and ensure that you and your collaborating partners agree about how to cover expenses. Before partnering with city departments, for example, Forklift needs to make sure that city staff will

be paid to work with us. To be covered by liability insurance and workers' comp, staff need to be on the clock and paid by their employer. I also see this as an important sign of our partners' commitment to the project. And it is important for us to demonstrate that commitment, too. When working with community members who are not on the job, Forklift pays these participants for time spent in rehearsals, attending planning meetings, and performing.

Before my team and I can enter the work environment, we must have permission from the institutional leadership. In order to do this, we typically need to attend safety training and agree to follow work-related policies like using and wearing safety gear. As outsiders, we must respect the systems in place to keep employees safe. It is of vital importance that we don't put an employee or ourselves at risk by not following protocol. This also means not speaking to the press until we have approval from the department media contact, and not using a photo of an employee at the job on social media before we get permission from that employee and the department leadership to do so. Each work group and community will have different requirements, but it is important to ask about these before entering the work space or shadowing employees.

Before ride-outs begin, I tend to map out on a high level how much employee time will be required for job shadowing, rehearsals, and performances. I also enumerate the other resources my team and I will likely request, including marketing and PR support, advertising, use of vehicles and other equipment, fuel for these vehicles, assistance with determining and reserving the performance site, and use of equipment the department might have on hand like chairs, tables, traffic cones, and so on.

There is an immense amount of logistic and administrative work that goes into our shows, involving many people who skillfully navigate all of the permits, permissions, and schedule coordination required to work on this scale and in public space. All of this is part of collaborative artmaking, too, and I have learned to build a very strong production team and to identify key people inside the partnering organization who can help us solve specific problems. No city department is a stranger to event management, so there are often a number of people within the organization who can assist with the complicated tasks of permitting, scheduling, vehicle organizing, and coordinating cast meals, among other duties. I am proud that Forklift has a reputation for being a great partner because we pay attention to the logistic details. Don't forget that they are part of what it takes to make an excellent piece of art.

5. Build trust.
Truly collaborative work depends upon extensive and sincere relationship-building. Take the time to establish authentic rapport with your

partners. Only then will they trust you, your team, and your process. One reason our projects typically last two to three years is that building trusting relationships takes time. Build that process into your timeline. Show up consistently, over weeks, months, or even years. Sometimes, though, a single event—often involving being vulnerable, or taking a risk—can really move a relationship forward. When working with professional women baseball players in Kyoto, Japan, for example, I stepped onto home plate, did my best to hit the ball, and struck out. Back in Austin, I once put on a harness, connected to climbing ropes, and tried to follow a master arborist up a tree, only to stall out a few feet off the ground. These moments may have been failures, but stretching myself helped endear me to the group, and also drove home the point that my collaborators are truly the experts. I am there as a novice, eager to learn from them.

Show genuine respect for a community or work group. Consistent and thoughtful action tends to speak louder than the best-intentioned words. That often means jumping in and doing the work. Work that I can do safely—like sweeping the floor or cleaning up after a meal—shows I am paying attention and want to contribute.

Getting to know people can be awkward at first. That is why I love the opportunity that working alongside someone and riding out can provide. There is something very powerful about picking up a broom and sweeping while getting to know people who are working in a prep kitchen (as opposed to standing there getting in the way while they are trying to get work done). Most people enjoy having someone around who is interested in their work; often very few people other than their coworkers actually know about their day-to-day work life. People also talk pretty easily while driving a truck or working a route.

With working and learning alongside community members, I practice a strategy that I learned from Liz Lerman, which she calls "active belonging." (www.d-lab.org/toolbox/foundations/). Active belonging is making the decision to belong in a group, so that even as you acknowledge that you are a newcomer, and no matter how awkward you might feel, you do not remove yourself from the present situation. To actively belong, you bring full self to the moment, and you join in without taking over. For me, that might look like making a joke, asking if I can pick up the next round of trash, or, as at Austin Energy, walking into the break room to shoot the shit with the linemen. Active belonging involves taking pleasure in being with people, and taking interest in what is going on.

In addition to working alongside people, it is important to spend time hanging out in unstructured moments: standing around while people wait for something to get delivered, set up, turned off, or turned on. This has not come naturally for me—I tend to be task oriented—but over time I have learned how to slow down, align with the pace of the group, and

allow moments to unfold. I think of this as meeting people where they are. Even when it looks like we are doing nothing, important things are often happening: these are times when people tend to share stories, laugh together, relate, and create memories.

Hanging out also means not rushing a goodbye. My fellow choreographer Krissie Marty is especially adept at this. She can linger in a goodbye with someone for a half an hour, recapping the day, making plans for the next one, inquiring about a family member. Truly there is an art to hanging out in the goodbyes and not rushing the exit; our best conversations often happen in the hallway after a meeting or as we are wrapping up to leave.

Food makes it easier to hang out because it gives us something to hang out around. When I arrive at places with food, people find it easier to sit down, stop doing, and relax. And then you get to talk.

Language matters too: it reflects culture. Pay attention to words, to slang, to terms you don't understand. Ask about them, and—as long as it is appropriate, respectful, and in line with your relationships with your interlocutors—use those relevant terms yourself. When I was working with Venetian gondoliers, I learned some Venetian dialect, and while no one was going to mistake me for a native Venetian, it helped show my interest and respect for the culture. While partnering with Austin's Aquatics Maintenance staff, we learned the names of basic maintenance equipment and their accompanying slang, like the backwash filter valve linkage, which the employees call "the one-armed bandit," so we could follow conversations and have clear discussions about our choreography.

6. Listen.

Throughout an entire project, my team and I consider and adjust the project's course around issues of ethics and accountability. Before entering a new community, make sure that you are competent in the skills required to build relationships and trust. Find a mentor or teacher. Spend time learning about how to practice the skills needed. This isn't easy or beginner-level work. It is especially important to spend time learning about the cultural bias—influenced by class, race, gender, educational status, and other identities—that we inevitably bring into our relationships with others. Also, do your research about the community you wish to partner with. Spend time learning about the community and notice what key issues they define as important. Why and how would working with you benefit this community?

Listening is at the core of my practice and is a skill I have developed over many years. We all know who a good listener is: Someone who doesn't interrupt or tell us what to do. Someone who, just by their calm presence, allows us to really share our thinking. Good listening is subtle

and delicate work, and I am at my best as a listener when I am relaxed and able to settle into just being in the moment. Ask questions that get people talking about themselves, and try hard to give people lots of space to keep talking. Often, the more someone keeps talking, the more open or personal that person's sharing becomes. Get excited about really trying to understand the person's world. Be curious about the minutiae of their decision-making—why it is they do what they do. All of us have a story about why we ended up where we are. I am looking to hear that story from the people I get to know. Work to validate your collaborators' feelings and experiences, remember what they tell you, track their stories over time, and let them know how delighted you are to be with them and learn from them. Put pieces of information together so you can have thoughtful conversations about the work or the community's history. Make eye contact if and when it helps a person feel comfortable. Sometimes that is not the case, and it's important to notice what works for different people.

Nearly everyone loves to share a story about themselves with an interested and good listener. I have heard all kinds of stories—funny, life-changing, heartbreaking. You may hear confidential information, and it is important that you keep that person's trust and not share personal information. People sometimes tell me things they haven't told anyone else at the job. As an outsider, I am a safe person to vent to or express frustration with. I hear complaints and criticism, too. Unless those problems have to do with our work together, my job isn't to fix them, but to support the employee or community member to solve that issue on their terms. With good listening, a person will get clearer thinking, work through ideas, and gain confidence on their own. I can't overstate the power of good listening to transform both people and organizations.

Still, I get told no. A lot. When I hear "No, that's not going to work," or even "No, I don't want to be in the show," I remember what I learned from Liz Lerman and the dancers she worked with at the Dance Exchange: "Resistance is information." When I hear no, I work to understand *why* —what am I missing or not getting? Sometimes when I am met with resistance, I can tell someone might be trying to find a solution. "No" might mean: "It doesn't work that way—but it could work this way." I return to curiosity here, and try hard to watch my own judgment and defensiveness as it creeps up. I like to follow a no with a question if it feels right. Often, I give space for the person to talk or even vent. This helps me understand the reason behind the no.

Of course, it is important to acknowledge a no: "OK, I hear you don't want to be in the show. You certainly don't have to be. It is completely up to you." But that doesn't mean giving up building a relationship with that person. Of course, there are people who decide not to participate, and that's OK. I remind people that there are many ways to contribute to our

project, and that just letting my fellow artists and me be in the work space with them is a vital way to help.

The same lessons apply on the administrative side. I have been challenged with lots of no's around safety and protocol. Work hard to remember that people inherently want to be cooperative and helpful, and that there are rules that institutions and departments must operate under. How can we get creative and find a solution together? When working with Urban Forestry, it started raining hard in the days leading up to our performance. The department was concerned about the trucks tearing up the grass in the park we were using, so in order not to have to rearrange choreography, we came up with a solution together: laying heavy-duty plastic mats under the trucks. When working with Austin Aquatics, we were required to have on-duty guards in the lifeguard stands during our shows at the pools. We worked with the lifeguards to choreograph the mandatory every twenty-minute staffing change, incorporating this into our shows artistically while following the department's existing procedures.

7. Cultivate attention and record what you notice.
A good listener notices and remembers details. Make notes in a journal so that you can remember key information, including both verbal and nonverbal communication: who is talking, who isn't, where are people standing, who follows whom, how people interact. Try to understand the typical cadence of the workday, the moments of interruption or variation, as well as interpersonal dynamics. It takes practice to get good at noticing these kinds of details, and it helps to debrief with a fellow artist or project partner when you have done a day of job shadowing together.

It is also important to allow yourself to simply experience — to just be with people without worrying too much about remembering every detail. Balancing that with moments of more focused attention means trusting myself to sometimes put away my notebook and just hang out. This puts people at ease, because they don't feel so intently studied. I learn a lot by relaxing and joining in, and I get a fully embodied experience of the place and people.

Interviewing is listening at one's best. Use both casual and structured interviews to deepen relationships and to learn more about what stories or experiences should be conveyed. Many interviews may happen naturally, through informal conversation, as people feel ready to open up. Sometimes we start with small group interviews so that people can get to know us without feeling they are under a single, bright spotlight. We try to keep these initial group interviews warm and easy, with participants enjoying the chance to reflect on their work or community together. In these group interviews, my team and I are paying attention to common issues the community members share that we can return to later, as well as who

seems comfortable talking and might be willing to do a one-on-one interview later. Group interviews don't always work for everyone. Women often have an easier time talking in a full group of women, whereas they may be quieter alone or in mixed-gender groups; men will sometimes hold back or feel less relaxed when put on the spot in front of their male coworkers. A solo interview, between just me or one of my team members and an interlocutor, can be an easier place for someone to talk without interruption and share more personal information. Overall, we work to follow the lead of our collaborators, noticing who feels comfortable talking and how.

More formal interviews, in which I record our conversation, happen much later in the process. By this point, enough informal conversations have happened that I have a good sense of what I want to ask, as I am looking to share the answers in the performance, worked into the sound score. I set up these recorded interviews in advance with permission of the employee and supervisor. Sometimes we do these interviews in a quiet room at the job site. More often, we sit in a car or truck, which has the added benefit of being a decent sound studio. Interviews can last anywhere from ten minutes to an hour, but in the early stages of getting to know someone, shorter is usually better.

8. Find the help you need.

Don't be shy about asking for help. It is a critical tool for artmaking. People like to help, and it makes for a better final product.

With every project, I hit roadblocks, and with every project, relationships help me move on to the next step. Rather than isolating myself and trying to solve all the problems on my own, which I can't do anyway, I remind myself to be vulnerable, face outward, and talk with people — both inside and outside of the project — about where I am getting stuck. And we as a group ultimately move forward in a way that I could not have figured out by myself.

I learned this during *The Trash Project*, when we were about thirty-six hours out from the show and it had been raining for days. There wasn't a dry leaf in the city, but I needed enough dry leaves to fill up the forty or so yard trimming bags that Virginia, one of the participating employees, was going to throw into the back of a truck for her solo. I was at a loss, so I turned to one of the department heads, Richard McHale. He considered, then said, "How about we use cat litter?" Apparently, the department keeps a copious stash of cat litter on hand to clean up occasional hydraulic spills from trucks. So we used cat litter to weigh down each yard trimming bag, filling the rest with air, so that they would stand upright and could be thrown as if full of leaves.

Asking for help also means reaching out with the partnering group to

other organizations who care about the issues your project is addressing. For *The Trees of Govalle*—our project with Urban Forestry—we worked with a local nonprofit to create educational pre-show activities about the importance of our urban forests. Additional partnerships like these can bring more resources and publicity to a project, and they also build connections that help people continue working together after a project ends.

It's important to get the help you need for the business side of art-making, as well. Artists do not just conceive and carry out projects—they also need those projects to be funded. Much of my job is devoted to fundraising, and I am privileged to have grown up in Austin with connections to businesses and individuals with the means to provide meaningful fiscal support for Forklift. At the same time, I have benefited from writing grants, asking for help from fundraising and nonprofit professionals who have guided me in creating fundraising plans, soliciting donations, and building an effective board of directors. Bring in the expertise you need to get the work done.

9. Build and get support.
Work that is based in process and relationship-building can be exhausting. It often extends beyond typical work hours, and can require a lot of emotional fortitude. Do what it takes to be able to show up ready to go. Despair, doubt, and hesitation—these feelings are normal, but to handle them with grace, you need to find ways to recover and renew. Your team needs that time, too. I still find that making dances challenges me like nothing else, and with every project, I reach a moment of deep uncertainty where I am afraid I am not going to be able to see my way to the end. I have gotten more comfortable knowing that hardships will always arrive, and when I feel that I'm at the end of my rope, I call a friend.

A crucial part of building support means having the wisdom to not take things personally. I am, admittedly, still working on this, though it has gotten easier. During one project, my chief partner at the city would yell at me during the first fifteen minutes of our standing meetings. He was a big guy and could get a little scary. I spent some time processing this, and finally realized that his need to yell wasn't about me. He was stressed in some other, more fundamental ways, and blowing off steam. Once I realized the yelling didn't really concern me personally, I decided to go into our meetings confident and prepared: I expected him to yell. He felt that someone needed to listen to him, and the best person for the job happened to be me. Once we got past those fifteen minutes of his grumbling and venting, we then were able to get down to working on the project together, reviewing details and covering items on my agenda.

I have also learned to remember that my collaborators, who are generously giving their time and expertise, are not there to listen to me com-

plain—especially if my frustration concerns them or their colleagues. I learned this lesson very early in my career when I was working in Venice with the gondoliers. It was a challenging project in many ways, and as the only woman around, I experienced a fair amount of sexism. One day I was at the end of my rope, and I got mad at one of my chief collaborators, sharing a few choice words as he rowed me across the grand canal. When we reached the other side of the canal and pulled into the boat dock, I stormed off, and immediately realized I had made a mistake. He might have been rude, or even sexist, but it would not serve the project if I took it personally. Later the next day, I returned and apologized, explaining to him that I was wrong to react in that way. He accepted my apology, and he apologized, as well. I was grateful that this fight did not end up jeopardizing our working relationship. In fact, he emerged as one of the key project leaders. But this experience taught me that although I work to bring my authentic self to the relationships, there are some limitations to what I should share. I need to set and respect boundaries around professional relationships, tracking my own feelings without letting them burst out in the workplace. I work to get enough emotional support off the job to stay clear-headed and calm when problems arise in the project or with collaborators—as they almost always will!

10. Create together.

The transition from building relationships to creating the dance itself is subtle, and happens at different times with different people. Some people indicate that they want to help months away from a performance, while others might not decide to come aboard until the week of the show. What is most important is to get people's creative minds engaged in solving the problem of how to make the dance—how to tell the story of their jobs, of a place, of an organization. Ask questions, use what's there, and look for the "yes" that lets you know that your collaborators are ready to make something together.

Finding what will work for the performing group is often the hardest thing to land on. Here is where we as artists need to give up our preconceived ideas of a specific piece of art we were going to make, and focus on listening to what our collaborators want to share. I ask open-ended questions to help generate ideas, like "What's the best thing about this machine?" or "I would love to show pole climbing at its best. To do that, what movement would we feature?" After spending months paying attention to the everyday movement, I tend to have a long list of potential choreographic ideas. I have been looking for what is unique to this community that people could expertly and easily feature in performance. Also, by now I will have an understanding of what stories or information my collaborators really want to share. But the actual performance content comes from

our minds coming together, making something that we wouldn't have been able to devise independently.

Of course I meet resistance, especially when collaborators have not felt confident that there was anything interesting to show or tell about their work. A City of Austin Urban Forestry employee told me, "Allison, there is nothing cool about the work I do. Who would ever want to watch me water a tree?" I listened, hearing him out. Gently, I then shared that I was confident that there were countless interesting aspects of his work. "Just give me time, and let me worry about that," I told him. In the end, he and his fellow employee made a great duet around the work of watering, featuring the watering trucks and their voices, sharing the types of trees they watered and why they thought their work was important to the city. As the dance ended, this employee, through pre-recorded text, told the audience what he thought about his job: "I enjoy doing it. When I first started this job, I didn't really think about what I was doing—I just did it. But now I enjoy helping out our planet and just making the earth a better place for the future generations." It was one of my favorite moments in the show.

11. Exit the piece, not the relationship.
The moments after a show are truly magical. Performers glow as they receive praise and recognition from family, fellow employees, and community members, many of whom linger to shake hands, ask for autographs, and take pictures. But there can be a letdown, even a kind of emotional crash akin to postpartum depression, as the weeks go on. Make time to revel in collective pride—not just after the show, but during the weeks ahead. At Forklift, our partners are eager to reflect on their experiences, and we want to listen. We work with leadership to find times to have lunch, attend an employee meeting, and just hang around so we can hear about what people are thinking and feeling.

Through formal post-performance surveys, we collect individual feedback and track our progress toward meeting our project goals. We try to do a first round of surveys with everyone who was part of the project, even those who assisted but didn't perform, within a month of the show. We often follow up with a second round, a few months later, to get further feedback and notice who is still eager to talk about the show. For some projects, we have returned up to six years later to hear how the project is still affecting participants.

In the months following the performance, we work with leadership to organize a cast party where we can screen a video of the show. I have hosted some of these at my house, for employees to attend on their own time, while others have taken place over lunch at the job, to make it easier for everyone to attend. We give a copy of the video to every participant, and employees are eager to celebrate all they have pulled off.

More and more, we are working with our alumni (our past collaborators) to share the story of our collaborative process. We look for alumni who are at ease talking, and who might be willing to serve on a panel with us or visit a university class. Sometimes we revisit projects around the anniversary of the show, showing the video at the job and convening a panel of employees who participated. It seems to rekindle some of the effects of the performance itself, and gives us a chance to learn more about the long-term impacts for the work group.

Planning how to end or transition a collaboration is a very important part of the process. Choreographer Jawole Willa Jo Zollar notes that when doing community-based work, artists must carefully consider their entrance and their exit, and I agree. Determining how to exit is in many ways the most considerable challenge my fellow community-based artists and I face — especially when we collaborate with communities who are not our own. At Forklift, we have decided to focus most of our work here in our hometown of Austin, Texas. This allows us to continue to be in relationship with past project partners. Apart from visiting the job sites as we can and inviting alumni to join us for classroom talks and conferences, we stay in touch by inviting alumni to performances and offering free tickets to our annual fundraiser. Past participants have joined our board and continue to coach and guide us, often making connections that help us on subsequent projects influencing how and where we make our work.

Over the years, I have come to understand that the performance is only one part of an ongoing relationship-building process, rather than the end or even the ultimate goal. More and more, I like to talk with partners about what they hope will happen *after* the show, and help them think about who we need to gather in order to make that happen. What can the performance leverage or be a catalyst for? How can we put people or organizations in relationships so that after the performance they can continue, or in some cases begin, the work the community needs most? As we stay in relationship post-projects, we find ourselves doing work that we hadn't anticipated, pushed into new realms and new practices. Recently, we even pivoted to film, creating a short video featuring some of the staff at Austin's first professional sports stadium. The video featured the events services team, grounds crew, and maintenance staff performing the movement of their jobs, set to music. The video showed on the jumbotron before the final game of the season. This project came out of years of relationship building, but ended up culminating in a way I could have never imagined before. With each project, different needs and initiatives arise. Our job as artists is to be responsive and open to those, ready to follow where our collaborators take us.

Appendix 2: Major Works

The Way of Water — Waller Creek (2022): A performance with the employees of Austin's Watershed Protection Department. Audience of 1,000+.

Dances for Dogs and the People Who Walk Them (2022): In partnership with the Austin Animal Center. Audience of 500+.

WesWorks (2021): A performance with Wesleyan University facilities staff. Audience of 1,000+.

From the Ground Up (2019): A dance with Wake Forest University facilities and campus services employees. Audience of 1,000+.

Givens Swims (2019): A dance for a city pool and its people, featuring Givens community members, city of Austin lifeguards, and Aquatics maintenance staff. Audience of 2,000+.

Nadamos Dove Springs (2018): A dance for a city pool and its people, featuring residents of the Dove Springs neighborhood, City of Austin lifeguards, and Aquatics maintenance staff. Audience of 2,000+.

Served (2018): A dance by and for Williams College Dining Services. Audience of 600+.

Bartholomew Swims (2017): A dance for a city pool and its people, featuring City of Austin lifeguards, Aquatics maintenance staff, and neighborhood residents. Audience of 2,000+.

Feet to the Fire: Riverfront Encounter (2016): A performance codirected with students at Wesleyan University in collaboration with employees of the Water and Sewer Department of Middletown, Connecticut. Audience of 500+.

Resource (2016): A performance installation with the employees and machinery of Goodwill Central Texas. Audience of 500+.

The Trees of Govalle (2015): A dance for the employees of Austin's Parks and Recreation Department's Urban Forestry Program and the Govalle-Johnston Terrace neighborhood. Audience of 2,000+.

Play Ball Kyoto (2014): A dance featuring the West Flora and South Diane baseball teams of Japan's Women's Professional Baseball League. Audience of 500+.

Afoot (2014): A dance with three marching bands in Houston's East End. Audience of 2,500+.

Play Ball Downs Field (2014): A dance featuring the Huston-Tillotson baseball team on Historic Downs Field in East Austin. Audience of 1,500+.

PowerUP (2013): A dance for the employees and machinery of Austin Energy. Audience of 6,000+.

Solo Symphony (2012/20): A dance for Austin Symphony conductor Peter Bay. Audience of 600+.

The Trash Project (2009/11): A dance for the employees and machinery of Austin Resource Recovery. Audiences of 6,000+.

SKATE! A Night at the Rink (2008/09): A performance featuring over thirty roller skaters. Audiences of 1,000+.

The King & I (2005/07): A dance for three trained dancers and five Elvis Presley impersonators. Audiences of 1,500+.

Sextet (2004): A dance for two dancers and two visually impaired men and their guide dogs. Audience of 500+.

The Gondola Project (2003/04): A dance for eight gondoliers performed on a canal in Venice, Italy. Audience of 1,000+.

In Case of Fire (2001): A dance for thirteen City of Austin firefighters. Audience of 500+.

Notes

Beginnings
1. Deidre Sklar, "Five Premises for a Culturally Sensitive Approach to Dance," *DCA (Dance Critics Association) News*, Summer 1991: 4, 9.
2. D. Soyini Madison, *Critical Ethnography: Method, Ethics, and Performance* (Thousand Oaks, CA: Sage Publications, 2005).
3. Dwight Conquergood, "Performing as a Moral Act: Ethical Dimensions of the Ethnography of Performance," *Text and Performance Quarterly*, 5, 1985: 10.

ONE In Case of Fire
1. Paying everyone, including all the artists and performing community members, is a non-negotiable aspect of our projects. This is a key requirement to be confirmed before we begin a partnership, as the collaborating institution or city department must underwrite the costs for their employees to participate. Payment is important because in a work setting, employees need to be covered by insurance when operating machinery, and that means the job needs to pay them. But also, many people have a second job and can't afford to give up earning that money by coming to a rehearsal or performing. Early in my career, I did a couple projects where I didn't pay my collaborators. The gondoliers I worked with in Venice, Italy, were not paid, and the people who participated in *Dances for Dogs* also volunteered. I was grateful for these participants' willingness to work for free, but today I would not move forward on a project without having the budget to pay all the participants.

FOUR *Dances for Places and Their People*
1. Nina Hernandez, "Shall We Dive In? Austin's Pool System Will Collapse If We Don't Save It," *Austin Chronicle*, vol. 37, no. 40: 16–19.
2. Cindy Elizabeth, 2019, www.cindyelizabeth.com/allegiance.
3. Forklift Danceworks, 2019, www.forkliftdanceworks.org/projects/ernesto-hernandez-perspectives-on-givens.
4. Nina Hernandez, "Austin Public Health Works to Address Covid-19 Racial Disparities," *Austin Monitor*, July 15, 2020: sec. City Council.
5. Cindy Elizabeth, 2020, www.cindyelizabeth.com/abeautifulsymphony.

Index

active belonging, 151
administration, 127–28, 154
Afoot, 162
Alexander, Virginia, 44–46, 62
Allegiance (Cindy Elizabeth), 116, 117
allies, looking for, 148
alumni, working with, 159
Alvarado, Joe, 81, 84, 90
Anderson, Don, 35, 36, 55–56, 57, 62, 142, 144
anthropology, 8
Arbo, Rani, 137
Arts in Public Places Program, 116
Ashmore, Neil, 66
attention cultivation and recording step for collaborative performance, 154–55
audience, significance of, 4
audio description, 37–38
Ausbury, Steve, 36–37
Austin, Texas, 1–2, 49, 127–28, 142, 148–49. *See also specific departments*
Austin Aquatics, 110–11, 112–13, 121, 127, 152, 154. *See also specific performances*
Austin Community College, 38
Austin Energy: award from, 99; Distribution, 78, 79, 86, 97; Network, 79, 95, 97; opportunities for, 69; overview of, 66; photo of, 72, 75; pitch to, 69–70; resistance by, 68–69; rodeo of, 65–66; scrutiny of, 75–76; Substation, 78, 87–88; Transmission, 79, 97; women within, 94–95; work process of, 78; work with, 3. *See also specific performances*
Austin Film Society, 49
Austin Firefighters Association, 25
Austin History Center, 123
Austin Indians, 103

Austin Palominos (Greyhounds), 103
Austin Public Health, 138
Austin Resource Recovery, 35, 43–44, 45, 46, 50. *See also* sanitation workers; trash collection
Avelar, Bruce, 133
Avilez, Ray, 109

Bajema, Beverly, 36–37
The Barber of Seville (Rossini), 12
Barsch, John, 87–88, 97
Bartholomew Pool, 112–14
Bartholomew Swims, 112–14, 113, 114, 127, 161
baseball players, 103–4, 105, 128–29, 141, 144. *See also specific performances*
Bay, Peter, 75, 85
Beautiful Symphony, A, 141
Beckerdite, Mark, 133
Berman, Ann, 38–39, 47
Berrelez, José, 97
Blackburn, Patrick, 67, 80, 95
Bolls, Rebekah, 81
Boster, Bob, 11–12
Bradford, Jeff, 66, 67, 71, 73
Brown, Azure, 103, 122–23
Brown, Eric, 97, 99
Brown, Steven, 126
Bruch, Jeremy, 85
Buck, Palmer, 24–25, 40–41
bucket truck, 53, 55
Buena, Gustavo, 12
Burns, Creola Shaw, 123
Bustamante, José, 37
Byrd, Lisa, 102, 104, 107, 116

Campbell, Glen, 96
Campbell, Todd, 79

Card, Ashley, 59, 81, 103
Carlson, Ann, 9
carpenters, movement of labor by, 4
Catterson, Allen, 125
Cay, Bernadette, 123
Cendejos, Miguel, 12
Central Texas Negro League, 104
chief curator, 27–28
Chong, Ping, 9
choreography, 8–9, 25–26, 33, 36, 118, 120. *See also specific performances*
Christopher Columbus syndrome, 107
Citizens Advisory Committee, 111
Clark, Midorie, 123
climbing, linemen, 73–74, 88–90
Clopton, Dawn, 27–28, 29, 30, 34
Coffey, Fiona, 137
Cohen-Cruz, Jan, 17
collaborative performance: attention cultivation and recording step for, 154–55; create together step for, 157–58; curiosity step for, 147–48; exit the piece, not the relationship step for, 158–59; expectations step for, 149–50; finding help step for, 155–56; listen for need step for, 149; listening step for, 152–54; support building/getting step for, 156–57; trust building step for, 150–52; warm connections nurture and work for, 148–49
college campuses, performances regarding, 130–37, 161. *See also specific performances*
Colvin, Kurtiss "Mr. Oowee," Sr., 117
communication, of electric linemen, 5
community-based artmaking, 10, 17, 22, 108
compensation, importance of, 148, 149–50, 163n1
comuArt, 129
concert dance, characteristics of, 7
Conner, Miriam, 114, 122
Conquergood, Dwight, 18
Cook, Ray, 73, 75
Cordova, Carlos, 68, 82
Covid-19 pandemic, 126, 140–41
crane, 55–56, 57
create together step for collaborative performance, 157–58
creativity, importance of, 2

cue sheets, 82
Cultural District team, 104
culture, language within, 152
Cummings, Blondell, 9
curiosity step for collaborative performance, 147–48

dance: cultural values of, 4; as informing life, 9; for mixed-abilities, 38; movement of labor and, 4; relationships within, 4–5; teachings from, 34
Dance Exchange, 10, 13
Dances for Dogs and the People Who Walk Them, 13–14, 161
dead animal collection, 46, 58
Defreeze, Jermain, 59
Dilworth-Cox, Pearl, 123
dishwashing, dancing process during, 1
Distribution (Austin Energy), 78, 79, 86, 97
dog walking, 13–14
Donley, "Cowboy," 110
Donley, Sylvia, 110
Dove Springs Proud, 115
Downs Field: famous players at, 104; history of, 103–4, 107; overview of, 101; photo of, 143, 144; projects regarding, 141–42; restoration plans for, 102, 107–8; story regarding, 102–3; work process at, 101. *See also specific performances*
Dudley, Tony, 44, 46, 58, 62
Dunovant, Judy, 132
Dusich, Joseph, 12
Dylan (dog), 37, 38, 39

East Austin, pools within, 111
Electric Service Delivery, 69–70
Elizabeth, Cindy, 116, 117, 140, 141, 144
Ellis, Cindy, 79, 86, 97
Esparza, Jesse, 74, 75, 78
"exit the piece, not the relationship" step for collaborative performance, 158–59
expectations step for collaborative performance, 149–50

family time, movement of, 14–15
Feet to the Fire: Riverfront Encounter, 161
finding help step of collaborative performance, 155–56
Fippinger, Randy, 137

firefighting/firefighters: choreography for, 25–26; injuries to, 23; interviewing, 29–30; ladder work of, 29; movements of, 19–20, 24; performance of, 33–34; resistance from, 24–25, 31–32; risk of, 30; September 11 and, 30–31; Station 11, 20–21, 21–22, 28; Station 17, 22–23, 24, 28; street study by, 26. See also *In Case of Fire*
Fire Prevention Week, 25
Fischtrom, Kayo, 129
Flores, David, 117
Floyd, Philip, 96
food, importance of, 152
Forklift Danceworks: attention cultivation and recording step for collaborative performance of, 154–55; board of directors of, 138; create together step for collaborative performance of, 157–58; curiosity step for collaborative performance of, 147–48; employees of, 114–15; exit the piece, not the relationship step for collaborative performance of, 158–59; expansion of, 128; expectations step for collaborative performance of, 149–50; finding help step for collaborative performance of, 155–56; formation and development of, 2–3; infrastructure of, 40, 138; job shadowing process of, 21; listen for need step for collaborative performance of, 149; listening step for collaborative performance of, 152–54; mission of, 108; origin of, 1, 40; partnerships of, 21; relationship building within, 2; resistance within, 17; support building/getting step for collaborative performance of, 156–57; teaching at, 137–38; trust building step for collaborative performance of, 150–52; warm connections nurture and work for collaborative performance of, 148–49
Francois, Valerie, 42–43
Frazier, Thomas, 97
Fredley, Theresa, 38–39
Freeman, Robert, 122
"From Desk to Field," 94–95
From the Ground Up, 132, 133, 161
fundraising, finding help for, 156

Fusebox Festival, 109

Galvan, Ron, 12
Garrison, Andy, 48–49, 62
GAVA, 115
Gaymon-Jones, Leigh Robbie, 59–60
Gendrich, Cindy, 137
Givens, Everett H., 116, 122
Givens Park Hands Full of Cash Car Club, 115
Givens Park Working Group, 126
Givens Pool, 116, 121–22
Givens Swims, 118, 122, 123, 124, 126, 161
Glassie, Henry, 18
Godinez, Manuel, 11–12
Gomez, Michael, 95
Gomez, Oscar, 12
Gondola Project, The, 22, 32–33, 162
gondoliers, 22, 32–33
grape-picking, 15
grounds keeping, 12
group interviews, 155
guide dogs, 37
Gutierrez, Garrett, 85–86
Gutierrez, Marcus, 125
Guzman, Leticia, 130

hanging out, 151–52
Hanson, Aaron, 80–81
Hanson, Angela, 108
Harden, Ada, 116, 122, 140, 143
Hart, Pam, 104
Hastings, Destiny, 118
Hay, Deborah, 17, 36, 40
Hensley, Sara, 110
Hernandez, Cesar, 84
Hernandez, Juan, 112, 113–14, 123, 125
High Performance (magazine), 10
Hirshberg, Jane, 137
home, movement of labor within, 14–15
Houle, Christina, 59
Houston, Lee, 51
Hughes, Celia, 37–38
"Hurt Man Rescue," 96
Huser, Julie, 28–29
Huston-Tillotson baseball team, 103, 104, 105, 141. See also *Play Ball Downs Field*

In Case of Fire, 25, 28–30, 31–34, 162
inequity, structures of, 3

integration, of pools, 111–12
International Community Arts Festival (ICAF), 129
interviewing, 29, 154–55
In the Upper Room (Tharp), 25

Jackson, Ivory, Jr., 51, 62
Janowski, Zach, 88
Japan Women's Baseball League, 128–29
Jay, Jodi, 123
Jefferson, Orange, 51, 53, 54, 62
Jesurun, Christina, 31
job shadowing, 21
"Johnny Substation," 87–88, 97
Johnson, Shonda, 57
Johnson, Tafari, 36, 51
Jones, Lloyd, 136
Joubert, Louise, 28, 29, 34
Junebug Productions, 17

Kamimura, Eriko, 129
Keeton, Kymberly, 142
Kellogg, D. K., 72
Kelly, Jamil, 84, 88
Kenneth Gardner Service Center, 35
Kiara, Carment, 115–16, 122
King & I, The, 38–39, 162
Klindt, Tamara, 48, 61, 64, 82
Kobayashi, Miyuki, 129
Konishi, Mika, 128–29
Kuppers, Petra, 17
Kyoto Arts Center, 128

labor, movement of: audience for, 4; communication through, 5; cultural values of, 4; dance and, 4; dishwashing, 1; family time as, 14–15; of firefighting, 19–20; of gondoliers, 22; within the home, 14–15; of linemen, electric, 65–66; relationships within, 4–5; of trash collection, 36
Lacy, Suzanne, 17
ladders, 29
LaMotte, Gretchen, 115, 137, 141
Langley, Jesse, 42
languages, learning individual, 149, 152
Las Estrellas, 110
Lerman, Liz, 10, 13, 130, 151, 153
liability insurance, 49
Limon, Johnny, 110

Linder, Nelson, 111–12
linemen, electric: climbing skills of, 73–74, 88–90; communication by, 5; demographics of, 67; personalities of, 78; photo of, 72, 75; resistance by, 66–67, 68–69, 71; rodeo of, 65–66; training for, 73; women as, 94–95; work process of, 78; work variety of, 71. *See also* Austin Energy
"Linemen's Conjunto," 91–93
listen for need step for collaborative performance, 149
listening, 149, 154
listening step for collaborative performance, 152–54
"Lone Streetlight," 95–96
Longfellow (dog), 14
Longoria, Trey, 91–93, 96
Lopez, Freddie, 12
Loveling, Karly, 37, 38–39
Lowing-Scott, Sarah, 13–14

Madison, D. Soyini, 17
Maher, Travis, 30
Maness, Jared, 90, 100
Manifesto for Maintenance Art (Ukeles), 40
Marks, Victoria, 9
Martinez, Johnny, 79, 97
Marty, Krissie: hanging out skills of, 152; leadership of, 138–39; photo of, 141; viewpoint of, 137–38; work of, 70, 71, 81, 82, 88, 94–95, 102, 112
Matus, Mike, 85
Mayfield, Jill, 41, 42
McGrath, Melissa, 5
McHale, Richard, 42, 155
McKee, Stephanie, 17
Meadows, Bill, 58
Mele, Cheryl, 68, 69
Mendez, Tony, 84, 95–96
Miller, Celeste, 17
Miller, Jimmy, 59
Miller, Mary, 123, 124
Mills College, 8, 10–11
mixed-ability classes, 38
Moore, Alvin, 101–2, 103–4, 106, 107
Morales, George, 120
Morris, David, 42
Morrison, Laura, 111

Muños, Jesse, 42
Murdock, Don "Doc," 20, 26–27, 34
music: characteristics of, 25; choreography with, 55; development of, 47–48; orchestra, 75, 85, 86. *See also specific performances*
Music, 36–37
My Park, My Pool, My City, 111, 114–15, 127

Nadamos Dove Springs, 118, 119, 120–21, 127, 161
need, attentiveness to, 149
Negro League Baseball, 103–4, 141, 144
Network (Austin Energy), 79, 95, 97
New Employee Orientation (NEO), 42
no answer, acknowledging, 153–54

Olenberger, Eric, 73
On Campus, 130, 133
O'Neil, Buck, 107
On the Job, 140–41
orchestra, for *PowerUP*, 75, 85, 86
Osgood, Lynn, 127
"Our People PowerUP" (Small), 96
Owens, Billy, 122
Owens, Ephraim, 104

Pace, Meg, 20, 28, 29
Parks and Recreation Department, 112
participant observation, 21
Paxton, Steve, 9
Pease, Charlie, 77, 80
Perez, Rosie, 120
permission, from institutional leadership, 150
personal connections, 22
Perspectives on Givens (Ramirez), 116, 117
"Phenomenon, The" (Small), 87
Phillips, Anthony, 51, 60, 62, 70
Pierce, Randy, 20
Pinsky, Clara, 110, 114–15
planning, process of, 150
Play Ball Downs Field, 104, 105, 106, 107, 140–41, 162
Play Ball Kyoto, 129, 161
playing awake, 36
Playland Skate, 51
point of contact, 148
police officers, 5
Poole, Sonny, 70, 74, 82

pools, 112–13, 118, 120. *See also specific performances; specific pools*
Porter, Eric, 86
post-performance surveys, 158
Pottenger, Marty, 9–10, 83
power, structures of, 3
PowerUP: cast meal of, 83–85; choreography for, 77, 81; collaboration for, 77; "From Desk to Field," 94–95; fundraising for, 70, 75; "Hurt Man Rescue," 96; impact of, 99–100; "Johnny Substation," 87–88, 97; "Linemen's Conjunto," 91–93; "Lone Streetlight," 95–96; music for, 75, 85, 86, 96; narrative arc within, 80; "Our People PowerUP" (Small), 96; overview of, 162; performance of, 85–98; "Phenomenon, The" (Small), 87; photo of, 84, 90, 92, 98; production budget for, 75; production planning for, 74–77; rehearsals for, 80–85; research for, 71–74; set-up for, 77–78; "The Underground Animal," 95; trouble call within, 80; "Watts UP," 93–94
Presley, Elvis, 38
Pruitt, Stephen, 46–47, 48, 49, 104, 123

racism, 111–12
Rainer, Yvonne, 9
Ramirez, Camilo, 134–35
Ramirez, Ernesto Hernandez, 116, 117
Ramos, Raquel, 118
Ray, Benny, 67
"Real People series" (Carlson), 9
rehearsals: for *In Case of Fire*, 30, 31–33; of *The Gondola Project*, 32–33; for *PowerUP*, 80–85; strategies for, 33; for *The Trash Project*, 56, 59, 60–61, 70
relationships, 2, 16–17, 148–49, 158–59
Relay (Austin Energy), 86
relay crew, 79
resistance, as information, 153
Resource, 161
respect, 151
Reyes, Roberto, 97
Reynolds, Graham, 46–48, 49, 61, 75, 82, 85, 86, 107, 129
Reynolds, Todd, 85
Rhodes, Willie, 41
riding out, 151

risk, 151
Rivera, Pete, 110
Roberts, Donnie (Texas Elvis), 38–39
Robideaux, Ann, 10–11
Rodrigues, Rowan, 121
Rosario, Felix, 134–35
Rosario, Victor, 134–35
Rose, Billy, 10–11
Roy, Molly, 59

Sadayuki, Natumi, 129
sandhogs, 10
sanitation workers: assumptions regarding, 49–50; demographics of, 35; employee training for, 42; equipment of, 50–51, 53, 55; job variety within, 44, 46; New Employee Orientation (NEO) for, 42; presentation to, 35–36; pride of, 49–50; resistance of, 35–36, 41–42, 43; respect for, 42; routine of, 43–44, 45; trash collection, 36, 42–43; work of, 42. *See also* Austin Resource Recovery
Saul, Lonnie, 33
Schellin, Sozan, 37, 38, 39
Second Chance Employer, 50
Seguin Lineman's Rodeo, 65–66
self-examination, 16
September 11, 30–31
Served, 130–32, 161
sexism, 67–68, 157
Sextet, 37–38, 39, 162
Sherburn, Jennifer, 81
Shouse, Mark, 133
Singleton, Darrell, 83, 84
"Sin Ti," 110
SKATE!, 51, 52, 162
skating, 51
Sklar, Deidre, 5
Slatin, John, 37, 38, 39
Slutes, Paul, 112, 113–14, 123, 125
Small, Allen, 73, 77, 87, 93–94, 96, 99, 104, 105
Smith, Dan, 68–69, 70, 99
Smith, Robert (Scot Free), 105
Smith, Tracy, 122
"Solid Waste Go-Getter," 51
Solo Symphony, 162
Soriano, Christina, 137
Spring (Vivaldi), 12

Station 11, 20–22, 28. See also *In Case of Fire*
Station 17, 22–23, 24, 28. See also *In Case of Fire*
Stephenson, Laura, 23, 24, 25
Stephenson, Mike, 23–24, 28
streets, study of, by firefighters, 26
street sweepers, 53, 55
Substation (Austin Energy), 78, 87–88
Sullivan, Mike "Sully," 20, 21, 22, 24, 34
support building/getting step for collaborative performance, 156–57
SWIMATX, 112

Take Me Out to Downs Field, 141–42, 143
Tapscott, Jonathan "Tap," 112, 113–14, 125–26
Tatge, Pam, 130
Taylor, Denver, 97, 99
Tejero, José, 145
Teltow, David, 68, 81, 83, 99
Tharp, Twyla, 25
Thompson, George, 51
Thompson, Kenneth, 107
Torralba, Fabiola, 115
Touch Sanitation (Ukeles), 40
Trabulsi, Blake, 14
traffic directing, 5
Transmission (Austin Energy), 79, 97
trash collection, 36, 42–43
Trash Dance (Garrison), 48–49
Trash Project, The: collaboration within, 46–50; development process of, 56; equipment within, 50–51; finding help for, 155; fundraising for, 49; overview of, 46–47, 162; participation within, 53, 55; performance of, 61–64; photo of, 54, 57, 63; planning process for, 46–50; production team work of, 58–59; promotion for, 58; rehearsals for, 56, 59, 60–61, 70; weather challenges of, 60–61
Travis County Exposition and Heritage Center, 74
Tree Folks, 110
Trees of Govalle, The, 109, 156, 161
Trevino, Jeff, 90
Trio A (Rainer), 9
Truesdell, Stephen, 19, 20, 24, 26, 31
trust, 3

trust building step for collaborative
 performance, 150–52
Turner, Nook, 121, 122

Ukeles, Mierle, 40
uncertainty, working with, 27
"Underground Animal, The," 95
Urban Bush Women, 9
Urban Forestry, 108–9

vision, shared, 149
visually impaired persons, 37
"Volver Volver," 121
vulnerability, 151

Wake Forest University, 132, 133
Wallace, Jerry, 52
warm connections step for collaborative
 performance, 148–49
Watanabe, June, 8–9
Watson, Gerald, 53, 55, 62, 70
Watson, Terrell, 78, 88–91, 90

"Watts UP," 93–94
Way of Water, The, 161
*We Are Here—Living into the Legacy of
 Dr. Givens*, 126–27
Webb, Jimmy, 96
Wells, Stella, 103
Wells, Willie, 103
Wesleyan University, 132, 137
WesWorks, 132, 134–35, 136, 161
"Wichita Lineman" (Webb), 96
Williams College, 130–31, 133
Wilson, Joey, 10–11
window washing, 11
Wood, David, 69, 70
Wynn, Larkin, 81

Zapata, Ofelia, 118, 120
Zapata, Tim, 118
Zavala, Ricardo, 120
Zeke (dog), 37, 38, 39
Zero Waste plan, 49
Zollar, Jawole Willa Jo, 9, 159

About the Author

ALLISON ORR is a choreographer and the founder of Forklift Danceworks. After receiving her MFA in choreography and performance from Mills College, she began to make dances that incorporate unexpected voices and bodies. Through ethnographic practice and ongoing research, Orr continues to make dance that is collaborative, site-specific, and inclusive. Her performances have included firefighters, civic workers, and baseball players, expanding the boundaries of conventional dance and interrogating what choreography can be. In recent years, Orr has been named a MacDowell Fellow, a Dance/USA Fellow in Social Change, and a Doris Duke US Artist Fellow, recognizing her as one of the most compelling artists working in the United States today. In addition to her current position as artistic director at Forklift Danceworks, she is a Distinguished Fellow in the College of the Environment at Wesleyan University.